Photographer's Market
Guide to Building Your
Photography
Business

Everything you need to know to run
a successful photography business

Vik Orenstein

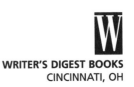

WRITER'S DIGEST BOOKS
CINCINNATI, OH

Visit our Web site at www.writersdigest.com for information and resources for writers.

Other fine Writer's Digest Books are available from your local bookstore or direct from the publisher.

11 10 09 08 07 9 8 7 6 5

Library of Congress Cataloging-in-Publication Data

Orenstein, Vik, 1960-
 Photographer's market guide to building your photography business: everything you need to know to run a successful photography business / Vik Orenstein.—1st ed.
 p. cm.
Includes index.
ISBN-13: 978-1-58297-264-0 (alk. paper)
ISBN-10: 1-58297-264-8 (alk. paper)
1. Photography—Business methods. 2. Photography—Marketing. I. Title: Photography business. II. Title.
TR581.O74 2004
770′.68—dc22

2004048025

BK ROTH
$16.90

Edited by Jerry Jackson Jr.
Designed by Clare Finney and Leigh Ann Lentz
Production coordinated by Robin Richie

Dedication

For Dale and Albie, my curly girls

Acknowledgments

I'd like to extend my heartfelt thanks to the photographers: Peter Aaron; Randy Lynch; Leo Kim; Stormi Greener; Beth Wald; David Sherman; Bob Dale; Hilary Bullock; Karen Melvin; Craig Blacklock; Lee Stanford; Rob Levine; Keri Pickett; Roy Blakey; Doug Beasley; Jim Miotke; Bryan Peterson; Laura Dizon; Gina Hilukka; Kelly McSwiggan; Abby Grossman; Shannonlee McNeely, and Lauren Peterson; Jim Mires; Irene Colhag; Juliette Colpa-Thomas; Stephanie Jordan; Patrick Fox; Colleen Baz; Stephanie Adams; Donna Taylor; Samantha Dorn; Christian Boice; and Mike Dauost, for their time, their interviews, their expertise, and their images.

And to Jim Orenstein, my CPA and business advisor for sixteen years and counting; Janet Boche-Krause, my lawyer; Diana Collier of Collier & Associates, my literary agent; Dale Wolf, for freely giving of her editing and nit-picking skills even as she was undergoing various treatments for cancer; my daughter Albie, for sharing my attention with this project; Vivian Orensten, my mother, for taking care of Albie and my home while I struggled to meet my deadline; Brad Crawford, my old editor; and Jerry Jackson, my new editor; Judy Davis, my friend, cousin, and general manager of KidCapers Portraits and Tiny Acorn Portraits, for putting up with my absences from work and my interesting brain chemistry while I completed this book; Jason Dale, for offering tireless technical computer help even when it was extremely inconvenient for him; Staci Williams, my sister, for unflagging support and encouragement; Heather Young and Denise Miotke at BetterPhoto.com for their technical support; and all my students, past and present, at BetterPhoto.com, for never ceasing to inspire me.

Table of Contents

What It Means to Be a Photographer

A lot of people say they want to be photographers, but what do they really mean when they express this desire? For that matter, what does it mean to be a photographer? What is a photographer, and what does he do?

Basically, most people think a photographer is a visual artist. They imagine that we spend most of our time shooting pictures and printing in the darkroom; we make a lot of money; we get to work with gorgeous models and advertising people and brilliant architects and other talented types; we get to use cool equipment and travel to exotic locations; and some of us get to see our work in magazines and advertisements.

Well, this is all true … about 20 percent of the time. But the other 80 percent of being a photographer falls into more mundane categories.

BEING A PHOTOGRAPHER MEANS BEING IN BUSINESS

"I became a photographer in part because I didn't want to be a businessman," says fine art and commercial photographer Doug Beasley. "But you can't be a photographer without being a business person. Not if you want to stay in business very long."

Unless, of course, you're independently wealthy. Then by all means, go ahead and have shoddy business practices. Don't

worry about anyone ever buying your work. Charge too much, or charge too little, don't answer your phone, don't return calls, and don't deliver anything on time. Knock yourself out. But for the rest of us, good business practices are as important to our success as our creative talent. You may be a photographer today, but no matter how brilliant your work is, if you still want to be a photographer tomorrow, you must concern yourself with every aspect of your business.

"That doesn't mean you have to be good at it. You're still allowed to struggle," jokes fashion and commercial shooter Lee Stanford, owner of Stanford Photography in Minneapolis. His kidding does make an important point—you don't have to be Donald Trump or Bill Gates, or a graduate of Harvard School of Business. Business may well be a challenge to you through your entire career. You may have to work twice as hard at your business as you do at your art. But can you name one worthwhile

thing you get in life without a little sweat?

"I think we all come into this business thinking we're going to be shooting most of the time. In actuality, we spend very, very little time shooting and a whole lot of time taking care of business," explains Minneapolis commercial photographer Patrick Fox, owner of Fox Komis Studio. "I like the business part; I think it's fun. You shouldn't go into photography if you can't be passionate about all of it, the business side included."

Personally, I never really pictured myself (pardon the pun) as

As art director and photographer for the last tour book for Grant Hart and Husker Du, Rob Levine needed action shots that captured them in mid beat.

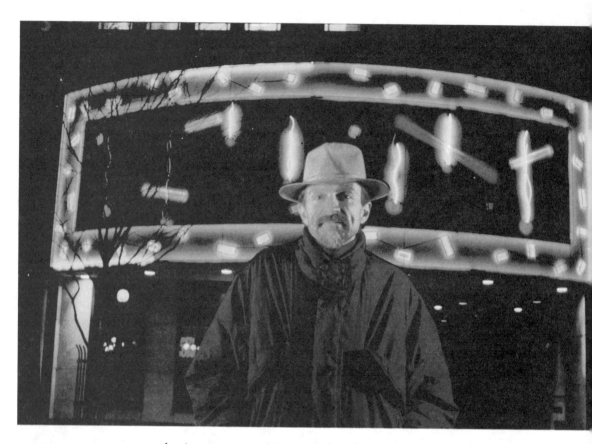

a business person. My attitude when I opened my first studio was along the lines of, "Hey, let's put on a show! We can do it in my dad's barn!" I never thought that someday I'd be running four studios, eagerly awaiting monthly reports from my bookkeeper, intently examining profit/loss statements, reconciling Visa logs, calculating my average sales, or studying fee structure as if it were a science. Sometimes when I'm doing these things I soothe myself with a little mantra: "I love the glamour, I love the glamour, I love the glamour."

Seriously, though, now I actually do love the business side of my ... well, business, just as Patrick Fox says. But it took me a while to embrace the whole business mogul thing. My first employee gently pointed out to me that there was this little thing called the alphabet, and that maybe my files should be organized according to it. An early client tactfully suggested that I audit his business course at a nearby university. Amused and flattered by

his concern, I declined. Now, thirteen years later, I wish I had followed through on his suggestion. Perhaps 90 percent of the photographers I interviewed have no business background, and many share this regret. Because while this lack of business background didn't stop any of us from building our businesses, we've come to realize it may have slowed down the process.

"I learned by making every business mistake there is ... some of them several times," says Doug Beasley. While he doesn't recommend his method of trial and error (and more error) to everyone, he adds, "If I could go back and do it over again I'd take business classes. But the lessons I learned the hard way, I'll never forget."

BEING A PHOTOGRAPHER MEANS HAVING AN OBLIGATION

War photographers feel a deep obligation to portray the horrors of the battlefield so that perhaps one day there will be no more war. They risk their lives to this end. The rest of us, working under significantly less danger, have the same obligation to tell our subjects' stories. Whether it's a simple portrait, a sports photo, or a fashion shot, we must really *see* our subjects and record their story in the context of their culture, their place in time, and history.

BEING A PHOTOGRAPHER MEANS BEING YOUR OWN PRODUCT

We have a tendency to think that as photographers we're selling our images—that our pictures are our product. But we are mistaken.

"When someone hires you for a job, they're not buying your images, because after all, you haven't even shot them yet. No, they're buying you," says Doug Beasley. "One of my recent commercial clients told me he chose me over the other hopefuls because I talked to him about how I wanted to shoot the job, and the others had talked to him about their equipment, their technology."

Though your clients probably think they are buying your images and nothing but your images, in reality they are buying their experience of you: your conscious and unconscious mes-

sages to them about your level of expertise; your understanding of their project; how much you value them as clients and like them as people. As strange as it seems, the final take is almost incidental.

What you are selling is the value they receive from working with you—your creative voice, your service, your vision, and the way you relate to your clients and your subjects.

BEING A PHOTOGRAPHER MEANS HAVING INTIMATE RELATIONSHIPS

A portrait photographer often sees her clients when they're feeling very stressed out: They're agitated from getting the kids together and pulling Dad away from the golf course and getting the dog to and from the groomer and assembling three-plus outfits per person and then getting everyone and everything to the photo studio in one piece. They're worried about whether their kids, husbands, dogs, and hair will cooperate. They're worried that they might have brought the wrong wardrobe, or that they forgot a key pair of shoes or that all-important soccer ball. They deliver themselves into your studio frazzled and anxious. They need reassurance and encouragement, and not from just anybody—they need it from you, their family photographer. And if they don't get it, it doesn't matter if you're Annie Leibovitz; you will not get good results.

You and your clients have been thrust into an immediately intimate situation and you will come out of it one of two ways—best buddies or sullen adversaries. There is no middle ground here.

You must meet their needs with compassion or the results can be disastrous. And you can't display compassion without being open and human yourself.

"Photography is an economic business built on relationships," says commercial shooter Bob Pearl, owner of Pearl Photography. "Aside from the enjoyment of capturing images, the clients are the greatest thing about this whole business to me. I have great clients. Most of them have become my friends. I love people. I think that's why my clients come back, for this as much as because they're happy with my work."

While taking a series of documentational shots of campers dancing for his client, David Sherman saw a different kind of shot he wanted to make: a long exposure of the dancers' hands as they swayed.
© David Sherman.

"It is about relationships. Name a business that isn't," says Patrick Fox. "We need to be professional and personable. We need to be 'people' people." And Patrick notes that this rule applies to others besides the clients.

"Be nice to the ... person who runs the office. Don't be a prima donna, because that person has pull. Building good relationships wherever you go, that's how you invest in your business."

"There's a lot of competition out there; the market is fierce," says commercial and wedding photographer David Sherman. "If two photographers are showing equally good work, the client will hire the one who's easiest to get along with, the one they feel rapport with. I got my contract with the NBA partly because I'm easy to work with, because there were people in the organization who liked me and went to bat for me."

Success can be a catch-22, because once you become more established, you tend to become more removed from your

clients. When you stop working hard to keep the relationships alive and start taking them for granted, you can lose them.

"It's like a marriage that way," states Lee Stanford. "Just when you think you can kick back and relax is when you have to get down to work."

BEING A PHOTOGRAPHER MEANS RIDING THE CREATIVE ROLLER COASTER

"The sad fact is that a lot of what we do is just not creative," says Bob Pearl, summing up the sentiments of almost every photographer I interviewed. "When you're shooting a boat catalog for instance, they often want the same shots: shots so you can see the seating in the boat. There are only so many angles you can use and still show the seats.

"You can get in a rut, because people start coming to you because you do a certain look or technique, and it's new and it's great, and you're excited and the clients are excited. But then that's all anyone wants you to do, and it's not so exciting anymore. But it still pays the bills, so you can't stop."

Here Sherman used the long exposure to capture the dancers' feet. These shots didn't wind up being used by the client, but Sherman got the satisfaction of making them for himself.

Each photographic specialty has its own standard shots: for fashion there are outline and laydown shots; portraiture has headshots, full length and three-quarter; models' comps require a full length swimsuit shot, a headshot, and a business shot; architectural has basic exteriors, detail shots, and wide angle interiors; and the list goes on. Even if you don't understand the terminology for each shot, you can deduce from the sound of them that they aren't the artistic shots you dream of creating in your new career.

"For each roll of film, you shoot ten shots for the client and two shots for yourself," says David Sherman. "You live for those two shots." Sometimes it's not the clients or the market that constrict a photographer creatively; sometimes it's just his own darn fault.

"You start out in this business scared," David says. "You're scared you're not good enough, you're scared you'll do something wrong and blow a take, you're scared someone will come up to you and accuse you of impersonating a photographer. But all that fear makes you work more creatively. When you've been in business for a while and the fear goes away, maybe you don't work as creatively anymore, because it was partly the fear that fueled your passion."

Adds Lee Standford, "It's like anything, once you master it you

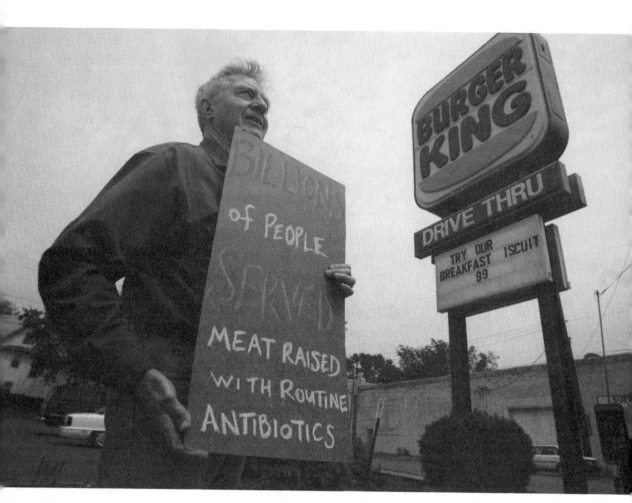

can get bored. I try to remember that this might be old hat for me, but it's an investment for my clients. Even though I can wait three days for a take to come back because I know what I've got, the client wants to see it yesterday, so I keep my turn-arounds quick and allow them their excitement, and it rubs off on me."

Sometimes mastering a new technique spurs a creative surge. That's why it's important to keep shooting your own work, to keep test shooting, to keep trying out new media, and to surround yourself with the nuts and bolts and process of your art.

BEING A PHOTOGRAPHER MEANS REINVENTING YOURSELF EVERYDAY

Photographers are at the mercy of the changing economy, the

marketplace, styles and trends, and technological advancements just as farmers are at the mercy of the weather.

The photography business is a little like that child's game, "Button, button, who has the button?" The child puts a button in her hand, puts her hands behind her back, wildly passes the button from hand to hand, then brings her little fists forward and asks you to guess where the button is. Similarly, you need to know in which photography specialty the button (i.e., the income potential) is. But just as in the child's game, the button doesn't stay in one place forever. Events happen in the industry that suck the money right out of one area and pop it into another.

For instance, twenty years ago there was good money to be made in stock photography. But digital technology and the Internet have made the playing field bigger, and the images easier and cheaper to obtain. There is still money to be made in stock photography, but it's harder.

Conversely, at the same time that the life was getting sucked out of the stock photo business, baby boomers were becoming more prosperous and starting families. Their newly disposable income and artistic sophistication opened up the door for high-end, artistic portrait studios to flourish.

Fine art and commercial photographer Doug Beasley is one

photographer who recognizes this as an opportunity, not a slamming door. "I can't change the whole market, so I change myself," he explains.

Patrick Fox gives the example of an architectural photographer who found the Minneapolis market a little lean when the economy faltered and made a change to lifestyle shooting. Lifestyle as a category didn't even exist when he first started in the business, but now it's a big part of the market.

"You don't necessarily change your specialty," says Minneapolis architectural and commercial photographer Karen Melvin. "You change your emphasis, or you raise the bar. Maybe you keep shooting architecture, but you market to commercial clients as well as editorial clients. Or you hone your art and raise your day rate, instead of trying to compete with the masses who are caught up in the price wars."

A typical paparazzi shot of Josh Hartnett that Sherman made as a stringer for a national news service.
© David Sherman.

Previous page: A variation on the standard head and shoulders shot—this one with dress-up clothes and a decidedly silly expression.
© Vik Orenstein.

This reinvention presents different challenges depending on your career stage.

On the one hand, when you are just beginning to make your way in the industry, you aren't as emotionally or economically invested in an area of specialty, so shifting gears can be simpler. It's an entirely different problem if you're an established, top of your field, high-end photographer with a couple of decades under your belt. You've dominated your market for a good long time and suddenly the number of photographers in your town has quadrupled, and 75 percent of them are giving away their negatives for free. Sure, you can reinvent yourself, or find a way to make these changes in the marketplace work for you instead of against you. But it's that old dog/new trick scenario: You have the ability, but you haven't learned a new trick in a long time, and you're not in the mood to start now. (Growwwwl!) On the other hand, once you get over yourself, get up off the floor and

shake it off, you realize you have years of experience fetching and shaking paws, you know your way around town and where all the neighborhood dogs hang out. These are assets that can make your reinvention easier and more enjoyable.

So no, what it means to be a photographer is not exactly what the uninitiated imagine it to be. But in my seventeen years in the business I've met hundreds of photographers in all areas of specialty, and I only know of three who have left the calling. The great majority of us are lifers—and we like it that way. I'm guessing you will, too.

TWO

You Are Here

Since you're reading this book you are in one of these different places: A) You are a student looking for a direction in education. B) You are a career person in search of a career change. C) You are an established photographer looking for inspiration to maintain, grow, or diversify your business. D) You are reentering the job market, or entering it for the first time.

People come to the photography industry from a variety of disparate places in their lives. One way to learn whether this business is for you, or to validate your choice if you're already "in," is to look at the way others have come into the field and created their photographic careers. Here are actual stories of a few successful photographers who have different approaches to their careers.

A WOMAN WITH OCCUPATIONAL HAZARDS: PHOTOJOURNALIST STORMI GREENER

"It's easier to shoot [pictures] in a war zone than to shoot weddings," says Greener. This from a woman who has been shot at in Bosnia, stoned in Afghanistan, and beaten in Israel. No, she's not kidding. Not entirely.

"You go to war, and you don't think. You just do what you have to do. You're on adrenaline, on autopilot. But you go shoot a wedding …" she shrugs.

Q. Does every photojournalist have to go to war?

A. No. I chose to. You could work on a large paper and never go overseas.

Q. Do you still go overseas?

A. No! At fifty-seven, I do not want to go to war. I say to myself, 'Would I rather be there than here?' and the answer is no."

Q. I'm assuming you didn't start out your career doing this type of assignment.

A. No, I started out in Idaho, shooting fires, bike accidents, the usual.

Q. You had a degree?

A. No, these days you have to have one, but in those days you didn't. My degree wasn't in photojournalism. I got the job not from what I knew, but by being a pest. I didn't have much

photographic work, and what I did have wasn't very good. But I asked the publisher of the paper for the job. He said, 'Oh, you're not a photographer, go to work in the library.' It took me months to wear him down. Finally, he put me on for sixteen hours a week. I had assignments, and I found my own stories, too. One of my colleagues, Tom Freick, taught me so much—what a lens would do for me, how to walk into a situation and size it up immediately. I owe a lot to him."

Q. I assume anyone starting out now in photojournalism would have to relocate to a very, very small market."

A. Yes, but it's not so bad working in Podunksville. If you're good, within a year you'll be getting plum assignments and movin' on up.

Q. Aside from getting a degree and being a pest, what can you recommend to aspiring photojournalists?

A. Well, if you're on the young side, get a job on your year-book staff and on the school newspaper. Look for a school with a good program, find a mentor—someone who will help you is a must—do internships. Internships are never a dead end; they're always valuable. You get practical experience and you get to hang around professionals.

Q. So you'd recommend your job?

A. Sure. I love it.

Q. No regrets?

A. Well … that's a loaded question. If I could go back and do it over again, I would do a better job of balancing work and family. I didn't realize how much my job affected my daughter until she was grown and she made a video as part of a Nation Press Photographer's "flying course." She talked about hearing the phone ring in the middle of the night, and knowing that when she woke up her mother would be gone. She talked about wondering what would happen to her if I were killed on assignment. She basically blasted me.

Q. How did you feel about her discussing this in a public forum?

A. It hurt, but it was important—hopefully it will help others learn not to let the business eat them up. That's the most important piece of information I have to share.

UNFLINCHING EYE: EDITORIAL PHOTOGRAPHER
KERI PICKETT

Keri Pickett's work appears regularly in *People* magazine. She is the recipient of numerous awards, fellowships, and grants, including a National Endowment for the Arts Photography Fellowship. She has published two critically acclaimed books: *FAERIES: Visions, Voices, and Pretty Dresses* (Aperture Books) and *Love in the 90s* (Warner).

Q. You've accomplished a lot at a relatively young age. Did you always know you wanted to be a photographer?

A. No, I didn't figure out I wanted to be a photographer until I was nineteen. I was in college, thinking I'd go into something like political science or physical education. I saw a friend walking across the student union with a roloflex camera—she was taking a mass communication class and she told me she was renting the roloflex for $15 a quarter. That was the beginning.

Then my grandmother gave me a great camera, a Nikkormat, and I think that made me value what I was doing so much more, because she valued it enough to give me that gift. After college and traveling in Europe, I moved to New York to try to get an internship.

Q. Did having Roy (New York fine art/commercial portrait photographer Roy Blakey; his profile appears in chapter eight) as your uncle help get you any breaks in New York?

A. (Chuckles.) He let me stay at his apartment for two weeks and then he booted me out. I was using up all his phone time. Fortunately that was long enough for me to get an assisting job at a studio where they shot tabletop stuff. I loaded large format film, ran errands, anything that needed to be done.

Q. Tabletop seems like an odd fit for you.

A. It was. That's my only regret, if I have one—that I didn't just start out shooting people right away. But from there I went to work for a photographer who shot for modeling schools. I'd process a hundred rolls of film at once, and go into the darkroom and print two hundred 5" x 7" prints.

Then I sent Fred McDarrah, the director of photography at the *Village Voice*, a postcard a month for six months until he broke down and gave me an internship. [Rock photographer]

Laura Levine taught me a lot there. It was a great experience. I got to cover politics, culture, performance art. I even got to chat with JFK once.

Q. Your personal work is often challenging, even heartbreaking. Your series with the terminally ill children or with the Sharing and Caring Hands Homeless Shelter—not exactly subject matter that would strike one as having a popular audience. And yet this work has been incredibly well-received.

A. I think if you create important work it will sell—it will take awhile, but it will sell.

Q. How do you work on a project for 5, 6, even 7 years with that kind of uncertainty? Never knowing if anyone will see it?

A. I feel like its more freedom than uncertainty. I've been an indie for twenty years. I love the freedom of owning my own life. My own existence.

Q. What's your advice for anyone who wants to be an editorial photographer?

A. You have to produce your first body of work. Don't expect anyone to fund it for you. It should be well thought out, reflective, creative, showing a goal and a passion. It should celebrate the people whose story you're telling.

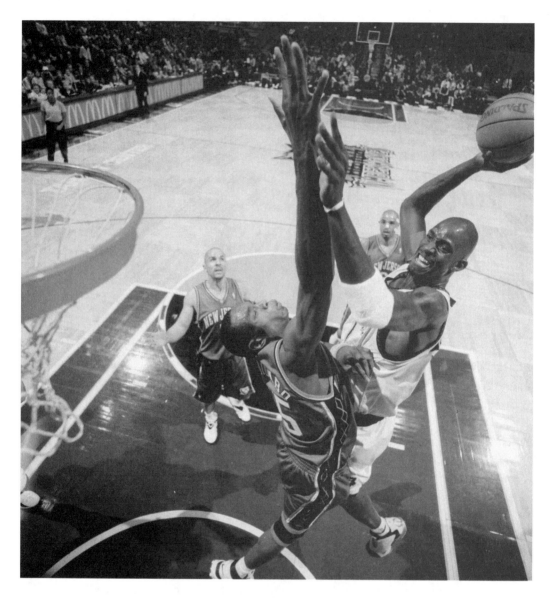

Here photographer David Sherman captures the drama of a Kevin Garnett slam dunk.

A LOST SOUL: COMMERCIAL AND FASHION PHOTOGRAPHER LEE STANFORD

"I'd had four years of college, and I still didn't know what I wanted to do. Marine biology seemed neat. I had an art minor. Then journalism seemed exciting for a while. I finally decided I was wasting my dad's money and stopped going."

Lee isn't quite sure when his photography career began.

"That's open for debate. Maybe in '85. I shared a studio with

two designers and I shot model and actor headshots and comps. I started getting small jobs for local hair salons, and the business just grew by word of mouth. My first official commercial job was shooting girls in bikinis for a beer company. How cool is that?"

In 1986 Lee committed himself to larger fixed overhead by signing a lease for his very own 2,000 square-foot studio in the trendy Minneapolis warehouse district. He has never looked back.

"I've had growth every year for pushing twenty years even in bad economic times. Can't complain about that."

Steady growth for eighteen years with no rep, and very little self promotion. In fact, Stanford's experience goes against much of the information in this book. He must be the exception that proves the rule.

"I tried to get a rep. No one wanted me. I guess my look is on the artsy side and most reps I talked to felt that would limit me too much. I hardly ever show my book. I hate that part. I know I should do it more, and I should schmooze more, but I don't. I probably lose some business because of that."

Not only has Lee built his business with very little promotion of any kind, he also has no formal photography or business background.

"If I had to do it over again, I'd take a business class. Just for things like filing for tax exemption numbers and things like that. I had to teach myself business right along with the photography."

Lee doesn't regret skipping photography school, or the much touted assisting jobs.

"I learn faster when I teach myself. Essentially, I learned by cutting photos out of magazines and recreating them myself. Some people come out of photo school with very rigid ideas about how things should be done. They're afraid to break rules. But school's not bad for everyone. And tech versus art school—I know a guy who went to Brooks and a guy who went to a tech school who both do really great work."

Would Lee recommend this career?

"Yeah! I can't think of anything better! You get to make up your own job. You have flexibility—you can work nights or weekends if you want.

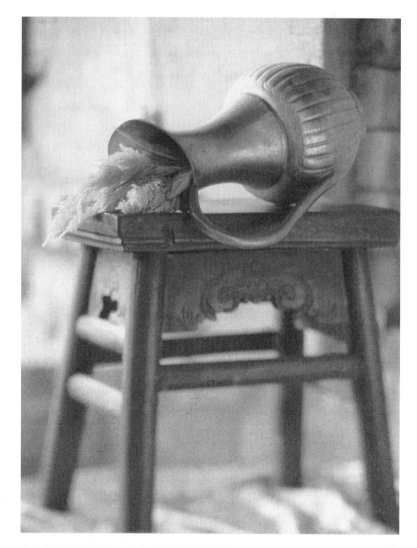

A LATE BLOOMER: NBA/TIMBERWOLVES TEAM PHOTOGRAPHER DAVID SHERMAN

David Sherman came to photography relatively late in life, after working in the real world for eleven years. He holds two degrees in agricultural economics—not exactly an area that even hints of his ultimate career choice.

"My first job out of college I worked in a bank marketing agriculture products," he says. "I was always interested in photography—I took one undergrad elective course. But I just didn't see it as a way to earn a living."

That all changed in 1991, when David realized, "My work was just not making me happy." Being dissatisfied with your job is one thing, and making the leap to becoming a self-employed photographer is another. But David has a simple answer for how he worked up the nerve to take such an enormous risk: "I kept my day job! For more than four years. I started out doing Bar and Bat Mitzvahs and weddings on the weekends."

After that he was ready to make the move to full time. He began to make a business plan in preparation for applying for a bank loan.

"Then I got lucky. I had a very generous cousin who believed I could make a go of it, and he financed me completely."

Did David's business background help him build his successful photography business?

"Yes. No. Yes. I mean, it helped prepare me for negotiating with clients and freelancers, anticipate personnel issues, and understand cash flow."

David says he has no regrets about shelving that unfinished business plan once he had financing.

"You'll be told that you must have a business plan, but that's bull. At the end of the day I'm still a photographer. I get paid when I work, and I don't when I don't. You can't really make a business plan for that."

If not his business background, then what factors did help contribute to his ultimate success? David points to the generosity of fellow photographers who provided him with crucial on-the-job training.

"I was very lucky, the (NBA) league did a wonderful thing for me, they paid me to learn on the job. So these league shooters led me around from game to game and taught me everything until I was ready to shoot: timing, angles, special equipment ... everything. Every aspect they shared their experience and knowledge with me. They were great."

Personality also plays a big part in getting ahead. David is quick to credit his relaxed nature and agreeable personality for at least part of his continued success.

"A lot of my work I get because I'm easy to work with. I don't have much of an ego. For instance the Timberwolves gig—

I got that job over other more experienced photographers who were willing to relocate for it—the reason I got that was because I'd done a little freelance shooting for the organization (not games, but crowd shots), and they liked me so they really went to bat for me—pardon the sports pun! I was willing to hang out at every game, assist for nothing ... so when the league ended their contract with their previous shooter, I was there, and I had friends in the organization."

And, of course, desire plays an important part in success. "I wanted to succeed," says David. "I had to succeed, because I wasn't going to go back to the kind of career that I'd left."

Any regrets?

"No, no regrets. But if I could do something different I'd have somebody—not an agent, but a partner, someone as committed to the business as I am, to field calls, make bids, produce jobs, and show the book."

Happy as he is with how his photography career has unfolded, he's not sure if he'd recommend it to anyone one else.

"It depends on the economy. In bad times you find out which clients are loyal. A lot of them will start shopping price when times are bad, and go with the low-ball bid even if the quality isn't there. So that would be hard. But if the economy is good, go for it."

A TEXTBOOK EXAMPLE: COMMERCIAL PHOTOGRAPHER PATRICK FOX

Patrick Fox is a top-billed commercial photographers in Minneapolis: He runs a 6,000-plus square-foot studio in the trendy warehouse district, and he shoots almost everyday—a phenomenon almost unheard of in this medium-sized market. His seventeen-year career has weathered economic upheavals, dramatic fluctuations in the local market, and all the usual stages that a business goes through when it ages, expands, and adapts to changes in technology and market demands.

Patrick forged his career pretty much by the book: He attended Brooks Institute of Photography and holds an MBA in photography. After college, he assisted a food photographer for one year, worked in-house for five years for a department store

An example of Jim Miotke's stock photography, titled "Flower Box." © Jim Miotke. All rights reserved.

shooting fashion and product, and opened Fox Studio in 1987—specializing in location fashion and product shooting.

Q. What got you interested in photography to begin with? Was it to meet girls?

A. (Laughs.) Yes, most guys in this business go through a stage I call the "I gotta shoot babes" stage.

Q. But that stage doesn't last?

A. It can't last. This is way too tough a business to be in just to get dates.

Q. But you do get to shoot babes?

A. Yes. You do get to shoot babes. But I'll tell you right now, anyone thinking of becoming a commercial photographer should take a good, hard look at themselves and ask: "Do I have vision? Do I have a good personality? Am I bright creative-

ly and technically? Do I have the abilities necessary to run a professional business? Am I lucky?" It takes luck, but of course as you know, we make our own luck."

Q. So maybe by luck you mean persistence? Passion? One of those "P" words?

A. Yes! Persistence.

Q. What about talent?

A. Sure, you have to have talent.

Q. How do you know if you have talent?

A. You have to show your stuff. Not to your mom or your friends—to people who know their business and will level with you. I personally know of several art buyers—people at the top of their fields—who will see your book if you call and ask, and then call and ask again a few more times. If you're persistent.

Q. So wait, let's back up. Say I want to be a commercial photographer. I'm talented. I'm creative. I'm technical. I'm a people person. I'm business savvy. I'm lucky. Where do I start?

A. School. Definitely school, or some sort of extremely intensive training.

Q. Photography school?

A. Sure, yes. But a liberal arts degree is great. That's what I look for—a well-rounded liberal arts grad, because you can teach someone how to shoot, but you can't teach them how to think.

Q. So school, then the big time?

A. No! School, and you get a lot of feedback on your work. Then you make a portfolio or book. Then you get a job. When I first started, you only had to assist for about a year. Now you have to assist for five years. A lot of people think they're going to get a great job just out of school. But that doesn't happen. School is just the starting point. After that, the learning begins.

Q. What kinds of images do I put in my book?

A. You show your ten best images, no matter what the subject. As you get new ones, rotate out the old ones.

Q. Well, but I want to be a successful photographer. Translation: I want to make the big bucks. So aren't there certain specialties, or types of images, that are more salable? And shouldn't I specialize in those hot areas?

Opposite:
One of Doug
Beasley's fine art
prints: "Torji Gate at
Miya Jima, Japan."
© Doug Beasley.
All rights reserved.

A. No. Start general, then specialize as your career matures. You want to get to higher and higher levels of competition. When you first start out, you'll be competing against fifty other guys for the same job.

Then, after a while, it'll be you and twenty-five other guys. Then you and maybe five guys. Then ultimately, it might come down to just you and one other guy—your nemesis. Eventually, you will have to become highly, highly specialized. It's become almost ridiculous. To give you an example, I was showing my book a while ago. The art buyer said, "This book is very "springy." Can you shoot "Christmasy"? That's how extreme it's gotten.

Q. You said you were showing your book. Do you work with a rep?

A. Yes, but I only started recently. And it's not a conventional

relationship. Normally, reps are paid a percentage of the jobs they sell. My rep is paid by the showing.

Q. That's a pretty big change from the last time I worked in the commercial industry seven years ago.

A. There have been a lot of big changes since then. Like art buyers. It used to be the art director who chose the photographer. But now the art buyer is the gate keeper—the art buyer's entire job is to hire artists and photographers. It's a better system. The art buyers know who's best for a job better than the art directors used to, because it's all they do. So far this trend is largely only in the bigger agencies, but you see it in some smaller ones, too.

Q. Speaking of changes—it seems to me that the 80s and 90s were a golden era for fashion photography. Shooters charged high fees and got plenty of work. Then it all dried up. Any insight?

A. I can only speak for this market. But yes, we had a couple of huge clients in Minneapolis who made this a bigger market than the size of this city would dictate. But we had a very small talent pool (talent being another word for models) and the big clients took their shooting to other cities. Then there was a trickle-down effect, and other clients left, too. And then of course, what good talent there was moved to other markets.

Q. Is that why you shoot product as well as fashion?

A. No. That was a lifestyle decision. To shoot all fashion I would have had to be willing to travel a lot. I'll travel some, but I like being here. I have a cabin up north. And I enjoy product work.

Q. So what's the secret to your success?

A. There is no magic bullet.

Q. But darn it, Patrick, as the author of this book I'm duty-bound to provide a magic bullet: a recipe.

A. I was the president of ASMP (American Society of Media Photographers) for two years. Every once in a while I'd answer the phone and it would be a guy wanting to know the recipe. He'd want us to tell him how it's done. There is no recipe! What works for you is what works for you. I do things one way today because it's the right thing to do—today. Maybe tomorrow I'll do things differently.

That said, it certainly doesn't hurt to find out how other people do things, and to get other people's opinions. But don't mimic them. Take what you learn and tweak it—make it your own. A person who only knows how to do what someone else does will not succeed. It's the person with vision—the person who learns how to cook and then writes his own recipes—who will succeed.

Q. I notice that in bad economies there are photographers who shoot for dirt cheap fees just to keep the business rolling in. How do you compete with that?

A. I don't.

Q. So a bad economy doesn't impact your business at all?

A. I can't say that. In bad times I'm not turning away jobs like I do in good times. There have been times when I've turned away 33 percent of the jobs I get called for. But in bad times I'm still shooting almost everyday. So I can't complain.

Q. In a nutshell, what really important advice would you like to leave us with?

A. Read. Anything and everything. Not just about photography. Read about stuff you don't like or have no interest in. For instance, my politics are liberal but I read the *Wall Street Journal* everyday. Have an understanding of how the world works and how life and events all fit together. Then you'll be prepared for anything.

FILM MAKER TURNED STILL ARCHITECTURAL PHOTOGRAPHER: PETER AARON

New York architectural photographer Peter Aaron holds an MFA from the NYU Institute of Film and Television. He regularly shoots for such national publications as *Architectural Digest*, *Architectural Record*, and *Interior Design Magazine*. Most recently he shot a two-part piece for *Architectural Digest* on the Andrew Wyeth family compound.

"The magazine has never done a two-parter with anyone before, and of course it was fun to meet and spend time with the Wyeths," says Peter.

Q. You had planned to become a cinematographer. How did you wind up an architectural photographer?

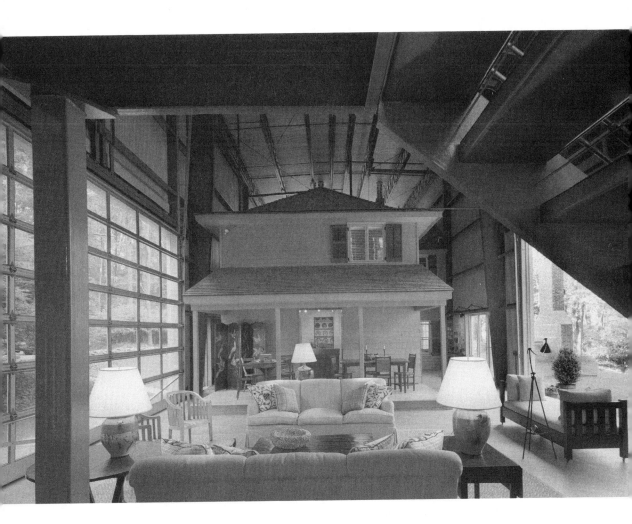

A. I tried filmmaking for a while, but I just couldn't seem to find the right group of people [to become involved with.] Photography was always a hobby, so I thought maybe that would be a good way to make a living. I went to magazines all over Manhattan and showed my portfolio. And I got a few bites.

Q. What kind of shots were in your book?

A. Everything. It was quite general. I was told that my interiors and exteriors were my strongest material, so that was how I chose architectural photography.

Q. And so right away you started getting assignments?

A. Pretty much. Youth was on my side. I was maybe twenty-eight or twenty-nine. Magazines are youth-oriented businesses.

The editors, the writers tend to be young. Young photographers should not be afraid to go to magazines and show their books. They are likely to get a friendlier reception than they might imagine. You should realize that the magazine isn't doing you a favor by seeing you—you're doing them a favor. They need photographers.

Q. I assume that it's not enough just to be young.

A. Of course, it helps to be good.

Q. And how did those early assignments go?

A. I did well on my first jobs, but I felt totally out of my depth. So I approached the most important Architectural photographer of our time: Ezra Stoller. I was lucky—he allowed me to assist him, and he became my mentor. So for two years I went with him all over the world and learned a ton about composition, and doing business.

Q. And after those two years it was back to assignments?

A. Well, yes. At that time Ezra's daughter, Erica, decided this would be a nice milieu for her, and she joined Esto and became my rep.

Q. Esto is an agency that represents architectural photographers?

A. Yes. At the time it was only intended for Ezra, but when Erica came on other photographers were brought in. I still had to market myself, because as yet I had no reputation. So Erica got some of my clients and I got some—at the beginning it was about 50/50.

Q. What made you different? What was it that made you stand out from the others calling on those same magazines?

A. Historically architectural photographers shot with "soft light." They used only strobes. Coming from film school, I realized that you could light a room the same way you could light a set. I used tungsten to create expressive lighting. Side lighting and back lighting, lighting that's coming from where it should be coming from. I used pools of light instead of blankets. I guess you would call it low-key, because there are shadows and shapes and depth. Now it's the norm, but at the time it was innovative. My work looked like I had just taken a snap shot—it looked natural. But it took a lot of work to get those natural shots.

Q. So when you started out, you had youth on your side, and you were innovative. But you've been shooting for twenty-eight years. What's on your side now? Aren't there some advantages to being old and experienced?

A. Certainly. There was a time when I kowtowed to my clients, and listened to their opinions on how to take a shot. But now my clients ask me my opinion. Of course it's harder to approach some of the magazines as an older photographer. They want the next new look.

Q. What would the new look be?

A. It could be anything.

Q. Cross-processing?

A. Yes, it could be that. It could be lighting with a hand held diesel fueled flash light. It's often something quirky. Usually it fizzles out quickly.

Q. You have no desire to light with a flashlight?

A. None.

Q. Well, obviously you don't have to. I see your published work all the time—especially frequently in *Architectural Digest*. That's a wonderful publication.

A. Yes, and I give them the copyrights! I'm actually not proud of that aspect of working with *Architectural Digest*. But the work is challenging and the published material is very well done, highly visible, and excellent for my portfolio.

Q. Are you shooting digital?

A. No. I'm not shooting digital at all. The technology is not wide-angle friendly. They do make digital backs for 4" x 5" cameras, but the minute you slap a wide angle lens on there, you get fall off and color shifts, and other technical issues. So I'm shooting film, and then making scans before the client sees the take. There are improvements that can be made—lots of improvements. I can take out exit signs and power lines and anything else that might distract from the building.

Q. This ease with which images can now be manipulated thanks to digital technology—do you see this as a good or a bad development?

A. I think it's a real boon if you treat it well. The pictures look better—much better. But one shouldn't blur the truth. I

don't make changes in a photo to portray anything that doesn't exist in the built world. That would be dishonest if, say, the photo were being entered in an award competition.

Q. Aside from the ethical issues, isn't there another issue? Does the ease of correcting images digitally allow a bad or a mediocre photographer to make good images?

A. Interesting. I'm not worried about that, because you have to be able to light well. Even the very best Photoshop artist needs a well-lit image to start with, or there really isn't much he can do with it.

Q. So you would recommend this business?

A. Yes, to a qualified person, certainly.

SKETCH ARTIST PUTS DOWN HIS PENCIL: CORPORATE/ INDUSTRIAL PHOTOGRAPHER BRYAN PETERSON

Bryan Peterson is the author of two books: *Learning to See Creatively* and *Understanding Exposure*, both published by Amphoto. He works on assignment as well as shooting stock. He teaches photography courses at BetterPhoto.com and lectures at Kodak sponsored seminars in the United States and Europe.

Q. How did you become a photographer?

A. I graduated from high school in 1970, and I just wanted to do something that would earn me enough money to put gas in my Volkswagen bus and buy some weed once in a while. I'd always been a good artist, so I got a notion to travel around and sell my sketches at art fairs.

I was a very detail-oriented sketcher. It took me a long time. I was complaining to my brother about going out into the field and spending three days getting that landscape just right, and he suggested I take pictures and make my sketches from those. The first time I went out and shot I was so overwhelmed by the immediacy of film that I never looked back."

Q. So you never even took a high school photography class. How did you teach yourself to shoot?

A. I learned by teaching. I became really intrigued with color film, and I went to a local college looking for a class on creative color photography—to take, not to teach. They said, "Hey we

don't have one, but you know as much about it as anyone, and it sounds like a great idea. Why don't you teach it?"

So I prepared one lesson for the first week—how to use orange filters. I had six example shots of pears. The class was well received, and the students were enthusiastic.

After that first class, I thought, "Now I'm all out of material. What am I going to teach for lesson No. 2?" I crammed for each subsequent lesson. I literally taught myself each new technique a few days before I taught my class.

Q. So you fly by the seat of your pants?

A. I do. And I'm very lucky. I live a charmed life. That's how I fell into publishing. I was knocking around New York one day and I dropped into the office at *Popular Photography* magazine. I didn't have an appointment.

I did have a lot of before and after shots: with and without a filter; with the correct exposure and one stop over-exposed; with the light to my back and the light to my side. I showed them these before and afters and told them I thought they'd make a good article. They said no, but thought it would make a good series. So they ran a monthly feature every month for two years.

Q. Was getting your books published that easy?

A. Yes. After two years my editor at *Pop Photo* asked me what I wanted to do with those articles now, and I said I wanted to make them into a book. He recommended that I try an editor at AmPhoto. So I shot over to their offices, again without an appointment, with a handful of tear sheets, and walked out of there with a contract.

Q. It does sound like you're charmed. Are you living your dream? Living where you want to live, shooting what you want to shoot?

A. Well, yes and no. I love my life. But am I shooting exactly what I'd like to shoot? No. I'd like to shoot strictly street production shots of people. Shots that are set up not to look set up. Lifestyle, humor, and business shots. I've got hundreds of shots in my head, I just haven't had time to shoot them. So if it came down to strictly shooting one thing, that would be it. But I never think, "Oh, yuck, I have to go shoot now," even if the subject isn't my favorite. I just love creating images.

A PARALYZED NOVELIST: STOCK, PORTRAITURE, AND EVENT PHOTOGRAPHER JIM MIOTKE

Jim Miotke graduated with an English degree from the University of California at Berkeley.

"I had my heart set on becoming a novelist, but I was completely immobilized by fear," says Jim, who can chuckle about it now. "I'd always liked photography. I took a few high school classes and one workshop. I picked up some knowledge working at a camera store and at a photo lab, but mostly I'm self-taught."

Q. I assume nonfiction isn't as scary for you to write as fiction, especially since your how-to book, *The Absolute Beginner's Guide to Taking Great Photos* (Random House), is doing very well.

A. Yes, nonfiction, for some reason, comes easily to me. It was a natural thing to combine writing and photography. And I guess the teaching is a natural off shoot of that.

Q. Yes, the teaching. Tell me about your Web site.

A. In 1996 I founded BetterPhoto.com. Then, in 2001 we started offering photography classes. All our teachers are published authors and are highly respected in their fields. I teach a beginner's class, of course. I look at my teaching work at BetterPhoto.com as a healing mission—to help people in overcoming their fear of equipment, of approaching a stranger, of business in general.

Q. Through your Web site and your teaching you meet a lot of people who want to become professional photographers. What advice do you give them?

A. You need a great deal of humility—especially in any type of portraiture. It's really a service industry, more so than commercial, fine art, or nature. You need to be able to be comfortable with uncertainty.

Don't quit you day job! Know that you have to do a lot of other stuff besides shoot pictures. People are often not receptive to the idea that you don't just start out at the top of your field—is there any field you can start out at the top of? But, all that said, it really is true—do what you love, and the money will follow.

A LABOR OF LUST: COMMERCIAL/LANDSCAPE FINE ART PHOTOGRAPHER LEO KIM

Leo Kim was raised in Shanghai and Hong Kong, lived for a while in Austria, and was educated in America's heartland. He always loved photography from the time he was small—using his hand, he indicates a height of about knee level above the floor. But he graduated college with a degree in architecture and design. The photography had been temporarily abandoned.

"After I graduated, I started thinking, 'Just why was it that I wanted to go into architecture, anyway?' I kept thinking about the beautiful black and white photographs of [architectural photographer] Ezra Stoller, and the wonderful images of Austrian commercial photographer Ernst Haas—he likes to play with color—and they really inspired me to find my own visual style."

Like many of the other photographers featured in this chapter, Leo is totally self-taught.

Q. Why didn't you go into architectural photography? With your background, it would seem to be a logical progression.

A. A lot of people ask me that. I don't have one answer. I love forms, shapes, textures. I love o-rings, I find them very exciting to look at. My style springs from arranging shapes to make a simple but beautiful picture. You can't really rearrange buildings! One of my clients once brought me garbage bags full of rubber parts. They were not labeled, not boxed—nothing. They wanted one 4" x 8" picture for a trade show. They told me I could do whatever I wanted to. So I made eight 2" x 2" images instead. Combining the shapes that way was much better than just one big picture. I shot them on black Plexiglas. The reflection on black is so deep!

Q. Was the client happy, even though you changed the assignment?

A. Yes, they loved it. They hired me many more times to shoot their annual reports.

Q. Do all your clients give you this kind of creative license?

A. Most. In my whole career I have had less than a handful of boring jobs. I believe you have to give the clients what they want, but not in the same old way. It's our job to educate them, to say, "Let's do this job in world class style!" Not with gadgets and contrived lighting, but we keep it simple. We do it with the visual style.

Q. How do you get these amenable clients?

A. I have always believed in promoting myself. You have to be business first, before you are a photographer. I market my work.

Q. Do you enjoy the business parts of being a photographer?

A. Oh, yes! It is a challenge. I feel I am still lagging behind at controlling my business. You have to control the business, or it controls you. One thing that has really helped me grow as a businessperson is publishing my book, *North Dakota: Prairie Landscape* (available through www.leokim.com). It has forced me to take new risks, to market and raise money, to keep meticulous records—all things I was doing before, but I had to take it to a higher level.

Q. It sounds like a real labor of love.

A. No! It was a labor of Lust! I turned down some nice jobs when I was working on the book, because when my intuition told me to go up there (to North Dakota) and shoot, I went. You can't be in two places at once. Sometimes to be in one place at once is hard!

Q. Have you even taken any business courses?

A. I was just getting to that! No, but I wish I had. Of course, it's all just theory until you practice it. You take classes, or you don't. You learn it one way or another.

Q. Do you recommend this business to others?

A. Yes. I love my life. I love this business. Sometimes I am out shooting and the sky opens up and the light breaks through and it takes my breath away, and I say, "This is for me? I can't believe it!"

A DENTAL HYGIENIST CHANGES PATHS: ARCHITECTURAL/ ADVERTISING PHOTOGRAPHER KAREN MELVIN

Minneapolis advertising/architectural photographer Karen Melvin came to photography after a brief detour into dental hygiene.

"I knew I was making a wrong turn, but my mother wanted me there. She dragged me back to school. There were black heel marks all the way to Milwaukee," she laughs. Now, fifteen years into her career, she is just finishing up a bachelor's degree in photography at the University of Minnesota.

Q. Why finish your degree now?

A. I have an eleven-year-old son. I didn't want him getting a degree before his mom. Actually, I started it many, many years ago. But I got busy and life happened. I'm very excited about the courses I'm taking—they're very germane to my career. A course I'm facilitating is called, "Where art meets commerce—finding your value in your market." That's pertinent to anyone's career at any stage. Another is in digital imaging which is an area where I'm light years behind.

Q. Backing up a bit—how did you learn to shoot?

A. I always photographed when I was selling on the road in my twenties. When I decided to make photography my career I took a crash course at a school of communication arts. I was lucky to have a commercial photographer as my instructor. He was a relentless technician. The other major influence was assisting the graduate school of photography.

Q. Your husband, Phil Prowse, is an architectural photographer as well. Does that cause any problems?

A. What kind of problems?

Q. Like, for instance, battling for the same clients?

A. Oh, no! Phil does his specialty, and I do mine. He does boy architecture, and I do girl architecture.

Q. Please explain that!

A. Oh, I do residential interiors and lifestyle, and Phil does commercial buildings and exteriors, sort of …

Q. Phallic?

A. Yes! Phil does phallic and I do the womb. It's nice because when I get a call for his specialty I refer them to him, and when he gets one for mine he refers them to me. Phil's learned to say, "I'm referring you to my partner," because it sounds more professional than, "Here, talk to my wife." I don't want to give the impression I'm sitting around the house eating bonbons. But we don't need a studio. All our shooting is on location.

Q. Has that helped keep your overhead low?

A. Yeah. I think I've survived in every economic market over the last fifteen years because I never had a studio. Location shooters who have studios tend to go under in a bad market or move back to their home offices.

Q. How did your career start out?

A. I assisted first, my instructor from school, and others. All along I was showing my book. I marketed to architects and interior designers, but a lot of other businesses, too. Hospitals, public relations firms, anyone who used interior shots. Then along with other freelance jobs I got an internship at Skyway News that turned into a three- year stint as a professional wrestling photographer.

Q. Another little detour?

A. Not quite as off the track as dental hygiene.

Q. At any rate, you evolved into an architectural photographer, but you've honed your specialty down even more, to residential interiors and lifestyle. Tell me about that.

A. To thrive in a tough market, I've had to refine my message, ratchet up my art to pull myself up out of the fray. I do that by showing work where light is the hero. I use and create light as a theme in my work. So it's architecture, but with a message of light.

The level of specialization required in these times is extreme, but I think it works to everyone's advantage. By working deep, not broad, you get to create a career that's exactly in line with your vision. You may not get every job, but you'll get most of the jobs that are perfect for you.

Q. If you could go back and do it all again, would you change anything?

A. Only that I'd start to promote my work nationally earlier. It brings me more commercial clients, more advertising work. I love this field! It takes more legwork, but it has better production value and it pays better than editorial.

Q. Any advice for the newbies reading this book?

A. You need to be persistent and keep reinventing yourself and your art.

NOT A STARVING ARTIST: FINE ART/COMMERCIAL PHOTOGRAPHER DOUG BEASLEY

Doug Beasley is a fine art photographer who sells to a commercial market. A lot of shooters—myself included—would love to have his job.

Q. How did you pull this off, this being able to shoot what you want, shoot fine art, but market it commercially and make a living? I thought you had to sell out to make it in a commercial market!

A. I tried to sell out, but it didn't work! When I try to shoot how I think someone else wants, my work is not as strong as when I shoot from the heart.

Q. You enjoy an extremely high level of creative freedom.

A. Yes. In this business when you're just starting out, you have all the creative freedom in the world! You're shooting to build your book. You're shooting what you want, because you are your client. You're shooting models' cards and actors' head-shots. You have no prestige, but you're free. Then you get some commercial clients, and you lose a little. For a while you lose creative freedom as you become more successful. Then once you reach the high end, the creativity comes back. Because at that level, people are hiring you for your vision and not because you're a technician.

Q. How did you break into the business?

A. I assisted for three or four years at some very high-end studios, and I learned a lot. I was very lucky.

Q. Do you recommend assisting to someone trying to break into the market?

A. Yes, or an apprenticeship. Choose one person whose work you admire and learn how to do everything from them—how to shoot, yes, but also how to get and keep clients, how to show your work, how to run a business.

Q. Speaking of running a business, does running yours get in the way of your art?

A. Not really. I'm looking for ways to get out of the office more, do paperwork less. But I really have no complaints. It's ironic, though, that part of the reason I wanted to become a photographer is because I didn't want to be a "businessman." But that's exactly what I am.

Q. Did you take any business courses, or have any other formal business training?

A. No. I learned the business by making every mistake there is—usually several times.

Q. Do you recommend this learning method to others?

A. No! I don't recommend trial and error—but then again, things you learn this way are things you never forget.

Q. You teach extensively through the University of Minnesota and through your school, Vision Quest. You must see a lot of raw talent, and a few clinkers. Can you predict who will be successful, who will make it in the business, and who will drop out or fail?

A. Sometimes. Some just have *it*, but some can learn *it*. You can develop a visual language if you have passion and persistence, and you feed your passion.

Q. How do you keep your passion burning?

A. You immerse yourself in your art. You surround yourself in it. You go into the darkroom and work. You shoot. You talk to other artists.

Q. Has your passion ever ebbed?

A. Sure. In the mid-90s I was disillusioned about the business, I was almost bitter. But I threw myself back into making images I love, and I found fulfillment again.

Q. Can you describe what that entailed?

A. I simplified my method of shooting. I'm down to bare bones. When I go in the field I bring only my Hasselblad and an 80mm lens. Maybe a 120mm also—I do like shallow depth of field, but I don't want to waste energy managing equipment, I want to put my energy into engaging my subject and getting into the stream of life.

Q. Any advice for the would-be photographer?

A. Recognize the beauty of this business, that you can control your own destiny; you can create your own life.

So there you have it. A few of our photographers knew what they wanted to do with their lives from the time they were children, but the rest came into the field via such different avenues as marine biology, dental hygiene, banking; architecture, and cinematography. They came to the industry as early as their teenage years, and as late as their 30s. For some it has been their first and only career; for some it's been a second or third. Many are self-taught. Some learned through the generosity of their col-

leagues or mentors. Others paid their dues at art or tech schools. Not only have they come into the business in different ways, each one has created a career, a specialty, a life that is unique onto itself. All have weathered economic upheavals, and some have survived phases of disillusionment, only to recreate themselves as stronger and better artists and businesspeople. Are there any traits they all have in common? Or is the camera their only common ground?

Perhaps they share a combination of traits: adaptability, desire, a willingness to take the grunt work along with the glamour, and, most importantly, belief in their own ability. How would your story look in this chapter? If you have these qualities, maybe you should find out.

Learning Your Craft

There are about as many ways to learn to become a photographer as there are McDonald's restaurants along the freeway. Some take years; some take eight weeks. Some are by the book, and some are unorthodox. One (or more) will be right for you.

APPRENTICESHIP

An apprenticeship can be a great thing for a young photographer. An apprentice assists a photographer for little or no pay, but in return he receives a mentor.

"I most certainly share more time and knowledge with an apprentice than with an assistant," admits an anonymous fashion shooter. "Even though I know they're both there for the same reasons—they don't just hope to pull my Polaroids, they want to learn the business—the assistant goes home at the end of the day with his $175 to $250. But all the apprentice goes home with is whatever knowledge and encouragement he gets from me. I take that seriously. I don't just take on apprentices for slave labor and let them just scavenge whatever scraps of learning they can. That's why I only take on apprentices at certain times of the year, because when I'm too busy I just won't be able to hold up my end of the relationship."

Not all photographers take this commitment seriously, so if

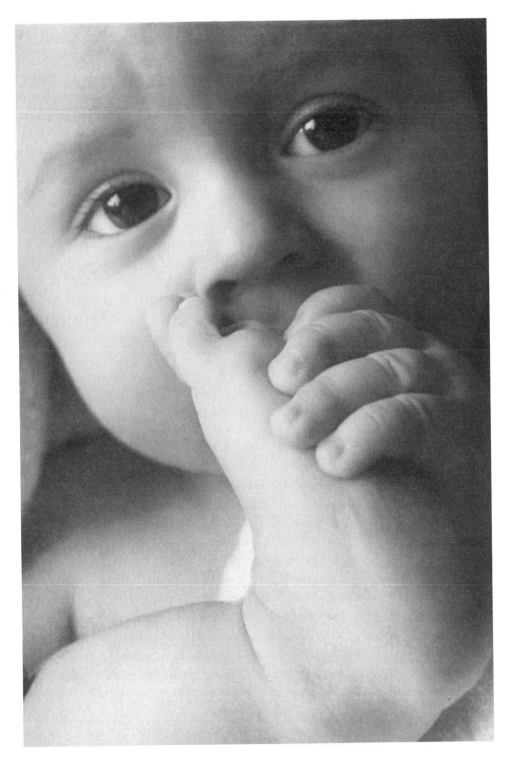

you choose to be an apprentice, meet with at least three or four photographers and while they're interviewing you, you should be interviewing them. You don't necessarily want to let them in on what you're doing. Don't Start out the interview by saying, "So, just what do you intend to do for me?" This will guarantee that you won't be working at that studio. Instead, listen to the photographer talk about photography. If he's passionate and excited about it, if he gets that fire in his eye, then he'll probably be a good and generous mentor.

ASSISTING

Working as an assistant to an established photographer either after or during school is considered by many to be *de rigueur*, especially in the field of commercial photography. But while many shooters insist it's a necessary part of any budding career, others are equally passionate in their opinion that if your ultimate goal is to be a self-employed photographer, you should not assist.

These opinions seem to come from two different schools, which are similar to the schools of advice from which generous, concerned individuals volunteered guidance to me as I was entering college.

"Learn to type!" a well-meaning uncle encouraged me. "Then you'll always have something to fall back on."

"Never learn to type!" A female executive (and this was back in the days when there were few female executives) told me. "You won't succeed if you have typing to fall back on!"

"Some people do become professional assistants, and never go on to be photographers," acknowledges our anonymous friend. "But hey, if they don't ever make it to the bigs, who's to say it was because they assisted? Maybe these guys wouldn't have had the gumption to do it in any case. And some people seem to like assisting. It's certainly less pressure than shooting."

Another less obvious drawback to assistant work is pointed out by Patrick Fox. "A young person just out of school coming to work for an old workhorse and seeing a huge studio with lots of billings might just jump to the conclusion that that's how his life is supposed to be. It can be kind of a mindblower."

Nonetheless, Patrick says assisting is an absolutely necessary step toward becoming a commercial photographer. "When I was coming into the business, you only had to assist for one to two years. Now it's five years, maybe more."

Fine art photographer Doug Beasley assisted at some very high-end studios at the beginning of his career, and he found the experience invaluable. "Whether you become a freelance assistant and work with a number of different people, or choose one person whose work you admire to assist in house on a semi-permanent basis, learn how they do everything. Not just how they set up lights—learn how they get and keep clients, how they make an estimate, how they bill every aspect of the operation."

Fashion shooter Lee Stanford agrees variety is key. Though he never personally worked as an assistant, he sees it as a good way to learn if you stay freelance and work with a variety of studios. "Everyone does everything differently. Every studio has a different ambiance, a different way of relating to clients. Pay attention to the little stuff. I was at a shoot once where the client had to have Diet Coke. That was his biggest priority. So the shooter had Diet Coke there. On that shoot, the Diet Coke was more important than the take. As a just-starting-out photographer, I never would have guessed that could be an issue."

A location portrait Gina Hillukka made while a student at a two-year technical school majoring in photography.
© Gina Hillukka.

TECH SCHOOL

While tech school may not be as prestigious as fine art school or liberal arts college, it holds some real advantages for the aspiring photographer. You get hands on experience with a full range of equipment and media, and you get to shoot a variety of subjects in the studio and on location. This is especially good for those who haven't decided what area to specialize in, because you get a little taste of everything.

There are other advantages to tech school. The tuition is considerably lower than at other types of schools, and the programs are shorter—two years as opposed to four or even more elsewhere.

"I'm very, very happy with the education I got at tech school," says portrait photographer Kelly McSwiggen. "We got to shoot constantly. I think I got an excellent technical background out of it. My only complaint is that there was absolutely no creative emphasis. We were taught only how to shoot what the teachers imagined our future clients would want, and not how to develop our own style or technique. I had to teach

myself that. I guess they cram so much technical teaching into two years that there isn't room for creative theory."

Says architectural/commercial photographer Karen Melvin, "I'm thrilled with my choice to go to tech school. I wasn't going to wade around through a lot of theory. I wanted to get my hands on equipment! I wanted to shoot, shoot, shoot. And that's what I got to do."

PHOTOGRAPHY SCHOOL

Brooks Institute of Photography offers two- and four-year degrees in various fields of photography, film making, and graphic design. While a degree from Brooks bestows a certain status, it tends to impress other photographers more than it does potential clients. It's also expensive and intensive. Many photographers go to a liberal arts college for two to three years, and then transfer their credits to Brooks to complete their photography major.

ART SCHOOL

Where tech school emphasizes the correct way of doing things and tries to anticipate the desires of the ultimate client, an art school education will typically bestow a great deal of creative theory and practice, with no consideration of the client or end user of the photographs.

"Quite frankly, the art students can be great at fine art photography, but they tend to make lousy assistants," weighs in our anonymous commercial shooter. "They want to do things their way, and they're not concerned about pleasing me or the client. They seem to be shocked at the typical day rate for an assistant, and their work ethic isn't the greatest."

Perhaps, but I have to jump in here and say that I have wonderful employees with art degrees both from liberal arts colleges and art schools. They've worked in my darkroom, assisted on commercial shoots, and hand-colored my portraits. With encouragement my "artists" become able to include the client's satisfaction in their ultimate goal.

CLUBS AND PROFESSIONAL ORGANIZATIONS

There are a lot of clubs for amateur photographers that are easy to join, both on the Internet and in the flesh. While the word "amateur" may put you off (you are, after all, working to go pro), there are many exceptionally gifted non-professionals at these chat rooms and meetings who love to talk shop and who will answer all your questions until long after most pros would have gone home. Not everyone who's gifted actually makes it into the business. Some don't want to take the risk. Some are

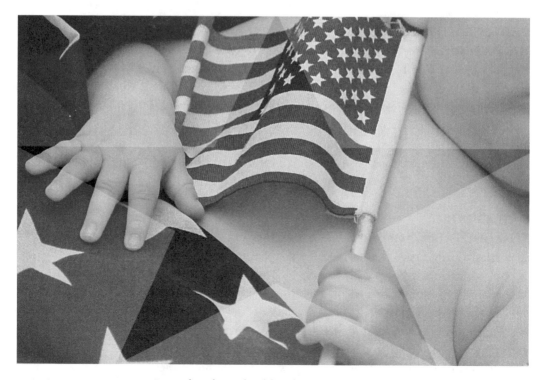

"gear heads" who like the equipment and media but don't have the motivation or the creativity to put their knowledge into action. Whatever their reasons, these folks are very accessible and happy to be of help.

Professional organizations can be harder to join—generally they want you to already be in the business—but check them out anyway. Even if they don't let you join up, they may let you sit in on some meetings whose topics are of particular interest to you. And while you're there, you might make a few connections.

LIBERAL ARTS COLLEGES

A degree in photography from a liberal arts college can be as useful if not more so than a degree from a fine art or photography school for the purposes of breaking into professional photography.

"A liberal arts degree is what I look for first, because it represents a well-rounded person with a well-rounded education," says commercial shooter Patrick Fox. "I can teach someone how to shoot, but I can't teach someone how to think. I can teach

someone everything he needs to know to be able to assist me in one weekend. But I can't teach him how to be curious, how to have intuition, or how to have vision."

SELF-TEACHING

Many of the photographers whose opinions you're reading in this book are self-taught. They had no formal photographic training whatsoever. That's not to say they didn't have teachers; many had very generous colleagues who showed them the ropes, but it was on an informal basis.

A photographer who is homeschooling himself typically spends a lot of time pursuing all the informal avenues listed in this chapter, along with applying Karen Melvin's tech school mantra: Shoot, shoot, shoot.

"You shoot a lot. You try to recreate some technique you've seen, or to create a technique to express an image that's in your head," says Lee Stanford. "The great thing about teaching yourself is that you make mistakes. Sometimes the mistakes are great—better than what you were trying to accomplish. I've heard it said that a good photographer is not one who doesn't make mistakes—he's someone who can repeat his mistakes."

The big drawback to self-teaching is that if you're not incredibly motivated, or if you're not 100 percent confident in your vision, you can fizzle out. While any method of learning photography requires strong motivation, the lone wolves among us need to be especially self-reliant in this regard.

CAMERA STORES

Working at a professional photo store is one way to learn photography, make contacts, and get paid all at once. Knowledge flows back and forth between store patrons and employees. And many professional shooters look no further than the guy or gal who sells him his film and equipment when he's in need of an assistant or apprentice. Sometimes clients will refer work to their favorite camera store helper when they get requests for shoots that are outside of their specialties. For instance, a commercial shooter who's asked to do a wedding might just pass along the business card of the person who sold him his new lens last week.

The two photos in this spread are an example of just how far an aspiring photographer can come in just twelve one-week sessions. Juliette Colpa-Thomas shot the first image for a BetterPhoto.com course in March of 2003.

INFORMAL OR INFORMATIONAL INTERVIEWS

Another method to garner more information from established, successful photographers is the informational interview. Photo students or wanna-be photographers call an established shooter and request a fifteen- to thirty-minute meeting in order to ask business, creative, and technical questions. Sometimes the underlying objective of the interviewer is to land a job with the interviewee. Sometimes the interviewer is really just learning about the business, and sometimes he is fishing around for a mentor. In any case, you can get a pretty interesting earful this way—if you can get your foot in the door. Be prepared for polite rejection. There are many, many people requesting this type of interview. I get three or four requests a week, and I can't possibly accommodate them all. Expect to be turned down by nine out of every ten photographers you call. That's the bad news. The good news is that if someone does agree to see you, she's most likely willing to share a good chunk of time and knowledge with you, probably give you a tour of her studio, and perhaps allow you to observe a shoot. Who knows— you might even get a job offer.

Any connection to the photographer you're trying to get in to see, no matter how tenuous it seems, will improve your chances. "I'm much more likely to see someone who calls me and says, "Hi, I'm your friend Joanne's friend Susie's daughter, and I was wondering if you might have time for a brief informational interview," than someone who says, "Hi, I'm Jane Doe ,and you have no idea who I am, but would you clear some time out on your schedule to meet me?" So don't be afraid to drop a few names. You probably have connections you aren't even aware of. Ask your friends and family if they know any professional photographers—I think you'll be surprised how many do.

READING BOOKS

Reading books on the creative, technical, and business aspects of photography is very helpful as an added learning tool whether you choose some form of schooling or self-teaching. But I never recommend just reading books—take them out in the field and apply the theories and techniques you find in them. If they include lessons or workbooks, do them! Don't expect to retain

what you read without hands on experience to back it up.

Not every word of every book is going to apply to you. So when you read, keep a highlighter and a pencil nearby. Highlight the ideas and theories that are germane to your place on your creative journey. Write comments in the margins. Put tabs on or dog-ear the pages that hold matters of interest so you can find them again. If you're one of those characters who likes to keep your books in pristine condition, get over it. Reading a book is like mining for gold. You have to sift out the sand and rock to find what you're looking for. The sifting part is critical, because if you don't wash away the silt, there could be chunks of gold in your pan but you won't be able to see them.

Books don't always teach us new things. Sometimes they remind us about things we already know, but have neglected to act on. Sometimes an idea in a book will inspire you to get your own idea and act on it.

HIRING A CONSULTANT

Another way to start your studio is to hire a consultant—usually a successful photographer who operates an established studio in your chosen specialty area—to show you the ropes. Consultants generally charge $200 to $500 per hour, and that probably sounds hugely expensive at first blush. But consider the savings in time and money over attending even a two-year school—I've consulted for people starting their own portrait studios who learned all they needed after just two weeks and a few follow-up calls.

"This is only for people who have the resources and who are positive they know what specialty they want to pursue," says Julie Floyd. "You don't want to get through an $8,000 stint with a portrait photographer and suddenly say, "Oops! I guess I really want to be a fashion photographer.""

ON THE JOB TRAINING

Some studios, especially portrait studios and photo mills, will hire employees will no experience and teach them to shoot. There are advantages and disadvantages to this.

"You learn one standard style of posing people," says Laura

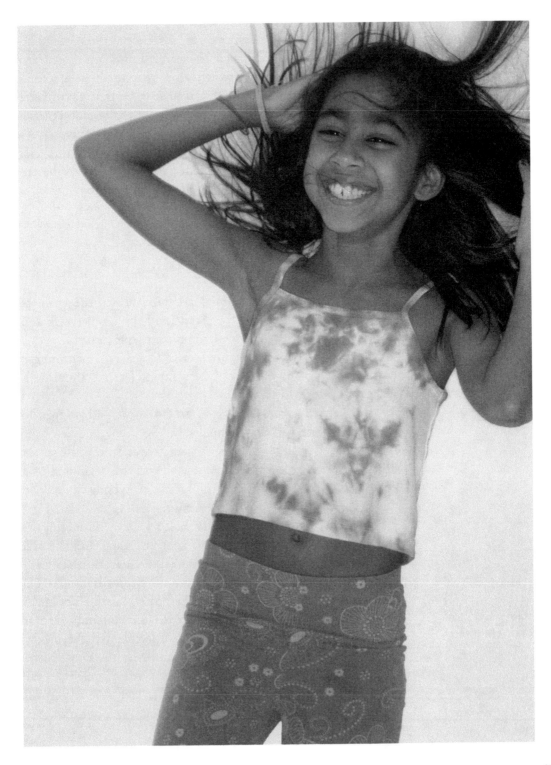

Dizon, who once was a trainer for a national portrait studio chain. You learn how to handle the camera. But you don't learn how to be creative on your own. You have to shoot a certain number of headshots, with the head in a certain part of the frame … you don't get to touch the lighting and you don't learn what an f-stop is, because you don't have to know."

But there are parts of her training that Laura found very useful. "They teach you about the ability levels of kids at different ages. At six months they sit up, at nine months they crawl, a year they walk. I actually think I benefited a lot from my time at that portrait studio."

One real perk: You get paid while you learn.

MENTORS

Finding a mentor, someone who is established in the business and is willing to show you the ropes and help you network and find clients, is a fantastic way to jump start your career.

Minneapolis photojournalist Stormi Greener is mentoring a Maine wedding photographer who wants to learn to shoot weddings with a journalistic style.

"I was traveling up the East Coast on a job, and stopped to shoot, and there was this woman standing in the middle of the road fiddling around with her camera," says Stormi. "I struck up a conversation with her." And that was the beginning of a great mentor/student relationship. But not everybody can rely on this type of serendipity to land a mentor.

Wedding photographer Hilary Bullock has dominated the Minneapolis wedding market for eighteen years, and she still solicits mentors from other complimentary fields. "It's a great way to learn," she says. "I have a business mentor right now I'm working with. He's great, and I've learned so much from him." Bullock recommends sending a letter to your potential mentor that is brief and professional. Be very specific: Tell the person what you are looking for in a mentor and why you chose them. Then follow up with a phone call. "By getting straight to the point," Stormi says, "you are showing that you have respect for the person, you understand that he's busy, and you don't want to waste his time."

Opposite:
Here, a student's work from BetterPhoto.com shows the value of Internet classes.
© Stephanie Adams. All rights reserved.

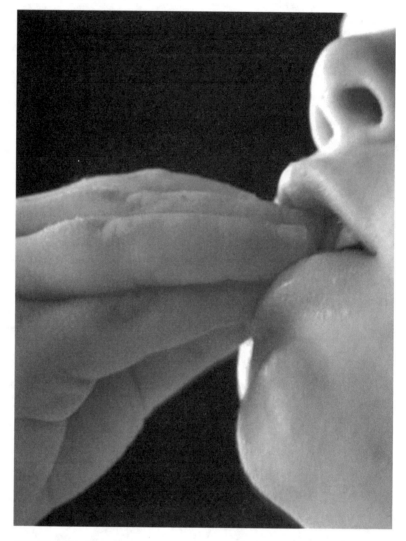

INTERNET CLASSES

Photography classes available on the Internet would seem to be a perfect solution for those who have day jobs and/or family obligations that make it difficult to commit to a regular, in-the-flesh class. The lessons come to you via e-mail, and you complete them at your convenience. Then you e-mail your results back to the site and receive critiques and feedback from your (highly credentialed) instructor, as well as from the rest of the class, which is usually chock full of those talented amateurs we mentioned earlier in this chapter. You are free to remain relative-

ly anonymous, or to network and chat with fellow students as much as you like. I am, of course, biased, because I teach several classes at a fabulous site: www.betterphoto.com. While BetterPhoto.com is the first site to offer such classes, I'm sure others will follow suit.

Whatever method(s) you choose to learn photography, be sure to show up for it. Use it. As obvious or silly as that may sound, I've had many, many Internet students make it part way through a class and then disappear, never to be seen again. They're still on the roster, and they have paid their fees, but they are just not participating. In fact, some people sign up for classes and never once submit work for critique or feedback from fellow students, and never ask a single question. I only hope they are at least following along with the lessons at home. Likewise, art schools and photography schools have an astronomically high drop-out rate. Just being able to say you went to Brooks or took a lighting class on the Internet is not going to make you into a photographer. I've followed up with a few of my students who petered out before the end of class and most will apologetically say that real life got in the way, or they had equipment failure and thus couldn't complete the assignments. This is so unfortunate, because many of the dropouts show real talent early along. The fact is, real life will always try to get in the way of your dreams, and equipment fails once in a while. If you're passionate about becoming a photographer, then you won't let these issues get in the way.

Finding Your Niche

H ere's another catch-22, in a field fraught with catch-22s, says wedding/portrait photographer Bob Dale. "You should start out shooting everything. You should be a generalist. That's how you learn. But then you have to narrow it down. The market demands that you choose a specialty."

Says commercial/fine art shooter Leo Kim, "You have to find your own personal style, before you can select a niche. You will start out emulating the visual styles of others whose work you admire. But sooner or later, your true self comes out. It has to. Then you will choose your niche accordingly."

In the good old days, a photographer used to be able to be a generalist. He could shoot a little tabletop, a little fashion, a little food, a little architecture. He was considered perfectly respectable if he shot a portrait in the morning and a building in the afternoon. But now in order to be successful, he has to specialize. If you're a food photographer, you shoot food—nothing else. If you're a fashion photographer, you shoot fashion. Period.

"I don't want to hire someone who shoots candy and girls," says an architect who often hires photographers to shoot his building projects. "I won't hire anyone who has anything other than architecture in his portfolio."

Says Patrick Fox, "We've been forced to specialize to a ridicu-

lous degree. It's come to the point where you're not just limited to one specialty, you have to shoot one look or one technique within that specialty."

In smaller markets, your neighborhood generalist is probably still respected. But the larger the market you shoot in, the more specialized you'll be forced to be. So, when choosing a niche— an area in which to specialize—consider what you like to shoot. Who and what are you drawn to through your lens?

"You have to shoot selfishly to be successful. Shoot what interests you," advises Doug Beasley.

Agrees Jim Miotke, "Follow your bliss, and the prosperity will come. It's an organic process. You learn about yourself as you learn to shoot, and ultimately it all comes together."

The sentiment is shared by Patrick Fox, who adds, "You have to love what you do—this business is too tough and too stressful if you don't."

But don't you have to consider your market, too? What if you want to specialize in baby portraits but you live in a retirement community?

"Then you move," says Patrick.

"You have to create a balance," says Lee Stanford. "You have to weigh your interests against your market and figure them both together when you're deciding on a niche. Because yes, you'll be miserable if you choose an area you dislike to shoot in, but if you never shoot because there are no clients who need your work, then you'll be miserable, too."

Doug Beasley is less disposed to consider the market. "I tried to sell out, and it didn't work. When I try to shoot how I think someone else wants me to, the work is not as strong as when I shoot from the heart." And Doug is great at practicing what he preaches—he is one of very few fine art photographers who sell images to a commercial market. He has total creative freedom,

A shot from the stock nature niche.

Opposite:
"The Kremlin at Night": a stock travel shot.

prestige, and a national reputation. He makes it sound awfully simple: "Just shoot what you are passionate about."

But Jim Miotke advises not to be afraid to pay your dues. "Even Ansel Adams had to shoot portraits," he points out. "Avedon, Warhol, all those guys started out shooting portraits and commercial stuff."

So while you're busy following your bliss (swimsuit models) be realistic about your market (executive portraits). Assist, interview, or observe people from different disciplines.

THE OLD NICHES

There are certain specialties that just jump to mind when you're thinking about photography. For example, wedding, event, editorial, fashion, commercial, product, food, tabletop, portrait, fine art, and sports.

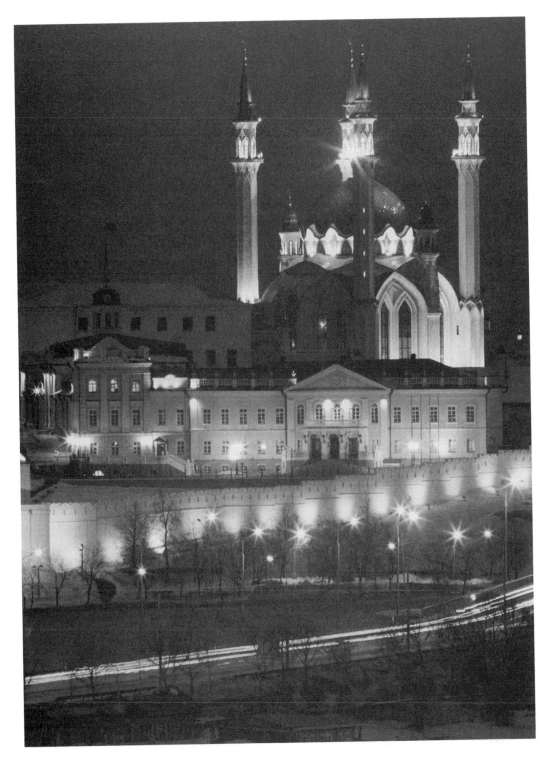

THE NEW NICHES

Digital technology has opened up a new range of niches, many of which don't require a huge financial commitment. Many Web sites and e-mail newsletters feature photographs that are shot with a high-end consumer-grade digital camera. The drawback to this is that if you choose this niche, you'll be competing with every other aspiring photographer who has a Nikon D100.

Another new niche is lifestyle."

"I'm not sure what lifestyle means. I think it's actually meaningless," says our anonymous friend. "I think lifestyle means sort of artsy editorial style shots of baby boomers enjoying being old." Whatever it is, there seems to be a growing market for it.

MAKING YOUR OWN NICHE

I've never liked competition. I've always thought that if there were people already doing something, then I should do something else. When I opened my first studio, everyone was still pretty much generalizing in my market. There was no one positioning themselves exclusively as a kid expert, or as an exclusive anything expert, for that matter, because common wisdom still held that if you specialized you'd lose out on too much work. But I figured I'd rather have a bigger portion of a small area than a small portion of a large area, and anyway, I pretty much only ever really enjoyed shooting kids. In calling my studio KidShooters and only shooting kids and their families, I didn't realize that I was creating a new niche or even that I was positioning myself within my market. I was just trying to do what I loved. I was lucky. It turned out that 1988 was a great year to start a kids' portrait studio.

You can create your own niche, too. Learn as much as you can about the existing ones, and zero in on the things about them you like.

HOW TO BE SUCCESSFUL IN MULTIPLE NICHES

You may be a much more well-rounded individual who feels passionate about shooting in two or even more different specialties. Or you may find that the market for your chosen specialty is drying up, getting flooded with competitors, or simply hasn't turned out to be all it was cracked up to be. How can you get a

toe-hold in a different area without losing your clients in your original field?

Be sneaky! Have different books (portfolios) for each specialty. Have different business cards, letterhead, invoices, and promotional pieces. Keep your studio name noncommittal, like, "Joe's Photography," and not specific, like "Joe's Portraits and Product Studio."

Pay attention to the work you show in your studio. If you're

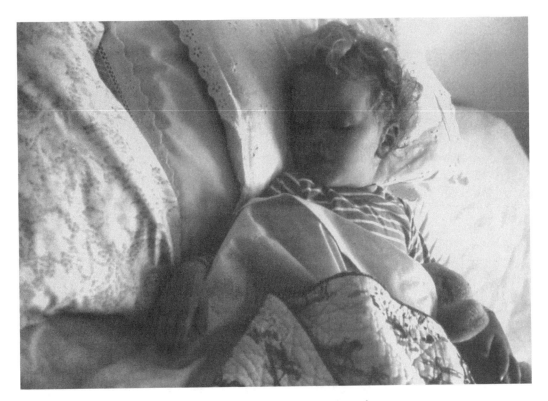

shooting for a portrait client today, have only examples of your portrait work on the walls. Shooting a product? Then display only product shots. And don't flap your jaw about your product shots to you portrait clients, or visa versa. If worlds collide and a client finds out about your other specialty, don't deny it. Just say, "Oh sure, didn't you know about that?"

And for goodness sakes, don't mix up your clients by being a graphic designer who also shoots, or a photographer who also designs. Since the advent of the digital camera, I've noticed a number of listings in the yellow pages for "Joe's Photography and Design." When a savvy client sees that, she'll probably just conclude (and she might be right) that you're a designer with a camera and not enough to do.

So you have your work cut out for you—to choose a niche that holds both enjoyment and marketability for you. Seems like a tall order. But every successful photographer I interviewed either knew going into the business what he/she wanted to shoot, or found that it all fell into place for them after a little thrashing about.

"Finding your niche is like falling in love," says architectural shooter Karen Melvin. "Once you find it, you know its right."

THE DANGLING WOMAN

Beth Wald created a very interesting, highly targeted niche for herself in 1986 when she became a mountain and rock-climbing photographer. She literally shoots while dangling from a rope over a 2,000-foot drop.

"It was a great time to start in this niche, because there weren't many other people doing it," she says, which I suspect might be something of an understatement. "There were other climbers who would carry a snap shooter and take a few snap shots, but when you're climbing you don't want to be carrying a big lens and camera body with you. I was one of the few who would take the time to set up a shot—find the right angle, the right time of day for the light."

Rock and mountain climbing were enjoying new popularity, with more and more magazines and catalogs to sell to.

It's hard enough having to think about lighting, exposure, and composition on a shoot, let alone doing all this while hanging from a rope. I wondered if Beth had ever been in danger as a consequence of combining her two passions of climbing and photography.

"Yes, I've been is dangerous situations," she says, without hesitation. "Now that I'm established, when I go out on a shoot for a commercial client, I hire a rigger who sets the ropes, and I don't have to worry about that aspect. But in the beginning it was hard to talk clients into budgeting for a rigger, so I was out there alone.

"Once I was in Nepal with a famous French mountain climber, and it was all ice. I use devices to go up the ropes—it's hard to explain to someone who doesn't climb—and these devices would slip on the icy ropes."

What led her into such a refined—and potentially dangerous—niche?

"Necessity! I wanted to figure out a way to make a living climbing—that was my first passion. Photography became my second. I was just out of college and had decided against a scien-

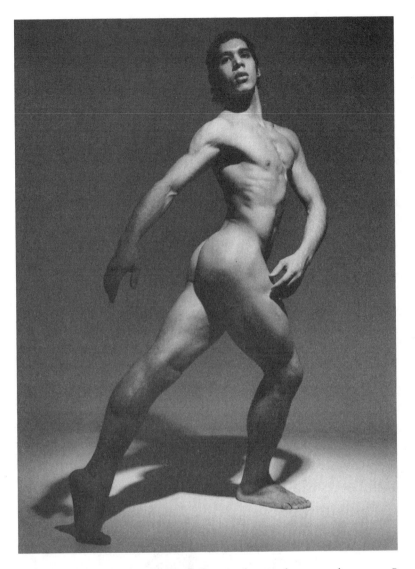

Photographer Roy Blakey has carved a place for himself in the highly specialized niche of the fine art male nude.

tific career—I'd studied ecology, plants, botany, because I thought it would be a great way to be in the mountains, but I discovered that was not the case. Most botanists are only in the field about one month out of the year.

"Now photography has become my first passion, and climbing my second."

She pondered whether there is still a place in this narrow niche for newcomers in this unstable economic market. "It's a tough market. But I think it's incredibly important for people to

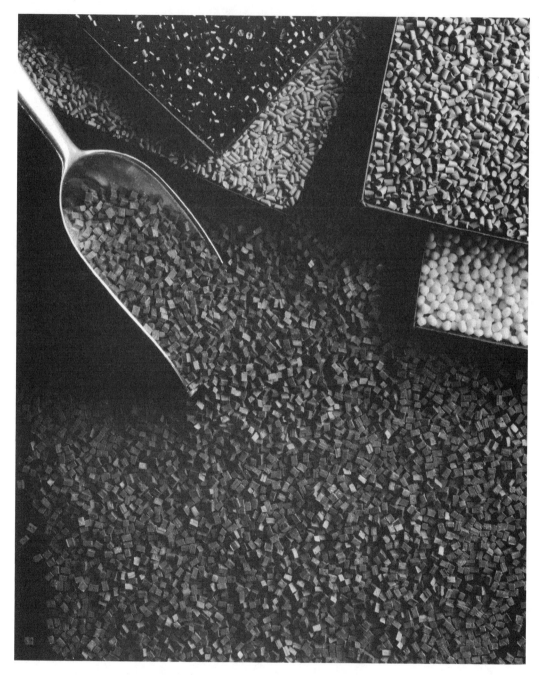

Above and opposite: Leo Kim has developed two distinctly different and highly specialized niche areas: carefully thought out tabletop product shots, often involving small industrial parts arranged in graphic patters, and black and white fine art landscapes of North Dakota.

get out there and create great images. There's always a place for talent."

So you need to find yourself a niche—the smaller and more focused, the better. But you also need to be flexible within the parameters of your specialty.

The business and creative models are changing constantly, so you need to be willing to change constantly, too—find ways to go out and make great assignments happen. If you wait for them to come to you, you'll be waiting forever. You have to be passionate about the business, and apply your creativity to it. Find new ways to get jobs, and get money to finance the jobs.

For instance, I did a shoot in Afghanistan for *Smithsonian Magazine*. The writer and I got together and pitched the story to the magazine. Magazines almost never consider proposals from writer/photographer teams—only from writers. They prefer to assign the photographers themselves. They told me outright that they'd never consider a pitch from a photographer. But we made that job happen. We had to combine several assignments to do it—*Smithsonian* couldn't afford to send us to Afghanistan. So we piggy-backed a story for *Sierra Magazine*, and we got a small grant, and it all came together. So I say, "Never say never."

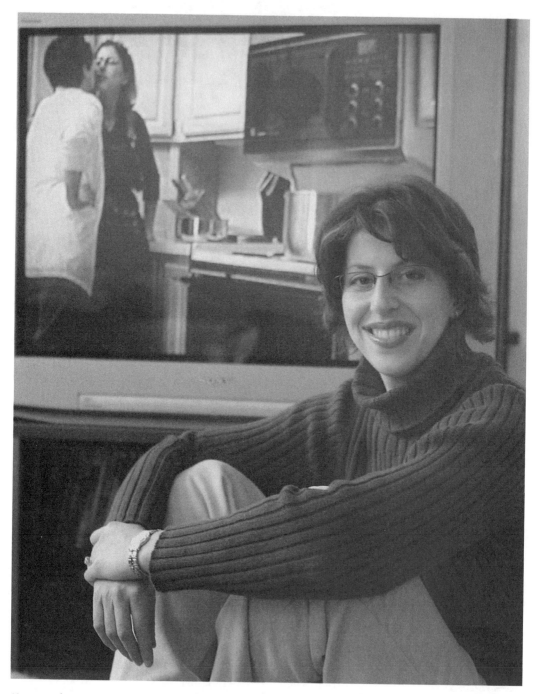

Here are three examples of editorial portraits shot on assignment for various magazines and publications: a philanthropist; a breast cancer survivor and spouse; and a filmmaker who made a documentary about her mother teaching her to make gefilte fish.

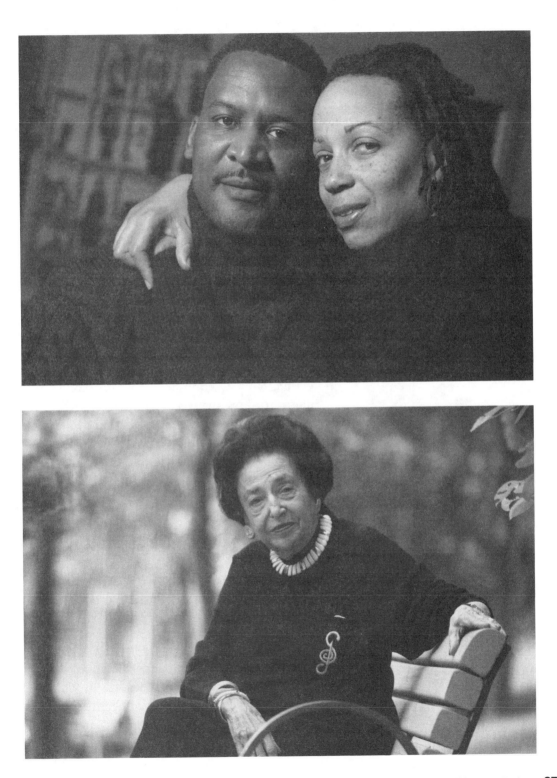

The Business Plan:
Your Blueprint for Success

A business plan is, essentially, a document which describes your business; describes your market and how you intend to position your business within that market; projects your operating costs; illustrates how many goods and/or services you have to sell, and at what price, in order to make a profit, who will be your clients, how many clients you need at a specific average sale to sell enough goods and services to retire young in the Bikini Island, and how long it will take to get those clients.

MAKE A MISSION STATEMENT

Your mission statement should be one or two sentences describing what you plan to do and how you plan to do it. Here are some examples:

Stanley Kalowski Studios will specialize in fine art, hand-painted, selenium-toned gelatin prints of streetcars in a high-end, retail setting. We will hold our streetcar photos to a higher level of permanence and artistic integrity than any other street car photo studio, and offer them at lower prices than our competitors.

Goofy Goose Children's Studio will specialize in white on white portraits of babies and toddlers. We will be the only studio in our area to offer room-sized portrait murals and to offer in-home design consultations.

AVOIDING UGLY SURPRISES

A business plan can help you avoid ugly surprises after you've already invested time and capital to start up your studio. For instance, let's look at my Tiny Acorn Studios. I had been in business for five years, and the stores were bringing in a healthy gross, but the net was less than I would have liked. Never having had a business plan, to start after five years seemed a little like closing the barn door after the horses were gone. But I wanted a better picture of what was going on than I could discern from the quarterly reports from my bookkeeper. So I sat down to do a partial business plan: I wanted to find out what my average sale per client was for my break-even point; what my average sale was currently; and what it would have to be in order for me to create a healthier net or profit margin.

What I learned shocked me: My average sale per client had to be $275 just for me to break even. I had no idea—and I should have. Fortunately, my average sale already exceeded $275, but not by nearly enough. I needed to raise it by at least $75. This led me to examine what products and services we were actually selling. I had a rough impression that the stores were already maximizing their portrait sales and selling custom frames to 50 percent of our clients, give or take. After doing the math I discovered that we were only selling frames to about 15 percent of our clients. A travesty!

I quickly held a series of employee in-services to teach our design consultants how to close frame sales at the proof viewing. Within a month we were framing 55 percent of our portrait clients, and as a nice little perk, the average portrait sale went up at the same time. I think the in-services raised the employee enthusiasm level all across the board, causing better overall sales in spite of the fact that the focus of the training had been frame sales alone.

If I hadn't borrowed this one little element of a business plan and applied it to my five-year-old business, I'd never have figured out what to do to improve my margins. Now I do a new business plan every year.

TESTING THE FEASIBILITY OF YOUR ECONOMIC GOALS

Making a business plan can help you determine whether it's likely you'll be able to meet your goal of making $35,000 in your first year in business so that you can quit your day job. Perhaps your business plan tells you that, given your projections, you'll need nine million clients to net that $35,000. You can cry in your coffee and forget the whole thing. Or you can go back to your plan and apply that creative mind of yours to lowering your projected fixed overhead, media costs, raising your prices, or some other method of preparing your dream to come true.

KNOW YOUR COMPETITION

How many other photographers will you be in competition with? Who else is shooting in your specialty in your market? Are you opening a studio next door to a well-established, well-loved photographer doing the same type of work and marketing to the same clients as you? If so, how will you claim your share of the market? Perhaps you should choose a location a bit farther away from the competition, or change the look or the price point of your product so you're in less direct competition. If your market is saturated with shooters in your specialty, you may want to rethink your whole approach.

It may not even be enough to just learn the players in your present market. Wedding shooter Hilary Bullock recommends learning the history of your market, as well. "Find out who the players are. Find out who's been around forever and who's been just passing through. Who dominated—and who's dominating—the various facets of the market? What's the current state of the market compared to five, ten, fifteen, even twenty years ago?"

That's not to say that you shouldn't go into your chosen field just because there's a lot of competition or because there's a trend toward digital or toward giving up copyrights. No one says you shouldn't take risks—that's what business is all about. But you should know what risks you're taking.

SETTING THE BAR

Making a business plan helps you set the bar: you know exactly how much and what you need to sell to satisfy your needs. It

can help motivate you in the same way that a quota helps to motivate a sales person.

A WAY TO LEARN YOUR MARKET

Part of making your business plan involves deciding who your client is. What demographic are you marketing to? And how many people in your city fall into that demographic? Where do you have to go to find them? What zip codes do they live in? How many other similar businesses are courting these same clients with similar products? What will you have to do to position yourself within your market to stand out from the rest? How will these people find out about you and your work? By the time you've completed your business plan, you'll know your market inside and out.

A TOOL TO APPLY FOR BANK LOANS (OR COURT INVESTORS OR PARTNERS)

If you intend to involve any other entities in your new studio at all—banks, investors, or partners—you'll need to have a business plan. You may even need one to obtain a lease if you're going into a high-end location and your business is untested. Only your dear old mom would consider forking over dough or other resources without having it spelled out in black and white exactly what you plan to do with it.

A WAY TO FIGURE OUT WHO YOU ARE

By the time you finish your business plan, you'll probably feel like you've been doing some serious navel-gazing. You may even be sick of yourself. But by forcing you to articulate who you are and why people should buy your products and services, making a business plan may show you how to be a different person from who you thought you were; or at least a different person from who you were when you started. For instance, when you started to make your business plan, let's say you thought you were a nature photographer. Well, sure, you love nature. So you think, where could I sell nature shots? Maybe to a calendar company, or a greeting card company. Perhaps some local businesses would use my nature shots in their annual reports. And won't

stock be a good market also? More research yields bad news: even if you can get a calendar or greeting card company interested in your work, you'll only be paid $75 an image, which, in the words of stock photographer Bryan Peterson, "Ain't hardly enough to get excited and quit your day job over." More bad news: everybody and their brother wants to sell nature shots for those local annual reports and through stock agencies. If you even want a stock agency to consider you, you have to have an enormous body of work, and you don't have time or money to go running out and shoot up the scenery—darn that day job! So now who are you? You're still a nature lover. But maybe you're a people lover, too. Maybe you can be a nature lover who shoots actor's and model's composites. Maybe you're someone to whom shooting and making a living is more important than just shooting nature. Your business plan will tell no lies.

WHO SHOULD HAVE ONE

All the photographers I interviewed unanimously agreed that everyone should have a business plan—and not just when you're starting out. I do a yearly business plan for each of my studios, and a five-year plan just for kicks and giggles. The plans are like a weather forecast—the further into the future they try to predict, the less accurate they are. But they aren't written in granite. I change mine when unforeseen challenges, like economic upheavals, occur.

"Who doesn't benefit from knowing what their profit margin is or needs to be? Or from knowing their market? Or from knowing exactly what their fixed overhead is? Anyone who starts a business without this stuff is fool hearty," says commercial shooter Patrick Fox.

Alright, so everybody should have one. But what, exactly, goes into your basic business plan?

YOUR NAME

Probably one of the first things you started to think about when you decided to go "pro" was what you would call your studio or business. It's fun to fantasize! But choosing your new name is a very serious endeavor.

Check out other photographers in your market who work in your area of specialty; sometimes there are unwritten industry rules or standards you need to adhere to in order to be taken seriously. In Minneapolis, for example, commercial, architectural, and up-scale wedding photographers generally use their name and the word "photography"—for example, "Lee Stanford Photography," or "David Sherman Photography." You won't be taken as seriously if you call yourself, "Jane Doe Photo," or "Doe Photography and Design." You might be able to get away with, "Doe Studio," but that's really pushing the envelope. So find out what the standards are in your market.

If you're a portrait or other retail studio, you have a lot more leeway. You can have a little fun when you're coming up with your name. But there are still a few rules to consider.

"First and foremost, your name should tell people what you do," says expert marketer Howard Segal. "Don't make them guess. You want your name to reinforce your product and your image."

I know from personal experience just how right he is: In 1994, I named my first retail portrait studio "Tiny Acorn Studio." The problems were immediately obvious—no one knew what we did. "I thought you were a frame shop," was a remark I heard often. Or a daycare center. To me, "studio" meant photography, but to our clientele, it was synonymous with "art," and "gallery."

So I changed the signs to read, "Tiny Acorn Portraits," took the little acorn off the logo and inserted a little camera, instead. That helped people figure out what we did. But the problems didn't end there.

"We looked you up in the phone book and we called information, and 'Little Acorns' isn't listed anywhere," I was told. It hadn't occurred to me that "little" and "tiny" were totally interchangeable in many people's minds. But it was too late to do anything about that—changing the name of an established business should only be done under very extreme circumstances.

You also want to make sure your name of choice is timeless. Certain words and phrases will mean the same thing forever. But some slang terms come and go, just like skirt lengths, and what

sounds hip or trendy today may sound trite or foolish tomorrow. For example, in 1988, the first "super models" were making the scene. Fashion terms, like "photo shoot" were very much in the pop lexicon. So when I called my new studio "Kidshooters" in 1988, no one had any negative connotations in regard to the name. But as the years passed and school yard shootings became common place, some people started to flinch when they heard our name. After the Columbine School killings, we simply couldn't hold out any longer, and we changed the name to KidCapers Portraits. We made an enormous effort to maintain continuity through the name transition, but we still to this day have people tell us, "Oh, you used to be KidShooters? I thought you guys went out of business." Ouch! Those are not the words a small business owner wants to hear.

So take your time and consider carefully before you commit to a moniker. It should say exactly what you do, it should be unambiguous, and it should be short and sweet. Because hopefully, you're going to have to live with it for a long time. What's in a name? Maybe not everything, but almost.

YOUR PRODUCTS AND SERVICES

Your business plan should detail the products and services you intend to offer, and should illuminate the special qualities that make these different from those already in the marketplace. Will your products/services be less expensive? More innovative? Of a better quality? On different or better media or materials? What attributes will make people want to purchase your product over those of your competitors?

YOUR CLIENTS

Your business plan should state exactly who your target client is. For instance, if you're opening a studio specializing in high-end wall portraits of children and pets, then your client profile would go like this: Families with children 0 to 16; average income of $150,000-plus; living in the northwestern suburbs; kids in private school; drive SUVs; and so forth. If you're selling moderately priced small prints, your client profile might go something like this: Families with children ages 0 to 10; average income

$75,000-plus; living within a four-mile radius of studio; avid scrap-booker or archiver, etc. The more targeted your client profile, the more successful your marketing efforts will be.

YOUR OPERATION COSTS

Your business plan should categorize and detail every operation expense, including:

- initial and one-time expenditures, such as incorporation fees, trademark expenses, name filing, furniture, equipment, etc.
- fixed overhead, such as studio rent, utilities, permanent employees if any, phone system, etc.
- ongoing expenses: office supplies, postage, stationery, photographic processing and printin,; marketing and promotion, and contract labor

PAYING YOURSELF

Remember that your time has value. I have known small business owners who think they're operating in the black, just because they don't factor in their own time on the job. They're netting $25,000 a year, but they're working 2,700 hours. That means they're making only $9.25 an hour, without even taking into consideration self-employment tax or the lack of benefits such as medical insurance that you'd typically receive at a "real" job. It's an easy trap to fall into: when you first start up your business, you're necessarily planning on making little or nothing during the first one to two years. You need to set your expectations low so you can plan to meet your financial needs elsewhere while your business is getting established. But at some point, you need to start figuring your own time as an expense, along with all your other operating expenses.

The way the government categorizes the funds you pay to yourself varies depending on the type of entity you are. A sole proprietor, for instance, basically pays all her expenses and then keeps whatever money is leftover. An owner of a sub-S corp. is required to draw "a reasonable salary," and then receives the balance of the company's revenue as "profit." This is the way the IRS insures that you pay withholding. Limited partnerships, corporations, and other entities all have different requirements

for the disbursement of revenue, so make sure you know the rules before you write yourself that check, or take a draw from your business account.

FEE STRUCTURE AND PRICE LIST

Your business plan will include your fee structure: how and when you charge for your goods and services, and your price list—what you charge for your goods and services. This is covered at length in chapter nine.

INVESTORS, PARTNERS, AND VENTURE CAPITALISTS

Your business plan should indicate whether you have solicited or intend to solicit partners, investors, or venture capitalists, and spell out exactly what they're involvement and compensation will be. There are many different types of partners and investors,and different ways to attribute ownership of the business and compensation. It's important to get it all down in writing in as detailed a manner as possible. Advice from a business attorney is a must if you are considering bringing others into your new business.

TO INCORPORATE OR NOT TO INCORPORATE

When you go into business, you choose to be a certain type of entity. What type of entity you choose to be will determine a variety of important variables, such as how and when you pay your personal and/or business taxes, how and when you pay yourself, what your exposure or liability is in the event someone gets injured at your studio, and more. You need to have a serious sit-down with a tax accountant or a tax attorney, who can advise you as to what business structure will benefit you most. Often your tax expert will have a computer program that will project your earnings in a variety of scenarios, so you can compare them directly.

Many new business owners are intimidated by the idea of consulting an expert on this topic, or are unwilling to spend the money on professional fees. They'll often set themselves up by default as a sole proprietor, when this isn't necessarily the best option.

YOUR MARKETING STRATEGY

A key element of your business plan is your marketing strategy. It outlines in detail the ways in which you intend to attract customers and build a client base. We cover this in great detail in chapter eleven.

"All right," you're thinking, "Sure, it sounds like great idea to layout all these details in advance. The only problem is—how am I supposed to know what my rent will be when I don't have a studio yet? I have no idea how much a business phone line costs, or whether I will need one line or two. Will I buy a copier/fax machine, or run to the corner to Mail Boxes, Etc. when I need to fax or copy something—or is that even a likelihood? How do I know what it'll cost me to produce my product when I don't know what kind of volume I'll be doing, and therefore can't exactly negotiate price with vendors."

You've gotta start somewhere! First, find out where your clients are—geographically speaking. If you have a friend in commercial real estate (or a commercial realtor, for that matter) he can create some very detailed demographic reports that will tell you exactly where your future clients are and how far they'll drive to get to you. Then pick a location where you'd like to set up shop if you had your druthers—start at the top of your wish list—and find out what the average rent is in that area. Go see a few available spaces and get a feel for what's available. If you find the rent too steep, or the area lacking in the amenities you require, pick another area and research that. Be open-minded. When you find the right location, you'll know it.

Call some phone companies and find out what a business line costs. Start with one—you can always add another later.

Hold off on the fax machine/copier until you know whether you'll use it. If you haven't the first clue as to how much to budget for such expenses, guess at an amount and then mark it up 100 percent.

Figuring out your COGs (cost of goods) goes much the same way. Find some wholesale labs and run a few prints with them to see who gives the best service and does the best work. Base your projections on those prices.

When making these projections you want to start out with as

much knowledge as possible. When you're forced to guesstimate, lean toward the high end. It's always best to be conservative. You want to be surprised at the end of the year with a bigger income than you expected—not a smaller one or a deficit.

There's no question that making a business plan is a heck of a lot of work. You'll need to do a lot of research, and research is not the same kind of fun as taking pictures is. But it might mean the difference between heartache and failure and laughing all the way to the bank.

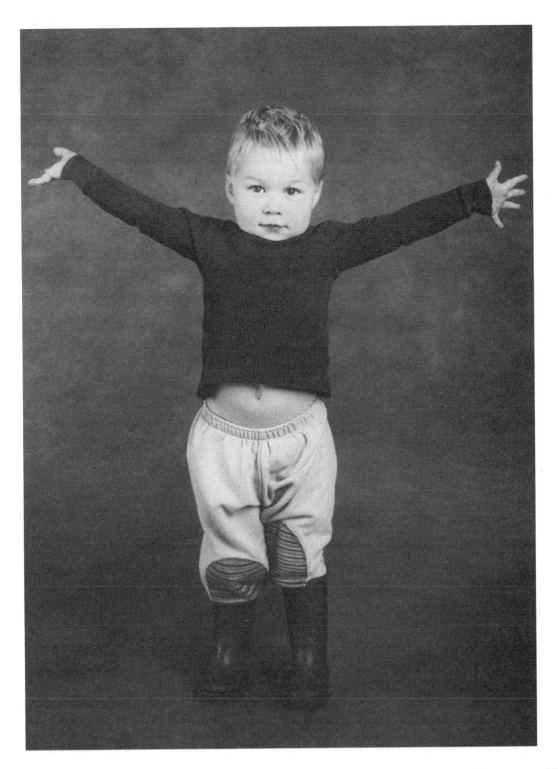

Breaking In:
Starting a New Business

One of the first decisions you'll need to make when opening a new studio or photography business is what kind of entity it will be. There are liability and tax issues that need to be carefully taken into consideration when you're weighing your options. I strongly recommend consulting a CPA or a tax attorney. This is one area where I believe professional advice is a must. The following are a few of the forms which a small business can take:

SOLE PROPRIETORS

A sole proprietor is exactly what it sounds like it is: an individual person doing business. He has no partners. He is not incorporated. If you're a sole proprietor with a name for your business other than your own, your bank, your accountant, and other professionals will refer to you as a D.B.A.: Stanley Kowalski D.B.A. (doing business as) Street Car Named Desire Studio. You may also be referred to as A.K.A.: Stanley Kowalski, A.K.A. (also know as) Street Car Named Desire Studio. The advantage of being a sole proprietor is that you don't have to do anything. You just hang out your shingle. The drawback is that your personal assets are totally unprotected if someone sustains a personal injury at your place of business or if you default on a lease or a loan or sustain any other type of debt.

PARTNERSHIP

A partnership is generally a business owned by more than one individual, but it is treated like a sole proprietorship, so the same potential personal liabilities exist.

LIMITED PARTNERSHIP

A limited partnership is another business structure created by state law for businesses with more than one owner. In some circumstances this structure can reduce some of the partners' potential liability for debts of the business. It may also have different tax consequences for each of the partners.

INCORPORATION

A corporation is a business structure created by state law. When a business is incorporated, it sells stock in the corporation, and the stockholders (or shareholders) are the owners of the business. If all the applicable corporate laws are followed, only the corporation is responsible for the corporation's debts—not the individual stockholders. This means that if the business loses money, the business' creditors generally cannot collect their debts from the stockholders' personal assets. If, on the other hand, the corporation makes money, the profits will be taxed as corporate income, and any dividends paid out to the shareholders will be taxed as the individual shareholder's personal income.

SUB-"S" CORPORATION

A "subchapter S" corporation refers to a type of federal tax arrangement that may or may not be available to corporations with a small number of shareholders. In many cases, being a subchapter S corporation can mean lower taxes for the shareholders—if the corporation meets all the requirements for being a "sub-S" corporation.

SOME SMALL TIPS THAT CAN SAVE YOU BIG HEADACHES

1. Understand Sales and Use Tax

I've made a lot of mistakes in my fifteen years in business, most of them of the, "Oops, oh well, life goes on," variety. But my most

expensive—and therefore most memorable—mistake involved a little thing called "use tax." On the form that I fill out every month when I pay my sales tax, there is a line for "use tax purchases." I had no idea what it meant, so I blissfully assumed it didn't apply to me. For years I left the line blank. Then one day, I got a call from the Minnesota Department of Revenue: I was being audited by the sales tax division. No problem, I thought. I charged my clients and paid the state the proper sales taxes. That was when I found out what "use tax" is. When you purchase merchandise from out-of-state sources by phone, internet, or mail, they don't charge you sales tax because you are supposed to pay the sales tax in your home state. That's a use tax.

For years I'd been buying almost all my equipment, art supplies, props, and other miscellaneous items mail order, from companies in other states. These purchases over the course of those years totaled in the tens of thousands of dollars. Once the tax I owed, plus the penalties were tabulated, that little oversight wound up costing me thousands of dollars.

And it didn't stop there. I also did business with an in-town printer who created all my printed material. Some of the material—holiday cards, for instance—was resold to my clients, so I wasn't required to pay sales tax to the printer for those (the end user—my client) paid that. But this printer also did my stationery and some promotional pieces—items of which I was the end user—and therefore I should have paid the sales tax on these. But he assumed it was all for resale, and never charged me sales tax, and I never paid any attention to his invoices. (I'm a photographer, not a business person, remember?) So there was another boat load of sales tax and penalties for me to pay.

Commercial photographers can also wind up in trouble when they don't charge their clients sales tax if the client is the end user. What is the moral of this story? Pay the state and charge your clients sales tax as required by law. Don't assume any lines on any forms don't apply to you. If you don't understand something, call the appropriate government agency and have it explained. Yes, you will spend a lot of time on hold and getting transferred from one department to another. But it'll save you money in the long run.

2. Have a Record Keeping System That Works for You

I don't know anybody who ever says, "Oh, goodie, I get to organize my files now!" And photographers are probably more record-keeping challenged than most. So you need to give yourself a lot of help:

• *Use visual cues.* You're a very visual person, remember? So use visual cues, such as color and tab placement, to make it easier on yourself. For example, I put all my vendor invoices in blue files and put their tabs all the way to the right. My leases, rental invoices, and everything else that pertains to my spaces are in blue files, with their tabs all the way to the left. Banking related documents: red file, center tab. And so on.

• *Be consistent.* Always keep your files in the same place. This might sound basic to some of you, but you'd be amazed at what some of the offices of photographers can look like. They're working on a file, so they take it to their desk or their couch or their copier, set it down to go do something else, and leave it there. Pretty soon something else gets laid on top of it, and something on top of that, and so forth, and suddenly the file is MIA. Depending on the depth of the stack, you might not find that file again until you retire and hold a going out of business sale. So my rule of thumb is this: always keep your files in the same drawers of the same filing cabinets when you're not using them. After you use them, put them back.

• *Keep it in plain sight.* I subscribe to the old adage, "out of sight, out of mind." So I keep all my stuff that needs to be filed in an "in" tray on my desk, where I can't ignore it.

• *Schedule a regular time to file and enter records.* If you stay current with your record keeping and filing you'll avoid those nasty pile-ups that take days to sort out, and you'll never lose a file. I file once a week—every Friday evening before I leave the office. Once a day would be better. I record credit card batches, sales logs, framing logs, etc., everyday. It's a lot like flossing. It's easier to remember to do it if you make it an everyday habit. And it's essential to your business.

• *Keep ledgers and logs.* Whether you keep your ledgers and logs on computer or the old-fashioned way—written in books—or a combination of the two, you should always keep your infor-

mation absolutely up to date. This means when you make a credit card transaction, you should record it immediately if not sooner. It's a real bear to try to go backwards from your batch receipts and recreate the day's transactions. When you get your report from your credit card server at the end of the month, reconcile it the same day you receive it. Bank statements—same thing. The longer you wait to update your logs, the longer you will have to spend entering the information once you get around to it.

And I always have redundant systems built into my record keeping. The client's name and phone number go into the computer on the mailing list, onto her invoice, and next to her appointments in our schedule book. Credit card transactions are recorded in a credit card transaction log, and in the client log. It takes a little longer, but it saves time in the long run.

3. Filing for a Tax Exempt Number

Conversely, you can wind up paying too much sales tax if you don't have a tax I.D. number, or if you don't use it. This was perhaps the second most expensive mistake of my business career. I purchased film, paper, chemicals, and other supplies from several local pro photo stores in Minneapolis. These supplies went into the making of my portraits, which were sold to my clients—again, the end users. I wasn't required to pay sales tax on these items. But as usual, I wasn't paying attention. Eventually, one of my vendors suggested I fill out a "resale tax exempt certificate" and stop paying unnecessary taxes. That guy saved me tons of money.

So, if you haven't already, file for a tax exempt number. Contact all your vendors and ask for "resale tax exempt certificates." The vendors will keep these certificates on file and this will allow you to purchase items for resale and pay no sales tax.

Commercial and architectural photographers will often find themselves in the vendor's role with their ad agency clients who resell photos to their end users. Be sure you keep resale tax exempt certificates on file for them, or you may have to pay a fine if you are ever audited even if they hold tax exempt status.

THE TAX MAN COMETH

Paying your income taxes is a whole new experience when you're self-employed. Kiss those handy little 1040 forms good-bye. You've entered the world of itemizing, of depreciation, of mysterious column A's that you add to column B's and subtract from column C's. The first year of my business I was determined to do my own taxes. I sat down with the form, put my tail between my legs, and ran whining to a CPA who specializes in small businesses. I felt silly going to a professional accountant for my piddly little $38,000 gross studio, but, boy, am I glad I did.

My accountant, Jim Orenstein (no relation) was able to not only do my taxes, but act as an advisor on such issues as disability and life insurance, whether or not to incorporate, and when and how to expand. He gave me the heads up when my net income hit the level at which I had to start paying my personal income taxes on a quarterly instead of a yearly basis. And he told me all about the dirty little secret that is self-employment tax. One of the more unpleasant surprises intrepid small business owners encounter is that on top of your regular taxes—which seem like enough, thank you—you are also required to pay an additional 7 percent on earnings up to about $87,000. Ouch! Cruel as it seems, there is a reason behind this.

What many of us don't realize until we become employers (of ourselves or others) is that while the government is happily making off with a portion of the employee's earnings, the employer is also paying employment tax. So when you're both the employee and the employer, you get hit with a double whammy. Just another little fun fact to know and tell. The moral of this story? You can live without an accountant. But why suffer?

CHOOSING A VENUE

You've budgeted for your studio space in your business plan, and now it's time to choose a door on which to hang your shingle. Whether you rent on an as needed basis from another photographer, or sign the lease yourself, the location where you set up shop will go a long way toward establishing your image in your clients' minds. Think about the identity you want to project: Do you want to be a trendy, artsy, edgy warehouse habitué?

A suburban office park straight shooter? A downtown or uptown girl or guy? If your studio is a retail business, do you want to have upscale boutique chic or shopping mall sass?

Your work can be artistic and editorial as all get-out, but if your studio is in a suburban office park, your venue will be undermining your message. On the other hand, if you're a photographer who shoots good old standard catalog shots and solid, mainstream product images, an office park might be just the place for you. Choose a location that compliments your message—your story.

You also need to consider accessibility. Are you going to need to get big wheel monster trucks into your shooting bay? Or won't you be shooting anything larger than an earring? Will your clients have to park far away, and will they be willing to pay to park? Or do you need a building with free adjacent parking? If your studio is on an upper level, is there a freight elevator, or will you be hauling equipment, sets, and props up and down in the passenger elevator? Will you need access to your studio on weekends and after hours? These are all issues that need to be resolved before you enter into any agreement or sign a lease.

If you rent as needed from another photographer, will there always be a shooting bay available to you? How far in advance will you need to reserve the studio, or will you have standing days for which you pay whether or not you shoot on those days?

• *Working from home*. There are pros and cons to operating your studio, office, or darkroom out of your home. The biggest pro, obviously, is that it doesn't cost you anything—assuming that you would have the home in any case. The drawbacks are two fold: It's harder to project a professional image when you bring clients into your residence; and it's just darned hard to know when to stop working.

"You just work all the time," says Bob Dale, who ran a studio from his home for eight years before leasing a retail space. "I'd be in my pajamas and slippers sitting at my desk masking negs at midnight."

If you do choose to work from your home, ideally any area to

which you bring clients should be completely separate from your living area, with a separate entrance, if at all possible.

And don't take liberties with that fabled "home office deduction" on your income taxes. You should strictly adhere to the rules governing the deduction. So many people have been tempted to cheat in this area that just claiming a home office deduction raises little red flags at the IRS and increases the likelihood you'll be audited.

• *Sharing space.* Since fixed overhead is the bane of small businesses everywhere, and rent will probably be your biggest fixed expense provided you don't have employees, sharing space either with another photographer or with someone in a complimentary business seems like the next best thing, cost-wise, to working from home. But it, too, has it's pros and cons. Obviously, reducing your rent by half or more is a big plus. But having "studio-mates" and "office-mates" can be a lot like having roommates—or worse yet, spouses! There's the basic "Odd Couple" trap—one of you is a neatnick and one of you is a slob. Or one of you subscribes to the "What's yours is mine and what's mine is mine" theory of equipment sharing. Or one of you starts poaching the other one's clients.

Another complication is that the image or identity of your office-mate's business will reflect on you and your business. This can be a drawback if your buddy's image isn't as high-end or as professional as yours.

If you do decide to share space, get an agreement down in writing as to what you'll do in the event of a "break-up." It can be sort of like the "buy/sell" portion that's written into incorporation papers, but it needn't be as formal. You also might want to have a written agreement divvying up the cleaning and maintenance duties—or better yet, take some of that money you're saving by splitting the rent and spend it on a cleaning service.

• *Renting as needed.* For the first two years of my business, I rented a studio on an as needed basis from an established fashion photographer. At first the arrangement worked out spectacularly; he was a slob and I was a slob, so we were compatible on the cleaning front. At first I only needed to shoot on Saturdays, and he only shot Monday through Friday, so there was no dis-

agreement there. But as my business grew, I started needing more shooting days. The day rate I was paying him for the use of his space was 20 percent of his monthly rent. So if I shot more than five days in a given month, which began to happen more and more often, I was paying him more than what it would have cost me to have my own space in the same building. And then his busy season kicked in, and suddenly the studio wasn't available to me on days when I needed it. So after two years, we parted ways.

Would I do it again? In a heartbeat! It was the only way I could have a whole warehouse studio to use without the big risk inherent in signing a lease. But my advice to anyone considering such an arrangement—from either end—would be to have an agreement to revisit your "terms of engagement" every three to six months, with the option for either party to end the relationship at that time.

• *Partnering.* Taking on a business partner is, in my opinion, a great idea, but one very few photographers ever try. Just as in any business, the photographer should only partner with someone who "brings something to the table." The partner should have something to offer that the photographer does not himself possess: capital, sales experience, business experience, clients, etc.

LEASE AGREEMENTS

It can be very scary the first time you sign a lease for a studio space. Most property companies require a minimum of a three to five year commitment. There's usually a page in the agreement that says the exact amount you'll owe for the life of the lease—and I guarantee you the number will be higher than you can count on your fingers and toes.

Beware of the personal guarantee. If you have incorporated, you probably did so to avoid personal liability in the event that your business fails and you can't pay your creditors. But landlords know this, and they don't want to leave you any outs. So most of them will ask you to sign a personal guarantee; this insures that you will pay the remaining rent as per the terms of your lease even if your corporation, or entity, is dissolved. If

you're new there may be no way around this. But if your business has a sound history, you may be able to avoid it. One way to try to eliminate the personal guarantee is to offer to pay a two- to three-month deposit in its stead; this way, the landlord is covered for the time it may take him to lease your space in the event you can't fulfill your lease, and you aren't on the hook for up to five years of rent.

Do the math—most commercial spaces are rented by the square foot and by CAM (common area maintenance) charges. Rent is rent; when you are quoted a price per square foot, that is exactly what you will pay. But CAM charges are different. At the beginning of the year, the landlord projects what the CAM charges will be for the next twelve-month period and bills you accordingly. If his projections are off and the actual cost of maintaining the building is lower than he anticipated, you will receive a refund at the end of the year. But if his projections are low, and it costs more than he projected to maintain the property, you'll get an extra bill at the end of the year. I've been hit for as much as $3,500 CAM adjustments, and I can tell you, it's a rude surprise.

There are many different factors that can make the CAM charges go up: snow removal, gas or electrical prices, special assessments, and unplanned repairs such as reproofing can contribute to a higher CAM. Even the occupancy rate of the property will affect how much your CAM charges are, because the more tenants there are to spread the cost among, the lower the cost is per tenant.

Before you sign a lease, be sure to add it all up. Take a look at the landlord's projected and actual budgets for the last three to five years. Have his projections been relatively accurate? Ask how old the mechanicals are, and the roof, and any other pertinent items. Is he anticipating any repairs in the near future? The more information you have, the less risk you'll assume.

BUYING AN EXISTING STUDIO

Rather than starting from scratch, some photographers opt to purchase an existing studio from a shooter who is retiring or going out of business.

Pros: You can get a client list, a complete set-up including photographic equipment, backdrops, props, and office equipment, take over a space that probably needs little or no build out, all in one fell swoop.

Cons: There might not be as much value in the studio as there appears to be at first blush. Buying a photographic studio can be a little like buying a private practice from a dentist or a lawyer—Without Dr. Livingstone, D.D.S., there is no Livingstone Dental Clinic, even if there is an office, a chair, a client list, and a drill. That's because when Dr. Livingstone leaves, his clients just might leave, too. Businesses are built on relationships, remember, and Dr. Livingstone's patients have a relationship with him—not with his office, and not with you.

It can be a workable arrangement if you don't pay too much for the business, and if the retiring photographer stays on and works with you for a year or two, part-time, to smooth the transition and help you start to win the trust of his clients.

BUYING A FRANCHISE

A franchise can be a safer bet. Before a business is offered as a franchise, it has to have a working model that has been proven to be reliably successful and repeatable. As a franchisee you'll have the advantage of a proven guide for every aspect of operation, and a product that you know can be sold. You also get comprehensive training up front.

But like any other avenue into the world of business, this one has its drawbacks. It can be expensive to start up, and the company takes 5 to 10 percent of your gross for a minimum of seven years. The very benefits that make you want to buy in—those proven systems—may dampen your entrepreneurial spirit once you've got some experience and you want to try out some systems of your own.

CONTRACTORS, EMPLOYEES, NEPOTISM, AND DOING IT YOURSELF

When you're just starting out it's wise to keep your fixed overhead to a minimum. There are various ways to do this.

You can hire independent contractors on an as needed basis. You just have to be careful to make sure that they actually are contractors, and not employees, or you could wind up paying some stiff penalties. There are a couple of big indicators that a person is a contractor and not an employee are. The person does the same job for other clients besides you. Examples of this would be a housekeeper who cleans homes for various clients, a photo assistant who works for more than one photographer, or a bookkeeper who works for more than just you. Another stronger indicator is whether the person is hired on a per job basis. You've got a big shoot coming up for MegaHuge, Inc. that's going to last two weeks. You hire the assistant for that job only. After the job is done you part ways.

While you don't have to file W-4's or take withholding for contractors, you do have to file a 1099 if they earned over $600 from you for the year.

Nepotism, the practice of hiring one's friends and relatives, can be an arrangement that works out like a dream—or like your worst nightmare. When family is involved, there's a greater likelihood that you could wind up taking advantage of them as your employees, or that they could take advantage of you as their employer. "Oh, I can get Auntie Frances to answer the phone for minimum wage, she'll just enjoy being able to get out and about, and talk to people," you think. Whereas Auntie Frances is thinking, "Oh, I can work for Stanley and he won't mind if I come in late when traffic is bad or the weather is nice or my gout is acting up."

It's also more difficult to tell friends and family when they're doing something wrong. When a plain old contractor or employee botches up an order, it's relatively easy to tell him, "You know this Parsons wedding order you sent in? You ordered 1,620 5" x 7"s instead of 57 16" x 20"s and your mistake cost us $9,400." It's harder to say that to your Mom.

That said, I have to admit that my mother worked full time for me for six years, and continues to work part time to this writing. My cousin and close friend work for me full-time, and at various times my sister has helped out on a temporary basis. If you have good communication skills, then my motto is, "A lit-

tle nepotism never hurt a nepit."

"Well, I'm not afraid of hard work," you're thinking. "I'll just save a whole wad of cash if I do everything myself. Who needs contractors, employees, or nepits?" And when your business is new, that may well be the case. But after a certain amount of growth—and that amount will vary from business to business, depending on a variety of factors—it is actually counterproductive to do everything yourself. After my business was about two years old, my accountant told me not to do anything myself that I could get someone else to do for $20 an hour or less. This is somewhat of an oversimplification, but his point is this—your time is valuable. If you own a growing business, the time you take emptying your waste basket or balancing your check register is time taken away from refining your marketing message or developing new products, or spending quality time with clients—all things that need to be done by you! You can't afford to delegate these. You need to learn to set a value and an ability level on each task and delegate the least valuable and least challenging ones. Otherwise you'll be working hard, but not working smart, and your business will suffer. Sure, it might seem like a large or an unnecessary expense to hire a cleaning service or a bookkeeper when you can do these things yourself—but like the old cliché says, your time is money. Another great cliché is "penny wise, pound foolish." So don't plan on doing everything yourself forever.

But when do you make the leap from doing it yourself or using contractors to hiring a permanent employee? Employees come with a much bigger commitment than contractors; you need to give them benefits and promise them a certain level of employment, and if you can't deliver on your promises and you need to lay them off, you have to pay them unemployment benefits.(Frequently you wind up paying them unemployment compensation even if you justifiably fire them.) You pay Worker's Compensation Insurance, Social Security, and Medicare taxes for them, and unemployment insurance. In return, they give you their talents and most importantly, their time—which is the most valuable thing any of us has.

I take my commitment to my employees very seriously. By

taking the opportunity to work for me, they are passing up opportunities to work elsewhere. There are few things harder then telling an employee that they don't have a job anymore, even when the dismissal is justified and necessary.

I went from contractors to employees when my studio met the following criteria: it had realized at least 20 percent growth every year for four years; it became more expeditious to hire people who would stay around for a while instead of having to repeatedly find and train new contractors; and the work load became too large year round for me to handle alone.

I have discovered over the years that one excellent employee can accomplish ten times more than a merely adequate one—and those excellent workers are worth keeping around.

PROTECTING YOUR NAME

If you are using your own name as your business name, you don't have to worry about trade marking it. Your name is yours to use. The down side of that is that anyone else whose name it is can use it, too. So if your name is Stanley Kowalski and your studio is called Stanley Kowalski Photography, and the guy down the street is named Stanley Kowalski, too, and he calls himself Stanley Kowalski Photography, there's nothing you can do about it. This could be especially troublesome if, say, you shoot high-end editorial fashion and he shoots cheesy boudoir shoots and ads that appear in the back of swinger magazines. You could lose clients if they confuse the two of you, and there would still be nothing you could do about it.

While you don't have to trade mark or service mark your own name, you do need to reserve your domain name as soon as possible. Since it is, after all, the World Wide Web, there's a good chance that some other Stanley has already got your name of choice. You may be forced to use Stanley J. Kowalski Photography or even Stanley James Kowalski Photo.

"Oh well," you say, "I don't think I'll ever want to have a web site, so I won't bother with domain." But you should bother; consider it insurance.

THE REASONS MOST SMALL BUSINESS START-UPS FAIL

I hate to bring up an ugly word like "failure" when you're just getting started, but the fact is that roughly 80 percent of all new business start-ups fail. I'm not trying to be pessimistic, or even cautionary, just pragmatic. I believe that if you're aware in advance of the reasons others before you have failed, you'll be able to avoid repeating them yourself.

• *A lack of knowledge.* Failure can result when the new business owner hasn't done his research. Not just research into his market as it exists in the present, but the history of the market, and the names of all the major players. Knowing where your colleagues have been will help you steer yourself where you want to go.

• *A lack of passion.* No matter that you try to have realistic expectations going into your new business venture; no matter that you've intentionally taken off those rose-colored glasses to face the glare of reality; no matter how well you try to prepare yourself, starting up your own studio is going to be harder than you think. Really. So unless you have that big fire in your belly, unless you love creating images so much that you wax rhapsodic just thinking about it, don't bother. Because you will find the sacrifices too great and the rewards too few, and you'll go sprinting back to that "real" job before you can say "Bruce Weber and Annie Leibovitz."

• *That little four letter word: fear.* Human beings are funny animals. We fear failure. We fear success. And in either case, that fear can make us abandon ship.

• *Lack of adaptability.* The market changes. Technology changes. Fashions, styles, and trends change. Your maturity level (and that of your studio) changes. The economy changes. Your financial needs change. All this requires you to adapt. Just as in Darwinian theory, it's survival of the fittest—evolve or become extinct.

• *Quitting too soon.* Giving up and giving in—it's horrible and wonderful at the same time. The faint of heart ride the cash flow roller coaster and the first time there's no money in the till, they assume the worst! "I'm not profitable, I'm operating in the red, I'm failing, I have to cut my losses!" and they jump ship.

But the fact is, Cash flow and profit are two different issues. It commonly takes new businesses about two years to become profitable. If that seems like too much uncertainty to you, stick with your day job.

• *Working hard, but not working smart.* Some of us bind anxiety by being busy. We think if we're in constant motion we're moving ahead, when in fact we're only spinning our wheels. Sometimes the best thing you can do for your business (and for yourself) is to take some time off, go sit still and clear your head, set your subconscious to percolate on your studio's biggest priorities, and get some recreation. You'll be more productive when you go back to work, you'll work smarter, and you won't be as likely to suffer from burn out or make bad decisions.

THE MYTH OF BUSINESS-CHALLENGED PHOTOGRAPHERS

All right, I'll admit that I am one of the culprits who has bought into the "I'm a photographer, not a business person" myth. I actually like to think I'm bad at business—it makes me feel more artistic. But as my less artistic, more business-oriented friends point out, I must be good at business, or I wouldn't have four studios grossing two million a year. Erica Stoller, owner and operator of ESTO Photographic, Inc., said it best: "Photographers clearly have a visual bias, but I'm often surprised at how well they deal with the written word (a skill important in every profession). And how good their instincts are for business. But there's a strange cultural divide: art vs business. In fact, business arrangements can be creative and not all that difficult." Erica posits that the trouble comes in when the photographer/business owner is wearing both hats at once because "... it is hard to concentrate on one job while thinking about the last job and worrying about the next."

I agree with Erica—the "too many hats syndrome" is an affliction I think most entrepreneurs suffer from, whether in professions commonly regarded as creative or not. But how do you ease the burden? Erica recommends having someone who makes your arrangements for you: someone who negotiates fees, sets up jobs, and who "... has the [emotional] distance to present your work with enthusiasm and some hyperbole and who, if the going gets rough, can say 'No.'"

For those working alone, Erica emphasizes that it's important to create a system or protocol that allows you to move forward without reinventing the framework for each assignment.

A RECIPE FOR SUCCESS

All right, I admit I already stated emphatically in earlier chapters that there is no recipe for success. But there are some ingredients. And since I've told you some of the ways that you can fail, Its only fair I tell you some of the qualities that can contribute to your success.

• *Adaptability.* You started out shooting family portraits in 1988. Direct color, white on white was big. It was so big you didn't take out your canvas backdrop for four years. You even named your studio Blanc de Blanc. You never thought you'd have to ever shoot anything else, ever again. You set your sights on coasting into retirement as a one trick pony. But business starts dropping off and you look around at your market to see what everybody else is up to. It appears that black and white fine art prints are having resurgence in popularity. You're adaptable, you can learn how to change with the market—and you do. Before you need to take out a loan just to keep the doors open—before you have become a dinosaur. You change your name, but not too much—Blanc Avec Negra, perhaps. You go back to school, or back to the darkroom, or back to square one—whatever it takes to learn to make top quality black and white art prints. And business picks back up again. You've adapted. And you didn't have to rise out of your own ashes.

• *Common sense.* Over the years I've learned that common sense isn't so common. If you have it, you're in the minority. If it goes without saying that you pay your bills on time, keep adequate records, answer your phone; return all your calls, provide the best product you know how at an appropriate price, and view every client as a person as well as a source of income, you can parlay this unique sensibility into a successful career.

• *Talent.* Oh, yeah, that. Talent is important. It is necessary. But having talent without good business practices is like being in a boat on the water without a paddle. You may eventually drift to dry land, but will you still be alive to appreciate it?

• *An internal compass.* Common wisdom is usually right, but sometimes it's wrong. You need to know what common wisdom holds. Check it against your internal compass, and decide whether to follow the pack or to break off and do something new. That's how markets evolve; common wisdom states that one should be a generalist. Then one day someone stands up and decides to specialize. The rest of us hold our breath, watching him and waiting for him to fail. But he doesn't fail—he laughs all the way to the bank. Then the rest of us think, heck, we'll specialize, too. And new and better ways of doing business are born. An internal compass gives you a reference point, so you can decide whether to take a risk and veer off course or stick to the path.

• *Creative problem solving.* We become photographers because we want to do something that's creative—but then we often forget to apply our creativity to our business operations. Cash flow, record keeping, client relationships, sales and marketing are all areas that seem dry and boring until we look at the problems they present in a new way and create solutions to these problems. By bringing our creativity not just to the making of our images, but to the making of our businesses, we'll not only be poised for success, but we'll enjoy every aspect of our profession.

It can be daunting. Entities, tax exempt numbers, choosing and protecting a name, leasing space is just the beginning. This is not exactly the stuff you had in mind when you were dreaming of becoming a photographer. But the very trait that makes you want to make images creativity—can be applied to your business endeavors to bring your financial goals to fruition. It seems that creativity is not, after all, a handicap for a photographer running his own business, but a necessity.

Breaking Out: Bringing New Life to an Old Business

Congratulations! Your photography business has survived the treacherous start-up stage. You've learned how to weather the cash flow roller coaster, you know how to win and keep clients, you've been profitable for several years—more so than you had dared to hope! You're out of the woods, right? Or is there a little voice in the back of your head whispering, "Famous last words"?

DROPPING THE BALL

Oh boy, you've been in business for a while and people seem to know who you are. You call prospects and say, "Hi, I'm Stanley Kowalski," and they say, "Oh, yes, Stanley, I've seen your work." You have a solid client base and it's been a long time since you've gotten that fluttering, sick feeling in the pit of your stomach when things are a little slow. Maybe your business has even shown good growth every single year since you started. Maybe you're even turning away work. You're enjoying your Halcyon days. So what do you do? You relax a little. You don't send out that spring postcard. And it doesn't matter; spring is just as busy as you expect it to be. Then you skip the newsletter and you stop sending those thank you letters to clients who send you referrals. Still no adverse effects. You don't leap at the

phone anymore when it rings, and you get a little lax in your costumer service. You stop putting new work in your book. A year of this, and still no ill-effects. Two years, and your gross isn't up anymore, but it's stable. Three years: You're not turning away jobs anymore, but you're not worried. But the four year mark comes, and suddenly you're wondering, Where did everybody go? Where are my loyal clients?

When you're not on top of your game anymore, you won't see an immediate drop in business. It's a gradual erosion that is often not apparent until it's too late. You'll be like Wiley E. Coyote when he chases the roadrunner out off the edge of a cliff but he doesn't realize he's already doomed to plummet to eart h until he looks down.

By the time you look down, you'll be scrambling to get a marketing plan back in place, freshen up your portfolio, renew acquaintance with old clients and glad hand a few new ones, and brush up those customer service skills, all just in the name of damage control.

If only you hadn't dropped the ball, you'd still be growing your business right now instead of trying to build it back up again. Avoid the mistakes complacency breeds.

- Keep marketing—even McDonalds still advertises.
- Keep your book up to date—you may hardly show it any more, but you still need it to be the best it can be.
- Answer that phone—it's still your most powerful sales and marketing tool.
- Keep up the customer relations—they're still the reason you're in business.
- Remember, you're one of the lucky ones—you're living your dream.

DISILLUSIONMENT

Another pitfall the owner of a young adult to middle-aged studio can fall into is disillusionment, and even bitterness. The honeymoon is over; you're living with the day to day reality of a photography business. The work isn't always as creative has you'd hoped it would be. You're working in the studio and in the office more than you'd anticipated. Some of your clients

have proven to be less loyal than you thought they were. The paperwork is a pain in the backside. It's sometimes hard to collect payment. You're still shooting good, solid technically excellent pictures, but some of the market has moved onto the "next new thing." The new thing isn't as good as your thing, and it'll only be a flash in the pan—you know this, you've seen it before—but it still insults your integrity. Other shooters are leap-frogging past you and snapping up some of "your" market. You aren't in touch with the beautiful parts of the business anymore. You can't remember what made you want to get into this. You are disillusioned.

Disillusionment is a very dangerous place. Attitude is everything, and if you don't change yours, your business will self-destruct.

• *Take a break*. If you're like most entrepreneurs I know, the word "vacation" isn't even in your vocabulary. Your work is your life. You find relaxing to be more tiring than working. You worry that if you leave town that one big client is going to up and leave you. Or you'll miss out on the mother of all jobs because you weren't there to answer the phone. Or some competitor is going to spring up across the street while you're gone. Probably you believe your studio will burn down if you're not there to protect it by sheer force of will. Get over it. The burn out you'll suffer from working without a break will be worse than anything that could happen to your business in your absence.

I speak from experience. I worked five to seven days a week with almost no reprieve for the first five years after I opened my studio. I loved my job. I had boundless energy. But then during Christmas season number five, I suddenly hated everybody. My clients, myself, my neighbors, the person in line ahead of me at the supermarket, the other drivers on the road, my friends and family—everbody! I hated going to work. I started to fantasize about going back to waiting tables, marrying rich, and winning the lottery. I'd had it with photography.

I really thought that my work was my problem. But a conversation with a friend who was a Pediatric ICU nurse—a woman who, needless to say, knew a lot about stress and job burn-out—told me what was really going on.

"You need a vacation," she said. "You've got job burn out. You go away, you come back, you like your work again."

I thought she was nuts. And right at that moment I didn't like her too much, either. I didn't take her advice until six months later. By then I didn't care if the studio burned down while I was away.

She was right! I went to central Mexico for two weeks to visit friends who lived there. I saw original works by Freda Kahlo and Diego Rivera; I visited pyramids and artists' colonies and ate fruit my friends called "snot grenades." It was a very exciting and intriguing trip, but in reality it probably wouldn't have mattered if I'd been holed up in a Motel 6 with nothing else to do—the point was taking a break from work. When I came back, I loved my clients, I loved myself, I loved my work—although I still didn't love the other drivers on the road. There is a reason why they call it *re* creation.

• *Volunteer.* We experience disillusionment when we reach a point in our careers when we feel our business isn't giving us enough. Ironically, one sure-fire way to overcome this feeling is by giving more to our community and our world. Volunteer to teach photography to low income kids or physically challenged people and see how fast you're reminded of the magic and the beauty of the darkroom, of the view through your lens. You needn't limit your volunteer efforts to photography-oriented work. If you need a total break from your regular grind, do something totally unrelated. Join an adult literacy program; become a Guardian Ad Litum; read to the blind. Are you missing the chaos and "action" you experienced when your business was new? Volunteer to be a reserve police officer.

• *Test shoot.* Part of your disillusionment may stem from one of the catch-22's with which the photo business is fraught; you open your studio because you want to do creative work, but as you become more successful, you do less and less of what you really love. So take some time for yourself and do some personal work. It may be hard to motivate yourself at first, since you're used to being driven by the client and by the almighty buck. Shooting something for pleasure will seem alien at first. But do it. It'll breathe life back into your drudgery.

• *Count your blessings*. Sure, it sounds trite, simplistic, and vaguely religious. But it works. Make a written list of all the things you're thankful for that your business has brought you: a good income, the freedom to be your own boss, job stability (you're not likely to lay yourself off, are you?), some creative expression, the satisfaction of knowing that people are willing to pay you for your creative vision ... I bet you can think of a few more. Save the list and consult it from time to time.

• *Explore alternatives*. Go career shopping and just see what's out there. You may find a totally different field that you'll be even happier in. Or, more likely, you'll come back to your list of blessings and be able to add a few more.

• *Vent*. Have a good, old-fashioned gripe session. I used to meet with a group of photographers for "happy hour" on Fridays after work for years. Inevitably the conversation would turn to all the aggravations we'd encountered that week at work. It always started out negative, but by the time we'd complained a little bit, we'd all wind up laughing, and jocular, and ready to face another week of business. It's not a matter of dwelling on the negative; it's a matter of letting the negative pass through you so you don't wind up carrying it around.

EXPANSION/CONTRACTION

Sooner or later your growing business will come to the point where it's almost unmanageable. You're at a crossroads. Do you take on more employees and a larger studio to accommodate additional business? You're doing well, so you can, but should you? Before you make the added commitment, ask yourself the following questions.

What Do I Want My Role to Be?

Up till now you've been a photographer—you shoot, you sell, you do the books, you empty the wastebasket, you do what you must to keep your batteries charged. But the bigger you get, the more removed you will become from these day to day, hands on realities of operation. You will become a manager. You will oversee people who will do your shooting, do your books, and empty your wastebasket. You will have to help them keep their

batteries charged. You will become one step removed from your product and your clients. If this doesn't sound good to you, then think twice before expanding.

Not sure if you view a role change from photographer to photographer/manager as a positive or a negative? Answer the following questions true or false:

1. It's easier to just do something myself than to try to explain to someone else how to do it.
2. No one else will be able to do my work as well as I do.
3. There's only one way to do things: the right way.

If you answered "true" to any of these statements, you might not be manager material. It's true that in the short term, it's easier to do things yourself than to shift down a gear and teach someone else how to do it, but ultimately it will save you time to delegate many of your responsibilities.

And while it's true that no one else will do your work exactly the same way you would do it, they may still arrive at an equally good or valid out come.

There's always more than one way to do anything. If you think there's only one way, you probably shouldn't be a manager; you should keep flying solo. Remember, even the Lone Ranger had Tonto.

Can I Make Do With Contractors?

Is it possible for me to take on temporary help to get through this busy time in the form of contractors? Or do I need permanent employees? If your surge in business is being created by just one or two huge clients, you may be wise to tough it out by hiring temporary help and renting extra temporary space as needed. I've seen many small businesses make the mistake of thinking that all they need to justify expansion is that one big dream client, because that client will be theirs forever. Nothing is forever. On the other hand, expansion may be warranted if your business has been growing steadily over time and if your client base is diverse.

Am I Making Enough Money Now?

How much money is enough money? Is there ever enough? Human nature dictates that there is not. And yet—are you happy with your lifestyle? Because expansion is a risk. You may or may not increase your income by expanding. It's no sure thing. But what is a sure thing is that you'll be increasing your fixed overhead—the kiss of death for many businesses. If you're happy with your livelihood now, you may just want to leave well enough alone, as difficult as that may be to do.

Is There Some Other Way I Can Increase My Profitability Without Taking on Additional Fixed Overhead?

If you're so busy you're turning away business (you poor thing!) maybe the answer to your problem is not to expand, but to raise your prices. That way the clients who can't or don't want to afford your services will naturally fall away and you'll be doing the same amount of work (possibly even less) and making more money. Or perhaps instead of taking on more staff or a bigger studio you could generate more business by going on location, or selling your existing images for stock, greet cards, fine art, or other applications.

WHY BIGGER ISN'T ALWAYS BETTER

The bigger they are, the harder they fall. Obviously if you have a bigger business and it's operating profitably, you'll realize more income than from a small one. But when bad times hit—and there will be bad times—the operations with larger fixed overhead will be more vulnerable to failure than the smaller ones. It's like what happens in an aquarium when there's a drop in water quality: when the water quality is good, the big fish rule. They lord it over the little fish. But big fish require more food and more oxygen than little fish do. So when the water quality drops and there's less to breathe and less to eat—well, the big fish are the first to die.

"You can be a big small business, cruise along and do fine for years," says wedding/portrait shooter Bob Dale. "But then say a large corporation comes into your market and they have a billion dollar marketing budget, they can suck up all your business

and they don't even have to be profitable to survive."

Reduced margins are the blessing of small businesses. I'm one of those who enjoy being a manager. I'm a motivator, teacher, house mother, and coach by nature. I enjoy my employees as much as my clients. So it was no hardship for me to evolve in my role as my studios grew. But I discovered a disturbing trend after several years: the bigger my business got, the smaller my profit. In my first year in business I had one studio and I only grossed $8,000, but I was almost 90 percent profitable. In my twelfth year, I had three studios and grossed two million, but my profitability dropped precipitously. It is possible to have a huge business, work really hard, and still have a smaller net than the other guy who stays small and works half as hard.

Sometimes small businesses wind up contracting rather than expanding. There's no shame in this—and it could make you more profitable. The trick here is to do it before the situation is desperate. Don't wait until you have to file chapter eleven and crawl away wounded. Make the move before your profitability drops to dangerous levels.

"At one time I had four studios," says commercial/fine art shooter Doug Beasley. "And I'm a location shooter! Imagine. Now I only shoot on location, I have no studios, and I'm much happier."

REPETITION LEARNING

When I became an employer, I had the naïve notion that I would only have to train each employee once, tell them their job description once, and send them off to work. Then they'd know what to do and they'd do it. Imagine my surprise when I realized the necessity of repeatedly training them for the same tasks and telling them what their jobs were over and over again.

Then I realized I operate the same way my employees do: I need to retrain myself, relearn lessons I already know, and tell myself my job description ad nauseum. We're all human. We need to brush up occasionally. We need continuing education.

It's easy for me to continually educate my employees, I hold meetings or in-services during the slow times of the year and cover the brass tacks, answering the phone, closing a sale, selling

up, customer service—all the basics. At the beginning, I was afraid the employees would rebel. "Why are you telling me all this stuff again?" I thought they'd do what my five-year-old does when I repeat myself. She rolls her eyes, crosses her arms, tips her head, and says, "Mommy, I already know that." But to my surprise, they seem to enjoy the meetings. I suppose the coffee and doughnuts doesn't hurt either.

It's harder to reteach yourself. Firstly, you need to realize that you've forgotten to practice some key policy, procedure, or philosophy—ideally before your business begins to suffer for it. Then you have to figure out where to go for a freshen-upper course—can you do it yourself or do you need the inspiration and motivation that a more formal setting, like a seminar, can provide?

• *Surf the net.* This is one time when surfing around on the internet isn't a waste of time. Start with an open mind and enter a few pertinent words: photography+business+marketing+sales, for instance. Then go where your search engine leads you. You'll probably find many sites that lead you to classes, seminars, clubs and groups, and books and periodicals.

• *Write out your job description.* Sounds silly, doesn't it? Why on earth would you need a job description? You're probably thinking, "I know what I do, and the only person I have to report to is myself." But do you really know what you do? And since it is yourself to whom you're reporting, how do you hold yourself to a high level of accountability?

I didn't always know exactly what it was that I did. I found out when I went to apply for disability insurance. The insurance company needed to know, not just what my title was, but what my functions were, in order to determine what it would cost to replace me.

"I'm a photographer—I take pictures," I told them.

"What else do you do?"

"Well, nothing, really."

"Who does your marketing?"

"I do."

"Who does your product development?"

"I do."

"Who does your sales?"

"I do." And so on. You get the picture. It suddenly occurred to me that I was doing more than I thought I was. I rushed back to my office and wrote myself my own job description. By writing down and categorizing what I did, I was able to figure out what things I could or should be doing more, and what things I needed to start doing that I wasn't currently doing at all.

So take a minute to sit down and list all the functions you perform in your business. Then decide what areas you may be lagging in, and punch 'em hard. I look at my old job description and create a new one once a year.

• *Take a seminar.* Chances are if you've been in business for a number of years, you're not going to learn much that you don't already know by attending a seminar—possibly a few tidbits or possibly nothing. But what a seminar will do for you is reinforce those things you already know, and remind you to practice them. I regularly attend marketing seminars for instance. I have attended John Hartman's Marketing Boot Camp twice. I usually don't leave these meetings saying to myself, "Oh boy, that's news to me!" But I do say to myself, "Oh, yeah! I forgot all about doing that. I should start doing that again." And I do.

• *Revisit your past work.* Sometimes you can be your own best mentor. Dig out your old promotional material, your old schedule books, your old lighting notes—anything that documents how you've done things over the years. You may be surprised to find that some of the things you used to do were pretty darn good. Maybe even better than the things you're doing now. Reincorporate them into your repertoire.

• *Teach someone else.* Nothing reinforces what you already know better than teaching someone else. I always wind up energized, recharged, and on my game after teaching classes on business and creative techniques. I learn—and relearn—as much or more than I impart to my students. If you're not into standing in front of a class full of people, you can take it one student at a time by becoming a mentor, or taking on an apprentice or an intern.

• *Join business and professional groups.* Becoming involved in business networking and professional groups, you'll find

opportunities to both speak and be spoken to on a variety of germane topics, and you may expand your client base in the bargain. I've given talks to groups that focus on women in business, church groups, the Junior League, the Minneapolis Women's Club, Kiwanis Club, small business owners and many others.

• *Read (or reread) a book or periodical.* Pick a book or magazine. It could be on sales, marketing, public speaking, motivation, management, general business practices, relationships—anything that you can apply to your business. You can skim, speed read, open up the book and start reading on the page that falls open, or do the whole in-depth, cover to cover thing. All that matters is that you tickle those little memory cells enough to refresh your perspective on your day-to-day business.

TRACKING PERSONAL ECONOMY, INDUSTRY ECONOMY, AND NATIONAL ECONOMY

In order to really see how your business is doing, you need to separate out the layers of different economic states that are effecting its development. In this way you'll be able to get a clearer picture of where you've been, where you are now, and where you're likely to go. Let's say you've been in business five years now. Make yourself a graph. From left to right, start with the year you opened your doors and progress to the present year. From bottom to top, indicate units of measure. Now use a red line to chart your personal economic progression. Use a different color line to indicate what the national economy was doing that year. You can use different factors in determining this: consumer index, unemployment rate, the stock market, etc. Or you can factor them all together and creative your own subjective impression of the economy over your years in business. Use a third color to create a line indicating your local industry economy. Did your market loose any major clients in a given year? Did any agencies start shooting out of town? When you've finished all three lines, take a good look at them and see how you did. Did your personal economy grow even in years when the national economy was flagging? Did your personal economy flag when your local market was growing? Spot the trends. Adapt accordingly.

PROS AND CONS OF MIDDLE AGE

Just as with anything in life, there's always a trade-off. You give up one thing to get another. The thrill and anxiety of youth gives way to the confidence and boredom of middle age.

• *Topping out*. Eventually your business growth will level out. It will have reached maturity, much like a child who enters her young adult years and stops getting taller. I didn't believe this until it happened to me. I had at least 20 percent growth every year for twelve years. No matter what the economy did, no matter what my competition did, no matter what my local market did. I thought that "topping out" was just a nasty little rumor—an urban myth. (But then, I also believed I was never going to die, either.) Then, in year thirteen, the growth started slowing down. In year fourteen, it stopped altogether. My business had reached maturity. This is good, because I'm stable, I'm secure, I can anticipate what my income will be from month to month and year to year. But it's also bad, because the excitement of watching the growth is over. Gone are the days of looking at quarterly comparisons and saying, "Oh my gosh, look how much we're up over last year!" Ironically, this mature, stable stage was what I eagerly looked forward to when I was a start-up. Now I look back fondly at the start-up stage. There's just no pleasing some people.

• *Fear and the lack of it*. When you're new in business, everything is scary. There are monsters under your bed. Are you good enough? Is someone else better? Will there be images on the film when it comes back from the lab? How do I file those government forms again? What if the client doesn't like my work? What if the client doesn't pay? What if I can't take the pressure and I wind up in at a nature retreat weaving baskets with my toes? What if I fail and I have to go back to my day job? What if I fail and I can't get another day job? What if I lose my life savings?

The fear is with you all the time. You have to face it down every morning when you get out of bed. You wear it all day and you go to sleep with it at night. And that's the good news!

The fear certainly is a powerful motivator. It's hard to live with but it makes it easy to keep on keeping on. Sometimes I think

fear is just another word for enthusiasm. When you've been in business long enough to be really confident in your abilities you need to replace the fear with satisfaction as a motivating factor.

"I was outside a church prior to a wedding, and I watched the photographers shoot it," says sixteen-year wedding photography veteran Hilary Bullock. "There were two young girls, all dressed very "hip" edgy, and they all descended in a frenzy on one big floral arrangement and shot it just crazily, from every possible angle. I would have taken just one shot, because I'd know the shot I got would be 'the one.' Enthusiasm or experience, either one will get the job done. But boy, they sure look different from the outside."

DEALING WITH LOOK ALIKES

If you stay in business long enough, eventually someone is going to imitate one of your innovations—whether it be your visual style, how you sell, your fee structure, or how you position yourself in the market. Take heart! When this happens to you, you'll know you've arrived. It means someone is impressed enough with your work to want to go out and do it themselves. Imitation being the sincerest form a flattery, and all that. But it can be aggravating, too. Especially if someone swipes your idea, and a little piece of your market goes with it. What can you do to stay ahead of the folks who want to jump on your bandwagon?

• *Raise the bar*. Refine your art and hone your market to pull yourself head and shoulders above the crowd. Make yourself the best darned photographer in your market.

• *Keep innovating*. By the time you've been doing something long enough for a competitor to take notice and knock off your concept, it's probably time to do something else, anyway. That way, when you see someone imitating your old visual style, or your old marketing methods, you can honestly say, "Oh, that. I was doing that three years ago."

• *Stay the course*. Almost always, the original of anything is the best. Those who come after can try to recreate your work—and your success—but it will often result in a pale imitation.

• *Put it in perspective*. As we've often heard it said, "There's nothing new under the sun." Ideas and inspiration go around

and come around. I once thought I was doing something really original and unique by grouping portraits into diptychs, triptychs, and other arrangements and framing them together. One day I went to a friend's home and saw a similar grouping hanging on her wall. "Aha! Someone is copying me!" I thought. But upon closer examination I realized those portraits were shot well before I was born. It would have been tricky for this photographer to have copied my idea. As it turned out, this was a popular look from the '30s into the '60s. Oh well. At least I was in good company.

FINDING SATISFACTION AND EXCITEMENT OUTSIDE OF WORK

In the early years of my business, my work was my life and my studios were my babies. It was easy to throw myself into every aspect of photography, because I was hungry, I was passionate, I was energetic—and I was scared. I never really believed I had any images on my film until I got the take back from the lab—and then I breathed a huge sigh of relief. At the time I didn't realize it, but I was having the most fun of my life. I never appreciated that early stage when I was in it; all I wanted was to be around long enough to stop being scared, stop feeling like an impostor, stop scrambling, and basically be able to say, "Hah! I've arrived. I'm the old kid on the block." I was like a little kid wanting to grow up too fast.

And let's face it: you can't go home again. You simply can't recreate the excitement and the rewards you derived from your business when you were an up-start and it was a start-up. But you still crave that excitement—I'll even venture to say you need it. So you need to get it elsewhere—outside of the studio, outside of the office, and even outside of the field of photography. It's imperative that you fight boredom at all costs. A bored photographer is a bad photographer; a bored entrepreneur is a bad entrepreneur.

This is a great time to develop a Plan B—a side business or investment that can help build your nest egg, or float you through the tough economic times. If you already have a Plan B, now is the time to take it out of the closet, shake it off, and fluff it up.

Wedding/portrait photographer Bob Dale knew he wanted to be a photographer since he was in the eighth grade, but he's never limited his entrepreneurial focus to the photography business.

"All along I've been into other things," he says, "like the stock market and real estate. I'm probably not going to have a salable commodity when I retire. I hope to, but I can't count on it. And I'm not counting on Social Security for a comfortable lifestyle. So I've always looked at my studio as a way to generate cash to make investments."

Or perhaps this is the time for you to finally write that novel that's been simmering on your back burner.

"Typically, people who are good in one creative field are also good in others," says Lee Stanford. "A lot of photographers are also good writers, artists, musicians, you name it." So one way to stay fresh is to pursue some other creative avenue.

END GAMES

Typically, middle age is when you start to think seriously about your retirement. Many entrepreneurs in other fields open their businesses with the intent of one day selling them. In fact that's often when they make the big bucks—not when they're actually growing the business. But if you're a photographer, what exactly will you have to sell?

You have a client list. You have goodwill (as it's called by those in the legal profession). You either own a building or you hold a lease on a commercial space. You have equipment, props, backdrops, etc. You have an image (also referred to as "corporate identity"), a proven system of operation, a product, and you have your expertise. You also have some big problems.

- How do you arrive at a price for your business?
- "Who can afford to buy your business?" posits Bob Dale. "Who has $50, 60, 100K or more lying around?"
- How can you convince your potential buyers that your client base will stick around even after you're gone?

There are many different formulas for figuring the value of a business. My personal favorite is to figure out your average net for the last four years, and multiply that by three to five.

Your accountant, lawyer, or a business broker can give you

an opinion on how to value your business; just be forewarned that a business appraisal can cost up to several thousand dollars.

Finding a buyer can be another sticky wicket. CPA Jim Orenstein has some suggestions on how a photographer might target a qualified buyer and make the transition between owners successful and beneficial for everyone involved.

He recommends dealing with someone you know—it could be a person who's already employed by you, or even one of your clients who may have expressed an interest in learning to do what you do. Chances are you'll need to finance them partially—but don't loan them the entire purchase price. If they have some capital invested up front they'll work harder to make a go of it.

Jim's method of passing on the business takes roughly two years from start to finish. The original owner/photographer brings in the new owner as a sort of partner, maintaining a presence while teaching the newbie the trade and helping him build credibility in the minds of his clients. The new owner earns a livable salary while paying the balance of the profit to the original owner toward the purchase price of the studio. Of course, until it is paid off, the loan from the original owner to the new owner is accruing interest. Commercial/fine art photographer Leo Kim calls this the "Someday This Will All Be Yours" approach to selling your business. He has very gradually begun to do this with a protégé who is not yet a photographer, but who has business experience and has shown a talent for visual art. "He really wants to be a photographer," says Kim, "and he already has the business experience. In six or seven years, when I turn it all over to him, I think he will do very well."

Just as the start-up has its hazards, so does the middle age of a small business. But if you apply the same energy and ingenuity to your studio when it's in its prime that you did when it was new, you might just find that this stage has its rewards, too.

Breaking Away: Exploring New Niches

There are a number of reasons why photographers leave one area of specialty for another, or add a new specialty to their existing one. The realities of their market may have caused them to steer their careers away from the type of images they feel passionate about, and so they come back to their desired subjects and styles later in their lives. They may love the subject matter/images they get to create, but dislike the particular industry or marketplace in which they are forced to compete. Their market, interests, or the economy might change and force them into new areas. They may lose the physical stamina required for location work, and turn to studio photography. They may need a new creative outlet and new challenges.

AND NOW FOR SOMETHING COMPLETELY DIFFERENT— OR SOMEWHAT SIMILAR

Entering a new niche doesn't have to mean switching from underwater fish photography to weddings, or from architecture to headshots. Often the change is much less extreme. A wedding photographer, finding his market suddenly crowded with upstarts willing to give away copyrights, might make a shift into lifestyle shooting—an area that requires a similar style and the same equipment, but sells to a different market with a different

fee structure. For a period of about five years I added child commercial shooting on top of my child portrait work—same subject, but different market, fee structure, and style. An architectural photographer may keep shooting editorial work for design magazines, but also market to commercial, architectural suppliers—same work, different market. Often finding a new niche simply involves some tweaking, not wholesale changes.

WHEN TO MAKE THE MOVE

It doesn't matter whether you're in the beginning, middle, or later stages of your career—if your existing market falters, if a golden opportunity presents itself, or if your heart wanders in a new direction—you should follow your gut. Of course, changing or adding new niches will create different pros and cons depending on what career stage you're in—a change at the beginning of your career, while it may prove necessary, will probably be extra difficult, given that you'll still be in the learning stages regarding both your art and your business. But on the pro side, you're young, you're supple, you're energetic, and you're willing to do anything to succeed. You don't yet have a huge ego involvement or emotional tie to your original area of specialty, so you're freer to try new markets.

Making the change in your business's mid-life can come with a bigger emotional price tag—you're committed to your specialty and your business is probably still appreciating significant growth, even if your market or the economy is failing. So making a change at this stage of life is cause to pause—is this really necessary? You'll have your doubts. On the other hand, you're well into your career, and while the learning never really stops, you've got enough experience and enough resources behind you to make this kind of a transition easier.

Changing niches late in life can be a godsend or heartbreak, depending on the motivation for the change. If you're making the change to pursue your dreams and make the images you've always imagined you'd one day make, then it will be easy. But if you're a well-established shooter with a glorious career whose market suddenly dries up and forces you to start over in some new niche, well, that's the heartbreak. You're used to being a big

dog; now you're practically starting over with the little dogs again. But there's a hidden "plus" here: once you get over the angst, you might actually like starting over. Some of that good wholesome fear, that thrill of the unknown that you had at the very beginning, might come back. It could provide a new lease on your creative life.

A NATURAL TRANSITION: NATURE PHOTOGRAPHER CRAIG BLACKLOCK

Craig Blacklock's late father and partner, Les, was one of the pioneers in the field of nature photography. When Craig joined his father in 1974, they were like kids in a candy store—shooting anything and anyplace they desired. There was always someone out there willing to pay top dollar for their images. While they didn't take assignments, they did keep their audience always in mind. "To be an artist is not just making yourself happy, it also means communicating with your public through your images."

Blacklock creates two different kinds of images for two different kinds of art appreciators: "I have my more abstract work, which people buy for its artistic merit, and as an investment. And I have my more literal work, which appeals to people who appreciate it for its regional value—they spent part of their summer on Lake Superior and they want to extend their vacation."

As the nature field became crowded and its practitioners increasingly disregarded standard industry billing and copyright protocol, it became very difficult to earn a living. Blacklock loved and cared deeply about his subject matter, so he wasn't about to give up nature photography. But he responded to the grim realities of the industry by creating new markets for his work.

"I opened two art galleries: Waters of Superior, and Blacklock Gallery," says Blacklock. Thus he created his own retail market for his fine art photos. And as the calendar market faltered, with fees for images dropping up to 65 percent, Blacklock began to publish his own calendars and books. "I still sell images for editorial use, and to designers and corporate art consultants—the people who do interior design for places like hospitals and banks.

And I'm with Larry Ulrich Stock Photography. But to continue to thrive in this field, I've had to add to the ways I sell my images."

By applying his creativity to his business as well as his art, Blacklock has managed to thrive and to maintain his integrity in an increasingly difficult market.

SAME BAT TIME, DIFFERENT BAT CHANNEL: KIDCAPERS AND TINY ACORN STUDIOS

I opened up my first studio, KidCapers (then called KidShooters) in 1988. My portrait prices were by necessity higher than those of studios that specialized in direct color or even standard black and white work because of the labor intensity of creating hand-processed, hand-painted fine art prints. My average client spent over $2,000 at that time on a photo session, portraits, and frames, and I developed a reputation for being expensive.

The reality, though, was that I offered my hand-painted portraits at a price substantially lower—per portrait—than my closest competitors. The myth that my studio was expensive arose from that high average purchase; it wasn't that my portraits were more expensive, it was that my clients made bigger purchases. For clients who both desired and could afford the best, this was no problem. But my friend and at that time, employee, Pat Lelich, noticed that quite often we were loosing clients because of this perceived expensiveness. Since it wasn't possible to offer our current product at a lower price and remain profitable, we became partners in Tiny Acorn Portraits, Inc., and opened up our first retail studio in 1994. Tiny Acorn Portraits were still custom hand-printed and hand-colored, but we eliminated much of the labor by simplifying the product. The prints were not sepia-toned and were not otherwise stabilized, so were not strictly archival. The coloring was done with transparent watercolor pencils rather than artist's oils (oils are more difficult to manipulate and take much longer to dry), and we started out offering pre-made frames rather than the extensive custom design and framing services we offered at KidCapers.

The result was a product that we could sell for nearly 50 percent less than the product at our original point of destination studio.

At first there were a lot of doomsayers. "You're competing against yourself," "Everyone will go to the cheaper, more visible and convenient retail studio and no one will come to KidCapers anymore," and "Are you crazy?" were some common comments.

I didn't feel I was competing against myself at all, though the portraits offered at both studios were hand-painted, the similarities stopped there. Each business had a different cache, a different price point, and therefore a different client base. (Although it's true, there was some overlap.) Only time would tell. At the end of the first year, the Tiny Acorn Studio had paid back it's initial start-up costs and was even nominally profitable—a really successful start, in my book. And during that year KidCapers enjoyed the same growth rate of 20 percent that it had for the previous four years. So the doomsayers were probably wrong. Tiny Acorn Portraits were a legitimate new niche. Sure, it looked similar, but ultimately it proved to be different.

A MARRIAGE OF CONVENIENCE: ARCHITECTURAL INTERIOR PHOTOGRAPHER KAREN MELVIN

When Karen Melvin started her career in architectural photography, she marketed herself primarily to local architecture firms and magazines. She also marketed to local hospitals, banks, and any institution that might need architectural images, but primarily her focus was on generating editorial work. While the editorial field in general offers better than average creative freedom and prestige, typically editorial rates are far lower than commercial rates.

So eventually Karen started to market her work nationally to product manufacturers such as window and tile companies who supply architects and builders. The results thrilled her.

"This niche pays more, and there's a bigger client base to draw from. There's more production value, more leg-work—and I love that part!"

Karen still shoots editorial work that winds up in such acclaimed publications as *Architectural Record*. She has successfully wedded her editorial and commercial specialties. But more and more, her work is in advertising.

Any regrets?

"Only that I didn't plumb this niche earlier," Melvin says.

NAKED AMBITION: COMMERCIAL PORTRAIT/FINE ART PHOTOGRAPHER ROY BLAKEY

After teaching himself photography in the army (he bought his first camera in the PX in Germany) and traveling the world as a professional ice skater in the touring show "Holiday on Ice," Roy Blakey came to live in New York in 1967. He began his photography career there shooting headshots for actors, dancers, and models. "It was wonderful. I was the very person for it because I cared so much about these people and about making them look their most beautiful." Blakey shot his share of celebrities, including Chita Rivera, Tommy Tune, Felicia Rashad, and Debbie Allen. Eventually his work wound its way into such magazines as *Time* and *Gentleman's Quarterly*. He loved his work, and yet there was a new fine art niche he wanted to try: the male nude. "There was no market for it, obviously. When I had a body of work I started calling editors to see about getting it published. They told me I was crazy," recalls Blakey. So he self-published *70s Nudes* in 1972. He pre-sold all 5,000-plus copies he had printed. Exactly thirty years later—to the day—the book was reissued, to critical acclaim. Referring to the fact that his models were dancers and models at the peak of physical condition, Blakey says, "We used to joke that the book should be called, *Blakey's Bird's Eye Boys—Frozen at the Peak of Perfection*!

Blakey's foray into this niche was made early in his career. After his initial print run sold out, his nudes were stored, forgotten in boxes until another fine art photographer found them and encourage Blakey to find a publisher to reissue them. While the huge majority of Blakey's career was—and still is—spent making commercial headshots, his brief detour into the world of the fine art male nude gave him a new creative outlet and a place in the history of fine art photography.

STAFF EMPLOYED TO SELF-EMPLOYED: PHOTOJOURNALIST/COMMERCIAL PHOTOGRAPHER ROB LEVINE

Rob Levine began his career in 1983 as a photojournalist, working on staff for the Minneapolis *StarTribune*. Now he is self-employed, sharing a warehouse studio with another photographer and shooting publicity and commercial images. He also hosts web sites for photographers where they can display and sell their images, including stock, and he sells studio management software through GripSoftware.com. While it was Levine's dream to be a photojournalist, the realities of working in the industry left him cold. "I just didn't feel they were treating me very well," he says. When asked why he didn't try to work for a different newspaper to see if working conditions were better elsewhere, he says, "Because the *StarTribune* was one of the best in that regard."

Far from the gritty, grainy, black and white images of his earlier specialty, Levine now shoots incredibly colorful, high resolution publicity stills for the Minneapolis Children's Theater. He gives this client maximum bang for its buck by hosting their Web site. The site contains literally hundreds of media contacts. People can sign in to browse or use the images, and when there are new pictures, we send out an e-mail to the whole list. It's a very efficient and cost effective way of publicizing the theater."

While Levine is passionate about his career as is today, he says his heart is still in photojournalism. "It's all about going out alone, and I love going out alone," Levine says. "But I'm very happy with my career now. I have no regrets."

IN COLD BLOOD: A WEDDING/PORTRAIT PHOTOGRAPHER RANDY LYNCH GOES FORENSIC

When Randy built his home in 1990 he built in a home studio. His intention was to shoot portraits there—and for a while, he did. He also took a job as a forensic photographer with a county sheriff's department. The home studio became a playroom for his kids, never to be used again.

Randy is one of those rarities in the photography profession: a genuine, extroverted, "people" person. You can see how he'd

be successful at portraiture and every aspect of that business. But when he talks about his experiences as a forensic photographer, he gets fire in his eyes. Words like "nanometer," "omni chrome," and "luminal" sprinkle his speech, and he's too engrossed with his topic to notice that those who are listening (i.e., me) might get lost in his dust.

I asked him if it didn't get boring, taking hundreds of pictures of one pair of jeans, each with a different filter, trying to illuminate blood or semen stains.

"It's never boring," he states emphatically. "When you find blood or semen, you've helped to stop a murderer or a rapist. How can that be boring?" Randy worked for the sheriff's department for ten years, and ultimately left because of political and personality issues within the department. "If it weren't for those issues, I'd still be working there today. I loved it."

But just as his dissatisfaction with his forensic job was coming to a boil, he was offered an opportunity to buy into a photo lab in the busy Minneapolis skyway system.

"It was perfect," he says, "because there's one big crunch time when everybody drops off or picks up their film in the skyway, and that's lunch time, so that's when I'm at the lab. The rest of the time I spend visiting commercial clients and taking care of business."

Randy now owns two labs, and he's poised to purchase a third. He has plans of opening up a portrait studio at another skyway location. That's enough to keep most people busy, but in addition to all this, Randy also has established himself in a third photographic niche—he shoots weddings.

"Nobody ever asks me for the negs," he says, "because I'm their lab! A lot of my wedding clients are my regular lab clients, so I've printed their work for them for years, and they'd just bring their wedding shots to me to print, anyway."

These are some great success stories. But trying a new niche is no guarantee of a happy ending. I once tried to offer a less expensive, direct color product at KidCapers Studio. Not only did no one buy it—not one family—but the very existence of this new product confused some of our clients and spurred rumors that the studio had gone out of business.

And you'd think that going from a huge, glamorous market like New York to a medium-sized market would be a breeze—that your little niche would be right there waiting for you. But when Roy Blakey brought his headshot business from New York to the Midwest, "It took forever for people to catch on to me. They all knew Ann Marsden (the reigning headshot queen of the time) and no one knew me. But I stuck to it, and now it's back to business."

GUARANTEE? WHAT GUARANTEE?

While adding or changing to a new niche is no guarantee of a heftier income, there are precautions that you can take that will increase your chances of success:

• *Keep your finger in the pie*. This is the photographer's mid-career equivalent of the warning, "Keep your day job!" Don't drop your original specialty until your new one has proven lucrative enough to warrant it.

• *Don't rob Peter to pay Paul* Do not, I repeat, do not enter into a new niche if doing so requires that you take needed resources away from your original one. If becoming a dirt bike racing photographer requires you to buy equipment with money that you would have otherwise used to send out your spring portrait mailing, don't do it. Or if going out and becoming a field photographer leaves no one at your studio to answer the phone, forget it. The risk won't be worth it.

• *Categorize your new niche*. Is it a simply a new product you can offer at you old studio, or a whole new business that requires a new venue and identity? Is it an entirely new specialty area, or just a different market for your current work? Is it a different product for your existing client base, or a similar product for an altogether different client base? Once the answers to these questions have solidified in your mind, you'll be better able to create a business plan—just as if you were starting out from scratch, as outlined in chapter five.

• *Question the mass migration*. When your market becomes saturated and other photographers head for greener pastures, you might want to stay put and bide your time. You may find yourself (happily) alone in a suddenly less crowded specialty.

You can see the logic in the progression of the niche-jumping photographers whose stories I've shared with you in this chapter. That's because their stories have already happened and we know how they come out—that's called 20/20 hindsight. If you're contemplating a similar leap, you don't have a luxury of knowing whether you'll have a happy ending. But then again, neither did they.

Calculator Magic: Pricing Your Work

Within the different specialty areas of photography, there are very different fee structures and methods for pricing your work, but photographers in every discipline share one characteristic: We have all, at one time or another in our careers, charged too little for our work, or we've given up usage rights and copyrights for little or no compensation.

To be fair, it's not just photographers who have trouble exacting their fees. I think its common among entrepreneurs and self-employed people all across the board. I have a psychologist friend who jokes that she's going to teach a seminar for other psychologists that will consist of nothing but three days of repeating the same phrase over and over ... "That'll be $150, please."

Fine art/commercial photographer Doug Beasley says, "It's somewhat arbitrary. I make up a number. Sometimes I check it against the ASMP (American Society for Media Photographers) guides and it's usually pretty close to what their standard is. I simplify the process—figuring out usage can be so complicated. I give away more rights than I should, but I'd rather live that way than live in fear of being ripped-off."

Fashion/commercial shooter Lee Stanford credits part of the success and growth of his business to his ability to become more

savvy about charging for usage and setting his prices. "I used to give away too much. Now I go by the industry standard, and no one flinches. I think clients expect to pay for good work, and they don't appreciate you any more if you give it away than if you charge a fair price."

Though usage fees don't often come into play in my portrait business, I have "grey" areas when a portrait client wanted to use a portrait for a business application, or a business owner wanted to sneak in a few portraits of their kids during a commercial shoot. Early in my career, I just swallowed my tongue—and the monetary losses, and allowed my clients any little extra favor, even if it violated my copyright. But now I, too, go by the book.

HOW TO SET YOUR FEE STRUCTURE

Fee structure is an entirely different animal than pricing. Fee structure refers to what the client pays for and when he pays it. For instance, this is the fee structure for one of my studios: The sitting fee is required at the time of the booking; the cost of the sitting is determined by the number of subjects; the sitting fee covers expenses (the client doesn't pay extra for film, processing, proofs, or anything else); the portraits are payable 50 percent upon placement of the initial order and 50 percent upon delivery.

That's my fee structure. Notice there aren't any dollar amounts in there—that would be my price structure.

Fee structures vary markedly from one area of specialty to the next. My fee structure is fairly standard for portrait studios. But a standard commercial shooter's fee structure would go something like this: A commercial photographer charges a standard day rate. The client pays the photographer's fee by the eight hour day—usually there is a ½ day minimum; the day rate will fluctuate based on the usage of the photos (higher exposure usage results in higher shooting fees); the client pays for materials and expenses, usually with a 15 percent mark up.

You can see that a commercial photographer's fee structure is decidedly different from a portrait photographer's. Each different area of specialty will have its own little quirks in its way of billing for services.

You need to find out what the standard is for your specialty in your geographic location, and use it with integrity.

PRICE STRUCTURE

Your price structure refers to what you charge for your products and services. Here's the price structure for one of my studios: The basic sitting fee starts at $125; a black and white 5" x 7" portrait costs $89; a hand-painted 20" x 24" costs $850, and so forth. A commercial shooter's price structure might look something like this: A basic day rate is $2,500 for limited usage; higher exposure usage doubles the dayrate to $5,000; travel time is billed at 50 percent of the day rate.

How do you know how to price your work when you're just starting out? First, you want to find out what your industry and market standards are. That is, what are other photographers charging who work in your city, in your area of specialty?

PROFESSIONAL ORGANIZATIONS

One way to get up to speed fast is to join a professional organization, like the one Doug mentioned earlier—ASMP. Not only do members receive a wealth of information on all aspects of the business including how to figure usage charges, but they also hold monthly meetings on issues like this very topic. If you attend these meetings, you can network with the people "in the trenches," and find out what they're charging, and get a feel for the pulse of your market.

If you're a portrait photographer, you might consider joining the: Professional Photographers of America (PPA). They have a beautiful monthly magazine that has articles covering all aspects of the portrait photography business, including creative, technical, and business.

APPRENTICESHIPS, INTERNSHIPS, AND ASSISTANT WORK

Of course, one of your goals, if you do an apprenticeship or work as an assistant, is to learn this aspect of the business. Remember the advice of our seasoned photographers: don't just learn how to set up lights when you assist—learn it all. When you work with an established photographer you can watch them

in action. You actually get to see the process of how they value their work, when they flex on a fee, and when their fee is non-negotiable.

INFORMATIONAL INTERVIEWS

Informational interviews can be instructive. You can also simply call up a few shooters and/or their reps and inquire as to their basic day rate. Some may give you this information up front. Others may hesitate to make a blanket statement as to their fee, preferring to make bids on a job-by-job basis.

HOP IN THE CAR OR PICK UP THE PHONE

If your area of specialty is portrait or wedding photography, you can often pick up price lists and information by stopping by the studio in question, or requesting it over the phone.

Whatever you do, level with the businesses you approach and be honest. I sometimes have people call my studios who are learning the market with the intention of starting up their own shop. They are often afraid to tell us that they are our would-be competitors, so they pretend they're potential clients.

Generally, we can spot them right away, and this approach makes my co-workers and me feel extremely disrespected. We are more than happy to send out information to anyone—there's no need to invent stories. Our pricing is public record, it's no secret.

Speaking of secrests, some shooters, even seasoned, established professionals, "secret shop" the competition from time to time. This is an especially common practice for big, national chains—I guess they like to see what we little guys are up to.

I have personally been shopped by three local shooters and one national studio—Life Touch, Inc. (They revealed their shopping trip to me and shared their impressions with me.)

I have never employed this practice, although I have been tempted. It is intriguing to find out how other people work.

Once you've discovered what the range is for prices in your market, you need to decide where within that range you want to position yourself.

BARGAIN BASEMENT, CARRIAGE TRADE, AND EVERYTHING IN BETWEEN

Let's say you're an architectural photographer in Minneapolis. There are established shooters—people whose names you see on photo credits in local magazines—whose day rates range from $1200 to $2000 for editorial work, with the average rate falling somewhere around $1600.

"I'm new," you think, "I'm just breaking in, so I should come in under the market, let's say at $1000 or $1100 per day, just until I get established." But that could be a bad idea.

PERCEIVED VALUE

If your billing rate is below market, potential clients will think your work is below market quality. This is because your prices tell the client how to perceive the value of your work.

It's different when you're selling a television, for instance. The television has an established value; it sells for $500 at a big electronics store. If the television goes on sale for $425, the consumer will be ecstatic! He'll know he's getting a great deal because he is getting a television that's worth $500 for $75 less.

Your work has no established value, other than what you charge for it. Your clients have no other way to appraise it, unlike the television.

"The client is probably not looking for the cheapest deal," says Pam Schmidt, a former photographer's rep turned art buyer. "Usually they want someone whose estimate falls somewhere in the middle. Low ball bids give the impression the work will be poor quality, and high-end bidders just aren't for everyone. There are clients who are simply price shopping—they're not concerned about quality, they just want a deal. But in my experience, you really don't want to be working with those guys. They want more for their dime than a regular client wants for their dollar, and they're really aggravating."

So where should a newbie position herself on the pricing ladder?

"Somewhere on the lower end of the middle—using your example range, I'd say just under the $1600 mark. Don't go for the low end, or not only will your perceived value be less, but

you'll be competing with a huge pool of shooters. And don't go for the high end, because you can't justify that—at least, not yet—and you'll take yourself out of the running for a lot of jobs, says Pam.

It's different for retail studios, because their location gives them a certain perceived value, a cache. For instance, my Tiny Acorn Studios offer a hand-colored 8" x 10" portrait starting at $79—much below what you'd expect to pay. But because the studios are located in high-end, boutique style shopping areas, the product doesn't strike our clients as cheap—it strikes them as a boutique product at a shopping mall price.

Perceived value as it affects your market position is an important factor to consider when pricing your work, but there are many other concerns to add to your equation, too.

COGS, FIXED OVERHEAD, AND YOUR TIME

Your COGS (cost of goods), fixed overhead, and your own time need to inform your pricing decisions. You have to charge what you need to stay in business (fixed overhead), cover the cost of goods/materials (COGS), and pay yourself, or else you won't be in business for long.

"When I first started shooting weddings, I thought I was really going to rake it in just by charging my clients $20 per hour and a 100 percent mark-up on my prints," says Stacey King. "I thought I was going to make an outrageous fortune. I felt so magnanimous I was throwing in extra rolls for free—after all, heck, film is cheap, right? But when I revisited my first three jobs, I realized that not only wasn't I making any money, I was losing it! I had forgotten to figure in things like gas and mileage, recovering my initial investment in equipment, the costs I had to eat when brides ordered shots they didn't pay for, my dedicated business phone line, office supplies ... you name it. It all seemed so insignificant at the time, but oh, baby, does it add up!"

PRICE POINT APPEAL

There's a whole psychology to pricing that could be the topic of several books all by itself. For some reason, $19.99 sounds cheaper than an even twenty. And 10 percent off gets just as

many people just as excited as 15 percent off—but up the ante to 20 percent and watch them come out in droves. Two sweaters for the price of one doesn't bring out as many shoppers as "Buy one, buy the second one for a nickel." I don't pretend to understand it. Sometimes the human animal is just a mystery.

I never worried about price point appeal when I opened up KidCapers Portraits. I was running on caffeine and blissful ignorance. But six years later, when I opened up my first Tiny Acorn Studio, I had a specific price point in mind that I thought would be especially attractive to my client base: I wanted to offer a hand-colored 8" x 10" for $49. That sounded like such a deal! A hand painted portrait for under $50? Amazing! So I went at the whole pricing process backwards—instead of figuring out my COGS, fixed overhead, and time and basing my prices on that, I noodled my expenses around to fit.

OH, THE DRAMA OF IT

Given that money is a very sensitive, emotional issue for many of us—photographers as well as clients—how can we make these transactions easier on everybody?

• *Give all the bad news up front.* Hiding or downplaying costs may get you a client, but it will never keep one. It'll be easier to collect your fees and you'll stay on good terms when the job is done if you give your client all the bad news up front. Reveal all fees that the client might incur in the process of his shoot. For instance, at all my studios there is an extra charge for the painting of additional figures in a portrait. Each subject after the first costs an additional amount. So, if the basic cost of an 8" x 10" is $50, and each additional subject is a $15 painting fee, then an 8" x 10" with three kids in it would cost $80: $50+$15+$15. We tell our clients about the additional painting charge before they even book their photo session. It's also stated boldly on our price lists and in our promotional material. This way the client never gets any rude surprises—and neither do we.

• *Know the difference between bids and estimates.* In various photographic specialties, such as commercial or architectural, when the photographer is in essence acting as a contractor for the client, he will be required to give either a "bid" or an "esti-

mate" to tell the client how much he will charge for the job. A bid is generally accepted to be written in granite. Here's a sample bid situation: *Winsome Woman Magazine* needs six outline shots for their May issue. Stanley Kowalski figures out what he thinks his time and expenses will be to do the job (if he's smart he adds 10 percent on top of that, because after all, surprises happens), and he agrees to shoot the job for that amount. That's it—if it rains and he gets stuck on location with a trailer full of rental equipment and damp talent, tough cookies. He eats the extra costs—he may even wind up taking a loss on the job. But if he gets lucky and gets the job done in half the time and half the film costs, he still gets paid the amount of his original bid.

An estimate is a little different. Stanley figures it will take him two full days to shoot at $1600 a day. Film will run $45 per roll for proofs and processing (he's already marked it up 15 percent per the industry standard), and it will take four rolls per set-up, or $880 total. Any bad weather days will cost $800. So Stanley's estimate for the job is $4,080, give or take a rain day. Technically, because this is an estimate and not a bid, Stanley is allowed to have his final bill come in at up to $4488, or 10 percent more than his original estimate. Conversely, if Stanley gets the shots he needs in only one day and half the rolls, he should only charge the client $2,040.

- *Get it in writing*. Never make a deal on a handshake. No matter how good every party's intentions are, misunderstandings can and do crop up even with clients with whom you share a long, happy relationship. Having a written agreement doesn't imply you think your clients are going to try to cheat you, anymore than the person who takes out a life insurance policy thinks he's going to die prematurely. It's simply insurance.

- *Bill for partial payment up front*. Believe it or not, this practice benefits the client as well as you. Obviously, it helps you insure that you'll receive at least partial payment, and helps you cover your expenses up front. But it also helps your clients with budgeting when the payments are spread out over time. It's human nature to put off until tomorrow what you can pay today, but when the final bill comes, it can be a nasty reality. Paying bills is sort of like childbirth—after it's over, we forget

the pain. So if a client pays you $500 up front for a $1,000 job, he forgets the "ouch" from that first $500. And after the job is done, and he gets his final $500 bill, it hurts less than that $1,000 would have.

DON'T APOLOGIZE

I don't know many people who feel comfortable asking for money on their own behalf. It's almost always uncomfortable. But whatever you do, don't apologize! Don't shirk or cower, or say, "I'm sorry, the bill is $450." It goes back to perceived value: if the client thinks you don't think you deserve your fee, he won't, either. You did an honest job, and you collect your honest fee. Period.

DON'T GIVE AWAY THE INTELLECTUAL PROPERTY FARM

It's always been difficult to protect intellectual property, and never more so than now. While more and more photographers are giving away their copyrights, it's more important than ever not to join the pack. Not only will you be losing money on the reuse of the images which you give away, you'll be devaluing the quality of your work (your images could be reproduced shoddily, and nonetheless still be said to represent your work,) and devaluing your own image (you'll be perceived as a "bargain basement" shooter and clients who are looking for the best photographers won't hire you).

Stick to your guns when it comes to enforcing your copyright. It can be hard during periods of bad economy and when your market is crowded, but in the long run, everyone will be better off.

WHEN A CLIENT VIOLATES YOUR COPYRIGHT

Don't assume that every copyright infringement is intentional—sometimes it results in a lack of knowledge on the part of the client, and sometimes, as when the client is a large corporation, it's a simple case of one hand not knowing what the other hand is doing.

"It happened to me with Kodak," says Bryan Peterson. I'd sold them two-year, limited usage on images from seven differ-

ent shoots, and once shots that were originally purchased by their American division got reused by their European division after the contract period was over. Once it was the other way around."

What did he do?

"I made them aware of the situation and asked for compensation, which they provided. You have to act on these things when they happen to you. Otherwise you'll be taken advantage of."

If a client violates your copyright agreement, what should you do?

I recommend taking action, but give the client the benefit of the doubt. When you approach them the first time, leave your big guns at home. Take the position, "I know this was an oversight/accident/misunderstanding, but ..." Be prepared to tell the client exactly what compensation you require, and explain how you arrived at your figure. Most of the time, whether the violation was intentional or accidental, the client is willing to comply.

If you're met with an uncooperative response, the next step would be a little chat with your lawyer, which will be dealt with in more detail in chapter fifteen.

Not all fee violations are as obvious as copyright infringement. Sometimes clients carry away the photographer's profits a few crumbs at a time, like ants at a picnic. One big way they do this is by squeezing extra shots into a job after you've already arrived at a price. It used to happen to me all the time when I shot commercial jobs. I was hired to shoot twenty-five cutout shots of kids and the client shows up toting thirty-five assorted playtables, sandboxes, and art easels and says, "Gee, we forgot to have the product photographer shoot these, can you just sneak these in between the kids shots?" The correct answer to this question is, "Sure, we can work those into the schedule! The shoot will go an extra four hours, so that'll run another half day, and about twenty more rolls of film." But they're standing there with the furniture they've lugged all the way up the freight elevator, smiling at me hopefully, and I know they want me to "just throw it in" and they know I know, and I just say, "Okay."

Another little profit crumb gets carried away when a job that was supposed to run regionally suddenly turns out to be national.

Or a job that you shot for one local store gets picked up by one of the store's vendors and used all over the country. Often these infringements are carried out in markets that the photographer never sees, and she never finds out. And even if she finds out, it can be excruciating to try to extract payment after the fact.

RAISING PRICES

Many businesses have formulas they use to figure out when and how much to increase prices. I used to have one vendor that raised prices 10 percent uniformly, across the board, every year. It had nothing to do with actual inflation, their COGS, or the economic environment—they just did their 10 percent increase each year, come hell or high water.

In recent years inflation has been nominal and the consumer index has dropped, so many businesses are holding off on price increases temporarily. On the other hand, the cost of medical insurance, worker's comp, and rents in some areas have sky-rocketed. So what's a photographer to do? When and how much should she raise her prices?

A slow, steady increase is best. I made the mistake of going six years without a price increase. I'd like to tell you it was part of a brilliant marketing scheme, but the fact is, I was simply not paying attention. My COGS and fixed overhead were going up every year, but my business was growing every year, too, so my income was increasing even though my margins were dropping. Then suddenly, I woke up and smelled the coffee. My trusty accountant told me, "You know Vik, you should be hanging on to more of this money you're bringing in." So I checked around my market to see what my competitors were charging, and raised my prices about 20 percent overall.

That seemed like a great solution until a long standing client came in and threw a fit. She felt betrayed. "How could you do this? I've been coming here forever!" she said.

At first I just wanted her to leave my studio and never come back. But after some contemplation I realized she was actually doing me a favor. I realized that if she felt this way, there were probably other clients feeling this way, too, only they weren't telling me about it. They were just ticked off, and maybe they

were even taking their business elsewhere. My solution was to honor the old prices for old clients for one year. That way I could have my much needed price increase, but my old clients felt pampered and appreciated. And now I keep my eye on my margins, so I make small increases when necessary instead of big ones when the situation is about to turn ugly.

I wouldn't recommend raising prices just because another year has gone by, but don't wait until you're just doing damage control.

The bottom line on pricing your services is this: always do an honest job for honest pay. Learn what your industry standards are, and position yourself within those standards according to your ability and experience level, taking into consideration your costs and the realities of your market. Don't let your emotions get in the way of you collecting fair fees. Don't give away your copyrights. Intellectual property is still property—you wouldn't give away your house after all! And keep your price increases slow and steady. Do all this, and your clients will respect you, and you'll respect yourself.

Getting a Great Body of Work

You thought your big job was going to be creating your images, right? I'll bet you never dreamed you'd take more time organizing, archiving, showcasing, packaging, and just generally handling your originals than you did shooting them. It's a dirty job, but we've all got to do it. Because the way we display our images tells others how we regard our own work. And a misfiled, mislabeled, or unlabeled original may as well not exist.

SHOWCASING

Regardless of what your specialty may be, if you have a studio you will want to display your favorite work on your walls. Presentation is everything! The way you frame and hang your work tells the viewer how to look at it. Cheap, premade frames make your work look cheap. Quality, creatively designed frame and matting treatments display your work in its best light.

Since my work almost always winds up on the walls in my clients' homes, I cover the walls at my studios with examples of my work framed in the most beautiful and popular residential style treatments our frame shop offers. Each image is framed differently to show both as many different looks as possible, and to emphasize our philosophy that each portrait should be framed to compliment the artwork itself, and not to match other framed

pieces or interior décor.

Many commercial photographers frame their images in very clean contemporary gallery style treatments, such as black lacquer, oak, or maple. A new trend I've been noticing that I really like is handmade, welded metal frames.

ORGANIZING

Organizing your work can be a Sisyphean labor, no matter what your area of specialty. Your raw material: negatives, transparencies, disks, or combinations of all these, and the many different formats all provide their own challenges. The uses you may or may not need them for in the future will determine how you archive them.

Portrait negatives. A portrait photographer is likely to have reorders on images from time to time, so he would benefit from archiving his originals by the year that they were taken and client name, with the original order forms intact. That way when a client calls and says, "I'm Mary Jones and you shot my son in '93 or '94, and I'd like to reorder the great one of him looking sideways and smiling … you know, the one I ordered as an 8" x 10" black and white? Oh, or was it hand colored?" you can find the file, look at the old order and figure out what on earth she's talking about.

Stock images. If you might ultimately use any of your images for stock, you'll need to organize them by descriptions and categories. This is one area where having your images on disk, whether they were originally film or digital capture, is an incredible plus. There is now great software (see Grip.com under author's picks) that makes it easy to cross reference each image under every applicable key word or phrase. Disks take up less space than transparencies, they're easier to handle, and your computer monitor is a heck of a lot more convenient for viewing images than a light box. If you upload thumbnails to your Web site, potential buyers for your work can browse at their leisure from anywhere in the world, bringing you to a much larger market. Avoid image theft by using watermarks, low-resolution scans, or both.

Most of us find it a challenge to keep all of our work organ-

ized, but the first time a client orders (or reorders) an image and you can't immediately lay your hands on it, you get an unbelievable feeling of despair and a sinking sensation in the pit of your stomach, and you do anything you can to never let that happen again.

HANDLING

It's easy to become casual or even cavalier in the handling of our originals when we do it everyday. I'll often pull files from earlier shoots looking for images to use for studio samples or promotional pieces. The files get scattered around my desk, on my credenza, and on the floor while I'm studying them. Inevitably one of the clients whose file I'm hoarding calls to place a reorder, unbeknownst to me, and my studio manager will frantically search for it. Eventually she will mention to me in passing, "Gee, it's a funny thing, but I can't find the Jarvey file from 1991," and I'll say, "Oh, that's because its currently on the floor by my desk," and she'll usually find some way to punish me. If I were smart, I'd have a bin on my desk that said something to the effect of, "closed files," that she could always check in when she can't find a file in its proper place. But then, if she were smart, she'd remember that this happens roughly three to four times a year, and come and tell me when a file goes AWOL. Oh well, I guess everybody needs a hobby.

I've seen studios where slide sleeves are piled up in drifts around the light box and totally unprotected, dusty slides are scattered about as if someone used them to play "52 pick up". I've seen naked negs on the floor in high traffic areas. I've seen stacks of disks in unlabeled, broken covers.

STORAGE FOR VARIOUS FORMATS OF ORIGINALS

There are standard ways to store various types and formats of originals that maximize their longevity and minimize potential damage.

Anything needing to be archived, such as photographic originals or prints, should always be stored in sleeves, files, boxes, and envelopes that are acid free. Archival storage products are available at professional photo stores, and via mail order or

online from such catalogs as *Exposures*.

There are several types of storage systems for 35mm slides. transparent, acid-free plastic sleeves are designed to hold up to twenty slides and fit nicely into three-ring notebooks for easy perusal. Acid free cardboard slide boxes hold slides in the original boxes they come in from the lab, or just in the storage box itself without the lab boxes. These are not as convenient as the sleeves, in my opinion, and should be used only for deep storage.

120mm and other medium format transparencies are most easily stored in acid-free plastic sleeves. These are much like the sleeves used for 35mm transparencies, but they hold twelve images (one roll).

4" x 5" and larger negatives and transparencies are housed each in their own individual acid-free plastic sleeve, and I find the most convenient storage boxes for these to be the boxes the film is packaged in. Additional boxes for this purpose can be purchased at professional camera stores.

ACID IS THE ENEMY

Don't ever store any original in anything containing acid. This includes regular file folders, regular paper envelopes, and regular cardboard boxes. Professional acid-free storage containers cost a little more, but are well worth it if you plan on using your originals again, either in the near future or in years down the road. Even if you don't foresee a use for them now, you may be surprised later.

Roy Blakey was.

"After I published my book of male nudes and sold all the copies, I completely forgot about the whole project for almost twenty years," says Roy.

"I moved to Minneapolis and [the negatives] sat in boxes on the floor in a closet in New York, until one day a colleague found them and said, 'Hey, Roy, these should be re-released,' and he helped me find a publisher.

The new edition came out thirty years to the day after the first. And it never occurred to me that those images would be revisited until this fellow found them and dug them out."

Even if you don't ever reuse the originals, someone else might.

Henry Larsen was a gifted amateur photographer who shot a wild array of subjects in the '40s, '50s, and '60s—everything from salon style nudes and pet parades in Iowa, to oil slicks on parking lot water puddles. He carefully organized, labeled, and archived every negative he ever shot, and when he died these images were passed down to his grandson, who is himself a photographer. Many of the images have been reprinted and given various treatments, including hand coloring, to be resold as stock and fine art images. Larsen's photographs are quirky, whimsical, and they don't fall into any particular "market." I believe he simply shot for the joy of it. I'd be surprised if he ever expected them to one day be "resurrected" after his death. But they became a gift to later generations of photo enthusiasts.

BEWARE THE WRATH OF FIRE AND WATER

Whether you store your images digitally on disk or you archive negatives, you will want your storage space to be reasonably fireproof and waterproof. If you don't have a lot of originals, you could store them in a safe of the type that can be purchased at an office supply store.

For a larger volume of originals, you may want to investigate off-site storage, especially if your studio is in a pricey commercial space—you don't want to be paying retail rent for cold storage.

There are storage companies that specialize in just this type of service, or you might look even closer to home: the building in which you rent your studio space may have basement or interior space that is undesirable for other uses (and therefore inexpensive to rent) which could be made into adequate fireproof, waterproof storage areas.

PURGING ORIGINALS

Because of the expense; labor; and space involved in housing originals, many portrait and wedding photographers purge their files periodically, after the likelihood of client reorders is past. Some offer the originals to the clients at a flat fee. Others simply throw the originals away. I strongly believe the originals should always be offered to the client before being destroyed. Those negatives may someday become priceless to family members.

PERSONAL MOTIVES FOR SAVING ORIGINALS

I personally have never destroyed or purged a single negative from any of my studios or my personal work. I've had clients who were very grateful for this fact years later when they've come back to me for reprints due to personal tragedies, such as divorce, a house fire, or the loss of a family member. The joy of being able to provide these people with photos of their families during a crisis is more than enough compensation for archiving the originals.

TO ARCHIVE OR NOT TO ARCHIVE

Ultimately, you must examine your own point of diminishing returns—the likelihood that you will at some point want or need to point reuse your originals vs. the cost of the space and labor involved in retaining them.

ALL THE BELLS AND WHISTLES

In any case, if you do decide to retain originals, do it right, do it up big, do it with all the bells and whistles.

- Meticulously label the originals and storage containers with all pertinent data, including the date shot, the client name, job or P.O. number, and subject matter.
- Use only acid-free, archival storage receptacles.
- Organize your archives in a fireproof, waterproof storage area.
- Consider employing a hierarchal system of archiving, similar to that used on most computer programs. More recent or more frequently used originals could be maintained in easy access—even on site at your studio, with older and less frequently called for images stored off-site or in "cold" storage.

PORTFOLIOS

Portfolios, or "books," are used by commercial, architectural, and fashion photographers as a means to display their work to potential clients. Each market or geographical area will have its own very rigid written and unwritten rules about what is required for the appearance of your book. Expectations and industry norms evolve over time. Often, the requirements or

standards that describe an adequate book seem ridiculous or unreasonable.

Ten years ago, the last time I had a commercial portfolio, the standard in my market was to show 4" x 5" transparencies of your ten best images. The transparencies had to be mounted inside two 11" x 14" sheets of Kydex—a plastic product used inside of suitcases. There were only two places anyone knew of to get it. It was expensive; and it was very, very difficult to cut. My professional frame shop mounted ten images for me in Kydex and handed me a hefty bill and a warning never to bring them that stuff again. There was one fellow photographer in town I finally found who would cut Kydex for a reasonable rate—then right after I found him, he moved to Alaska.

So I thought that was about as bad as it could get. But the portfolio requirements in this market now make commercial shooters yearn for the good old Kydex days.

These days, you have to hire a designer and a book maker to create a permanent, actual bound book for you. The goal is to make a portfolio that looks like a very expensive coffee table book. Forget about the quality of the work inside—the competition is fierce to have the most unusual, best designed book. The covers are made of everything including, but not limited to metal, leather, fur, book making fabric, and wood.

"It's pretty outrageous," says fashion shooter Lee Stanford. "The idea is supposed to be to show your best work. You used to be able to change-up images one at a time whenever you wanted to update, without having to make a whole new book. Now you can't do that."

RANT IF YOU MUST

While the portfolio standards of your market may seem silly—even tyrannical—complain and fuss all you want, but follow the rules. It's the only way to get anyone to look at your work.

PACKAGING THAT CERTAIN SOMETHING

No matter what your area of specialty, you ultimately deliver something into the hands of your client—either a CD, a proof

album, a print, or even a finished, framed piece of art. The way you package that something will affect the ultimate satisfaction of your client with your work product.

DISKS AND CDS

Present your disks and cds professionally. "Some photographers deliver us disks with the P.O. hand scribbled on them in Sharpie [permanent marker]", says an ad agency traffic director. "And others have gorgeous matching labels for their envelopes, disks, and CD cases. It's just really classy and it adds value, and gets people talking around the agency, when the package is nice."

PORTRAITS AND PRINTS: A SOW'S EAR OUT OF A SILK PURSE

Packaging was never an issue for my KidCapers Portrait Studio because most of our clients purchase framed, finished, wall art from us, which is delivered to their homes. But in the early days of my Tiny Acorn Portrait Studios, before we did our own framing, clients picked up their hand-colored photographic prints right at the studio. Never one who appreciated the value of good packaging, I had my employees send our prints off with the clients in whatever was handy—photo paper boxes and sleeves, envelopes from the lab, file folders, you name it. Thankfully, a very helpful (albeit disgruntled) client called me to voice her displeasure. "I can't believe it," she told me, "I paid so much money for these beautiful hand painted pictures of my babies and she [my store manager] just threw them in a file folder (this said with the same tone one would use when pronouncing the names of distasteful contagions) and tossed them at me!"

Now, I knew the employee in question very well. Well enough to know that she did not "throw" or "toss" the pictures or treat them with any disregard. But the important thing was the client's perception. She perceived a disregard for the portraits on the part of the employee because of the disregard with which I chose (or more aptly, didn't choose) the packaging.

Thanks to this client, who was generous enough with her time to share her insights with us, I had packaging printed up with our store name and logo and instructions on how to care for the

prints while they were in their unframed state. We have not had another similar complaint since.

And just as awful packaging can make a good product look bad, good packaging can make a great product look even better. A case in point: every year my studios offer two to three holiday card designs. We typically tied the envelopes and cards together with a ribbon and put them into a transparent plastic bag. Then one year a friend offered to assemble and package the cards for us. She found little bags like the type you bring home bath products in from a spa. She tossed some colored metallic confetti into the bags and tied them with French ribbon. She had cute little metallic stickers printed with our studio name and logo and affixed them to the handles. The whole package was so cute we'd have people stopping our clients on the way down the street to ask where they got their holiday cards—and our bookings skyrocketed that holiday season.

Now I do believe in packaging—I really, really do.

WEDDING PORTRAITS

Wedding photographers have natural, built in packaging in the form of folders, albums, and photo boxes. Some wholesale companies, such as Art Leather (see author's recommendations) offer such beautiful presentation albums, it almost makes me want to get married again (almost being the key word here). I believe wedding shooters do well to build the cost of a proof book and album or photo box into their fee structure and deliver their product complete—the perceived value is enormous.

LEAVE-BEHINDS

In the old days before personal computers, to create a "leave-behind," or brochure, a photographer had to go to the expensive route of off-set, four color printing. This process was very labor intensive and therefore, short runs—the size most photographers usually required—were almost as expensive as long ones. With this sizable investment, most of us created new printed material infrequently.

But now, with desktop printing better than ever and a variety of art paper available, we can cost-effectively create short—even

tiny—print runs of brochures. We can tailor our image selection to target specific clients and update and improve our leave-behind at will.

IF YOU'VE GOT IT, FLAUNT IT

If there is a moral to this story it's this: the regard with which you display, package, and otherwise showcase your images tells others how to regard your work, as well. If you spend a little extra thought, planning, and sometimes money to present your work in its best light (yes, pun intended!) you'll be rewarded with a healthier business.

Marketing Made Simple

'm going to go out on a limb here and issue a statement that might make me unpopular in certain circles: Speaking strictly in monetary terms, great marketing and sales ability are more important to one's ultimate success than great photographic and artistic ability. This isn't fair. But it's true. I speak from my fiftenn-plus years in the business, observing my own and my colleagues' studios. There are photographers who are more talented than I am whose studios have failed. There are photographers who have little vision whose studios are thriving. That other factor that separates the "Captains of Industry" from the photographers is simply the ability and the willingness to put yourself out there and forge and maintain relationships. In other words, those who are willing to market and sell.

"You don't just find a client base, you have to get out there and create your own client base," says Karen Melvin. "I think having a marketing plan is even more important than having a business plan, because if you have clients, you have business. You can have a business plan, you can have talent, you can have equipment, you can have a studio, but if you don't have clients, you're out of business."

"You have to sell. *Have to*," says Bryan Peterson. "I teach a marketing seminar and I ask a room full of photographers, 'How many of you guys have a commissioned sales job?' and

one hand goes up. Then I say, 'Do you guys realize you're all on commissioned sales?' Every last one of us is. You have to hustle to get clients and keep clients and create product and put it on the shelf and keep the windows clean so people will feel like coming in and seeing what you've got, and then when they come in you have to get up off your ass and greet them and show 'em your stuff and make them want you. People buy from people they like. It's as simple as that."

You are your own product. Like it or not, when you're wooing a client you're not just selling your services or your products—you're selling the experience of working with you; you're selling your image, your cache, your personality.

It sounds so simple! If selling is the key to success, why are so many of us reluctant to get out there and just do it?

"I call it the big 'P' word," says Peterson. "Oooooo, I'm afraid of people! Photographing them, calling them, walking into their offices and selling them. You gotta get over it."

Makes sense. But how does one get over it?

Peter Aaron suggests that a young photographer does well to remember that the potential client welcomes the opportunity to see good photographs. "Call them up, and say, 'I've got some interesting pictures I'd like to show you and I'd like to meet you and see what it is that you guys do.' You'll be surprised at the warm reception you'll get. They welcome it; it's a break in their day."

But be aware that not every call or visit will lead to an assignment or a new client—at least not right away. "I call it 'planting seeds,'" says Patrick Fox. "You make a contact, you're nice to the person on the phone, you're nice to the person at the reception desk. You get your book out there. Sometimes it results in a job right away. Sometimes it takes years. You have to plant a lot of seeds."

KNOW THYSELF

Every good salesperson knows her product inside and out. She knows its history and it's use. She knows what makes it unique. She knows how to tell its story. Before you can market yourself,

your services, and your product, you need to know exactly what it is that makes you different from all of your competitors.

"This is so important, now more than ever," says Karen Melvin. "More people want to be photographers than ever before and the market is soft. So you really need to stand out; you need to be specialized. You need a story about yourself."

Every successful photographer has something that makes her stand out among her peers, she knows what it is, and she knows how to get her message out.

HAVE A RECOGNIZABLE MESSAGE

When I started my studio in 1988 my own message went like this: I am the only photographer in town who specializes in wall portraits of kids. I only shoot kids (parents and pets welcome when accompanied by a child). I only shoot black and white film, and I only offer black and white, sepia toned, and hand-painted prints. I only shoot kids acting natural, both in action and at rest. I use no traditional posing. I capture the true spirit of your kids. I am the kid specialist.

Karen Melvin is an architectural photographer who specializes in commercial shots of architectural products. Her message is all about lighting. "I use light to tell a story, and therein lies my uniqueness," she says. "When I take someone on a tour in my picture, the light is our guide. Each element in the photo has a different value, as told by the lighting and the composition. It evokes a feeling. People respond emotionally to a picture in which light tells a story. They may not realize it; it's on a visceral level."

Once you have refined your message, what's the next step?

Says Karen, "You have to hit 'em with it until they get it."

BE PERSISTENT

Usually, people aren't going to call you up and hire you the first time they hear your name. You have to get under their skin. They need to be exposed to you, and your message multiple times before they take action. So you need patience, you need persistence, and you need a lot of ammo.

FOCUS YOUR EFFORTS

When I made my first direct mailing, I wanted to spread my budget out as far as possible to reach as many people as I could. I was determined to purchase a mailing list of 5,000 households and send them each one postcard. But my contact at my mailing service was insistent that I take a different tack: buy a list of 2,500 households and send them each two postcards, about two weeks apart. I hated that idea! I couldn't get over my naïve impression that more households equaled more bang for the buck. Apparently a lot of people think that way. But in the world of direct mail, common wisdom holds that people need to see your name 5.5 times before they will buy from you. So hitting a few households (or architects, or art buyers, or ad agencies) repeatedly will yield better results than a blanket approach.

Whatever method(s) you use to get your message out, concentrate your efforts on a small, hand-selected group of potential clients for the biggest payoff.

TELL THEM WHY THEY NEED YOU

You've told them your message, the story of what makes you unique. Now you need to tell them why they need your special talent. You need to tell them how they will benefit from working with you.

"It goes like this," says Karen Melvin. "I would call an art buyer and say, 'Hi, I see ABC Window Company is one of your clients. I shoot a lot of architectural products and lighting is my thing—I imagine great lighting is very important to showcase your product. I'd like to come in and show you some of my work I think you'd find germane …'"

CHARGE UP YOUR BATTERIES

Marketing takes a lot of energy and inspiration. You've heard it said, "You can't create in a vacuum." You can't market in a vacuum, either. Keep your batteries charged up by sharing marketing ideas and woes with other business people. Don't limit your contacts to other photographers. I recently sold my house and through a few casual conversations got a boat load of interesting marketing ideas from my realtor, and he got a few from me.

Take a class or seminar now and then on marketing. Again, don't limit yourself to offerings targeting photographers. Cross-train. It'll help you be as creative about selling your work as you are about making it.

Even examining your junk mail from a student's perspective can give you a little inspiration. Instead of throwing it away without opening it, study it. Does it have anything in it that appeals to you? Attractive graphics, a nice layout, a call to action, a compelling story, a special offer? Make a file to save the promotional pieces that contain some aspect that inspires you, and refer to it when you create your own mailings.

SET GOALS

In order to be successful at marketing and sales, you need to set quotas for yourself. If you give yourself a goal to make twenty-five cold calls a week, you'll be much, much more likely to follow through than if you just say to yourself, "Well, I think I'll make some calls each morning between nine and ten. It's unbelievably easy to find other things to do, and never get around to those calls. Ditto for printed material: set a goal of say, doing four postcard mailings and one newsletter a year. If, after a little time goes by, you find the goals you've set prove to be either too easy or too tough, adjust them. It may seem somewhat arbitrary, but the point is to have a realistic, workable marketing plan. If you set the bar too low, you're only cheating yourself. If you set it too high, you won't stick with it. So find a level at which you're comfortable, and maintain it.

Be sure your goals relate to the action and not the result of your marketing, i.e., a goal of making ten cold calls a week is more measurable and gratifying, and therefore more conducive to success, than is a goal of getting one new client a week, which is something that may or may not happen regardless of how many calls you make.

DRAW ON YOUR LIFE EXPERIENCE

You have marketing and sales experience. You might not realize it, but you do. Have you ever applied for or interviewed for any job? Then you were selling yourself. Have you ever worked as a

server in a restaurant and recommended the daily special, or suggested a special glass of wine to compliment a meal? Ever worked in a library and recommended books? Then you have sales experience. In fact, I'd be hard pressed to name any job (that includes people contact) that doesn't involve selling.

"All of my marketing and sales experience I drew from jobs I had when I was in my twenties," says marketer extraordinaire Karen Melvin. "I did cold calls for Block Drug, and later for a photo finisher. It's dialing for dollars. That's where I learned everything I needed to know about marketing."

That's not to say that you shouldn't study sales and marketing in a more formal setting. But your own experience is a bird in the hand. Don't overlook it.

COLD CALLS

Many people regard cold calls as the most difficult marketing task there is. Only one out of ten to fifteen cold calls even results in a "go-see," so those who are faint of heart, prima donnas, afraid of rejection, or just plain shy can agonize over picking up that phone.

But there are a few things to do to make it easier.

• *Do it in the morning.* Do your cold calls first thing in the morning, before you do anything else. Just like going to the dentist, the anticipation is usually the hardest part. By getting it over with early, you won't have to worry about it for the rest of the day, and it won't be a big drain on your energy.

• *Find the decision-maker.* Maximize your cold call success by learning to find the decision maker. You could make a sort of a "scouting call" to find out who in the office hires the photographers, when they're usually available, and how they like to be contacted.

• *Tailor your message.* Let your potential client know that you're calling because you've done your research and you respect their work and your photographic style would be appropriate for their needs—don't let them think you just pulled their name off of a list. "I've seen some of the prisons you designed, and I specialize in wide angle shots in really tight spaces."

• *Get to the point.* Be pleasant, but get right to the point. Be direct about the reason for your call. Chit-chatting or pretending

yours is a personal call to try to make it past the screening process to get to the decision-maker will only tick people off.

DIRECT MAIL

Direct mail is the common denominator in photographers' marketing. It is used extensively, in every photographic field, all across the board. The huge advantage of direct mail is that you can choose your target and concentrate all your advertising dollars on those most likely to become your clients. Dollar for dollar, this method of spreading your message is quite effective.

Direct mail guru Rick Byron tells us that there are three critical components to a direct mail piece: target; offer; and art. Your target is who you select to receive your mailing. Your offer tells them what they'll get if they work with you. Your art is the image(s), graphics, and layout of the piece.

"Most people spend 90 percent of their time and energy worrying about their art, and barely consider their target," says Rick. "But of these three, the most important element is the target. You can have a beautiful piece with a great offer, but if you're sending it to the wrong people, it's like throwing it away.

"I try to illustrate the huge importance of the target this way. An average response to a mailing sent to a targeted blind list is ½ to 2 percent. Now, what if you sent out a wedding invitation and you only got a response of ½ to 2 percent? You'd cry! You'd be devastated; you'd think no one loves you, because you're expecting a 60 to 75 percent response. Why do we expect such a high response rate for our wedding invitation? Because it's sent to a highly targeted list! The invitation could look like anything, it could be ugly, that won't reduce your response. The offer can be anything—dinner, a dance, appetizers, that won't reduce your response, either. Because your target is sooooooo refined! The more refined your target, the greater your response will be. Of course, good art and a good offer are also important, and the art especially so for photographers, but it all begins with the target."

Once you've got your target in your crosshairs, it's not enough to just show them a pretty picture and tell them your story.

"You need to spell out for them what to do now, when to do

it, and how they will benefit," says marketing expert Howard Segal. "It's called a call to action." For a portrait photographer this call to action is relatively straight forward. It would go something like this: Book a photo session. Do it in July. Receive a free 8" x 10". For commercial, fashion, stock, and architectural, and other specialties a call to action is not as obvious. "We can't offer a free print, or a box of steaks, or a discount. It's not professional," says Lee Stanford. In this case, your call to action could go like this: Visit my Web site. Stimulate your creative ideas for the spring shooting season. Expressive lighting will showcase your architecture.

"You also want to think about where this piece will wind up," says Peter Aaron. "Postcards are a wonderful format because people tend to keep them—on their desk or on their wall or their bulletin board. They'll refer back to them. It helps to have your pertinent information on the same side as your art so they don't have to flip it over to see who you are."

Postcards have an advantage over self-mailers and envelopes in that if the person is looking at his mail, he's looking at your piece. There's no danger of it getting thrown away unopened. The disadvantage of a postcard is that you can't say or show very much—there's just not enough space.

Whenever possible, follow up your direct mail piece with a phone call. Ask if they received your mailing, and if you could come in and show them your book. It's a cheap way to reinforce your name recognition.

WEB SITES

"A Web site can be a wonderful marketing tool. It opens more doors, because you can drive potential clients to your site to view your work instead of threatening them with the thought of spending fifteen or twenty minutes sitting down with you face to face and looking at your book," says Karen Melvin. "And another plus is that they're then pre-qualified if they call and want to meet you or get a bid."

Rob Levine hosts several photographer Web sites. "Some photographers have Web sites. Some don't. But people expect a photographer to have a Web site. Your Web site is you. It's what

your brochure used to be. But you don't have to pay printing or mailing costs, and you can change it at will. It's a great way to get your work out there. Where some photographers mess up is in thinking they need to have a huge, hard-to-navigate, unwieldy site. Your site should be simple and clean, and easy to use."

And you don't have to spend a fortune setting one up. Four years ago I got a bid from a designer for a site for one of my studios: $40,000. Two years ago I got another bid from another designer: $25,000. Now Yahoo.com has a page where you can put together your own Web site, and all it costs is a $29.95— a month hosting fee. A deal even at twice that price.

Be sure to use the hierarchal system to your advantage. You want your visitors to see your work. They might want to cut straight to the chase and see your fee structure and price list. Don't let them. Arrange your home page so that they can only get to the nitty gritty by going through your portfolio or gallery. Steering them through your mission statement and/or studio history and photographer's profile wouldn't be a bad idea, either. Depending on what field your specialty is in, you might not want to include your fees on your site at all, but direct serious inquiries to call or e-mail.

You can maximize the marketing value of your Web site by encouraging your visitors to sign up for a newsletter or special informational e-mails.

Be sure no one downloads your images by using watermarks, and/or low resolution scans.

Link your site to related professional organizations for greater exposure.

And, very importantly, keep your Web site up to date. Your potential clients will feel like they're lost in space if they visit your site and the images and information are years old. I'll never forget in the spring of 2001, when I was surfing the Net for a kitten for my daughter, one breeder's home page read, "… visit us in October 1998 to see our new litter of babies!"

NEWSLETTERS

Newsletters can be an inexpensive and effective way to make periodic contact with your existing clients. You can use your

newsletter to showcase your latest work, introduce a new product, give seasonal updates (i.e., "The bunnies are here!") and make another call to action: "Book by November 1st for pictures guaranteed for Christmas. Receive a free set of wallets." You can print up the old-fashioned, paper type of newsletter and snail mail it to your clients and prospects, or you can go electronic and send an e-mail newsletter.

SILENT AUCTIONS/CHARITABLE DONATIONS

In 1988, when I opened my first studio, I had very little capital, and at that point in my career I really hadn't seen the value in advertising yet. So I was determined to promote my new business as cheaply as humanly possible. I picked up the phone and called all the charitable organizations I could think of that provided services relating to children and families—children's hospitals and health organizations, children's theater companies, crisis intervention centers, private schools, and more. I found the offices which coordinated their events and development, and offered to donate $500 sitting and portrait packages for their silent and live auctions and raffles. Usually the voice on the other end of the line was very pleasantly surprised. One gal told me she'd never had anyone call her and offer a donation before—she usually had to solicit donations from local businesses. When I told her I'd even provide a sample, printed material, and a table top display, drop it off and pick it up, she said, "Oh my gosh, I'm going to drop my teeth!"

That first $500 silent auction donation resulted in a $2500 sale, and the client came back four times over the course of 8 years. I continue to contribute sittings and portraits to charities to the tune of about twenty-five silent and live auctions and three raffles a year. It's a win-win-win situation—you get your product displayed in front of hundreds of people with disposable income and at least one guaranteed new client, the charity gets to make some money, and the client gets to purchase an item that they in all likelihood would have purchased anyway.

There is an art to maximizing the marketing impact of your silent auction donations:

• *If you have an existing client who is a member of the charity's board, use that client's portraits as your sample.* The client

will be thrilled to show off her portraits. She'll really talk up your work, and the bidders will be more excited about a photographer who has shot for someone they know personally.

• *If you don't have a client on the board, provide your own sample, deliver it, set up your display, and retrieve it yourself.* This way you'll make sure that your product is showcased in the best possible light, that there's plenty of printed material for interested bidders who don't win your package so they can call you directly and arrange a shoot on their own, and you'll be sure to get your sample back. Most charities offer to have a volunteer or messenger pick up and drop off your sample, materials and display, but the danger in taking them up on this is that the volunteers are all usually incredibly frazzled and your sample could get lost in the shuffle or your printed material might not get set out, and that defeats the purpose of your donation from a marketing stand point.

I actually had the coordinator for one organization call me and say, "You know, we're really busy here and everybody knows your work anyway, so do you mind if we don't display a sample this year?" Yes, I minded! I wound up delivering the display myself and I've recommended it ever since.

PIGGYBACK ADVERTISING

When you collaborate with other related businesses to market your products and services, I call this "piggyback advertising." Over the years, I have done this very successfully with Creative Kidstuff stores in Minneapolis. Again, this relationship began in 1988 when I opened KidCapers Portraits (then called KidShooters Studio) and my advertising budget could almost buy a tall latte, but not quite. I cold called the owner of Creative Kidstuff, Cynthia Gerdes, who didn't know me from Eve, told her that I thought our visual styles and philosophies were compatible, and offered to shoot pictures for display in her store— portraits of her own kids, newspaper ads, product—and/or otherwise sell her my soul in exchange for the privilege of displaying my work and postcards in her store.

She told me she never had collaborated in such a way before, and frankly was rather biased against that sort of thing, but she

made an exception for me because she agreed that our philosophies fit and that the collaboration would be mutually beneficial.

For about five years my 8" x 10" plexiglass postcard holder occupied a spot on a rear wall in her store, and that tiny display generated hundreds of clients for my studio. In exchange I shot her newspaper and magazine ads, and portraits of her daughter. I most definitely got the long end of the stick in this relationship, and I'll always be grateful to her for breaking her rule about "piggybacking."

This type of arrangement isn't just beneficial for portrait photographers: wedding shooters could piggyback with bridal shops, architectural shooters could piggyback with businesses that sell architectural products, and commercial shooters could collaborate with local magazines.

Just as with charitable contributions, there are ways to maximize the impact of your piggyback advertising efforts:

- Only collaborate with other businesses that cater to the same client base you're trying to cultivate.
- Choose one or two businesses and stick with them for the long haul; you (and your collaborators) can lose credibility if your work is seen all over the city in association with different stores.
- Whatever agreement you work out with your sister business, get it in writing up front. It doesn't have to be a fifty-page contract full of legal terms—an informal letter of agreement will do just fine. Remember to put a limit on the length of the arrangement. You can always renew it later.
- Encourage the staff and employees at your sister business to use your products and services by giving them steep discounts. They'll talk up your business for you in a big way if they have their own experience with you to tell about.

MALL KIOSKS AND WALLS

Frequently large, enclosed shopping malls require rent that is prohibitive for most photographers—especially those just starting out. But many malls have creative ways available to take advantage of temporarily empty space. Of course, retail footage is a premium and neither mall management nor the mall mer-

chants like to see blank, empty walls where there was once a shop; it's bad for everybody's business. So often malls allow photographers to display work on the walls of vacant spaces for a comparatively nominal fee. You won't be there shooting or answering questions, but you'll be able to show actual samples of your work and have your promotional material available to a lot of potential clients. The drawback to this is that when the space gets rented, out you go.

A more dependable solution is a permanent, free-standing display within the mall. This costs more, but it allows you to be more of a presence, and you'll know exactly how long you'll be there.

MERCHANT ORGANIZATIONS

Malls and shopping areas often have merchant associations that create advertising, throw special events, and market in other ways at rates that are considerably lower than the photographer would pay if he were going it alone. Association dues are usually only a few hundred dollars a year, or can vary depending on the size of your business, and the cost is well worth it to be a part of promotions such as art fairs, block parties, special ads in newspapers and magazines, and more.

GIFT WEB SITES

There are Web sites devoted to gift ideas for the busy shopper and portraits are a natural gift for a number of occasions: Mother's Day, Father's Day, Christmas, and birthdays, to name a few. The cost for inclusion at one of these sights is nominal compared to launching your own direct mail campaign, and exposes you to a large, although not necessarily targeted, audience. To maximize the return on this investment:
- Shop around for the site with the best deal.
- Participate in the categorizing of your product to ensure that it comes up on the appropriate searches.

NEWSPAPER AND MAGAZINE ADS

In all honesty, I've never had great results from advertising in newspapers or magazines. When I have received a decent return on my advertising dollars, it's been when I've coincided my ad to

run at the same time as an article about me or my speciality, or when I've run an ad in an issue of a magazine for which I've also shot the cover. If you decide to try this avenue, a few tips will help you make the most of your investment.

- Use due diligence in establishing that the magazine or paper's demographic is as close to yours as possible.
- Always run an ad in three or more consecutive issues; once is simply not enough to establish name recognition.

CLIENT GIFTS

I've had great success in giving gift certificates to my biggest clients for them to give to their friends. They're delighted to have a gift to give, you get a new client, and you generate even more word of mouth—which brings us to our most fabulous method of marketing: word of mouth.

Of course, in photography as is any other business, word of mouth is the most effective and least expensive tool there is for landing new clients. How can you generate a "good buzz" and make people want to recommend you to their friends and colleagues?

It's simple: Make the client happy.

"Aside from creating images, making the client happy is the joy of it," says commercial shooter Bob Pearl. "People are a big reason for shooting, because let's face it, a lot of what we do is just not that creative. It's about relationships."

HAVE A MARKETING BUDGET

In order to stay on track, you need to budget both your time and your money for marketing. If you don't, you'll wind up buying that new lens instead of printing up that new direct mail piece, because let's face it, getting equipment is fun. And who wouldn't rather spend their time making pretty pictures instead of designing that mailer?

Make your marketing plan. Specify how much money and how much time it will require, and follow through. Then you'll really be in business.

The Secrets to Sales

Sales is much like marketing, except that instead of selling a potential client on using your studio, you are selling a person who is already your client goods and services. Think of marketing as "outside sales" and sales as "inside sales." Only certain specialty areas deal with inside sales, primarily portrait and wedding photography. However, even if your specialty is not one of these, you'll be able to use most of the theories and practices outlines in this chapter in your marketing work—so don't skip it!

LET THE SELLING BEGIN

When I train new employees in sales, the first question I ask them is, "When do you sell the portraits?" Often they respond that it is at the proof viewing, what we call the design consultation. Then I make a sound like the buzzer on a game show and say, "Oooonk! Thanks for playing!" You sell the portraits from the moment the client calls you for information, or comes through your door as a walk-in or a scheduled studio visit, until they've taken their pictures home, hung them on the wall, and received your thank you note in the mail. Every moment of client contact is a moment that you are selling portraits. Or, if you neglect to create a positive relationship with your client, these can turn into moments when you are un-selling portraits.

ANSWERING THE PHONE

Do you know what your single most valuable marketing, sales, P.R., and customer relations tool is? Neither did I when I started my first studio. It's your humble old telephone. Every call you receive is a golden opportunity to get, keep, or satisfy a client.

But simply answering your phone can be a challenge when you're a one-horse operation and you need to be in the field, in the studio, and out pounding the pavement, and especially when you do all this and keep your day job, too. But getting a real live human being at the other end of the line can be a strong positive influence on your potential clients, and can sometimes mean the difference between turning them into your next booking or driving them to one of your competitors. Realistically, you won't be able to answer your phone every time it rings when you're just starting out. So what can you do to make sure you don't lose clients who get your voice message machine when they call?

- *Have a professional, upbeat outgoing message.* State your studio name, your specialty, and the time frame in which you will most likely get back to your caller. If your studio is in your home, it's doubly important to have a professional sounding outgoing message. Don't try to be cute or clever. Ideally, you should have a phone line dedicated to your business so family members don't accidentally answer your business calls.

- *Return calls within three hours.* If you're on location or at another job, return calls during your lunch or on a break.

- *Convey to your callers that you're happy to hear from them.* Even if you're in a rush to get back to your shoot or your job, you should appear as if you have all the time in the world. Being harried or seeming busy will not make potential clients think they're important or otherwise impress them—it'll simply put them off.

- *Never give one word answers.*
"Do you photograph birds as well as dogs and cats?"
"Yes."
"Should I bring more than one outfit for each child?"
"Yes."
"I don't see any kumquats in your book. Have you ever shot kumquats before?"

"Yes."

See all the opportunities being thrown out the window here? The inquisitive potential client got an affirmative response in each case, but was not engaged and was really given no reason to choose that photographer to do her pictures. This conversation should have gone more like this:

"Do you photograph birds as well as dogs and cats?"

"Why yes—in fact, I shot a cockatoo last week. It was a beautiful bird. I did some macro shots of his face—it's amazing how expressive a bird can be, especially considering they have no lips."

"Should I bring more than one outfit for each child?"

"Oh, yes! Bring a bunch of things, and we'll pick out the most photogenic outfits at the studio. If you want to do some really dramatic shots, bring black clothes for each kid. And swimsuits can be a lot of fun for a whimsical shot."

"I don't see kumquats in your book. Have you ever shot kumquats?"

"Yes, I shot kumquats and pomegranates for Megafruit International, and I did a kumquat catalog for the Fruit of the Month Club. We did some really creative shots and even dressed the kumquats up in little Santa suits—it was the fruit for December."

See the difference?

• *Don't just answer the caller's questions—ask your own.* How many kids do you have? How old are they? Are they into any sports? Tell me about the history of your widget division. What types of images have you used in your annual reports in the past? The more interest you show in them and the longer you keep them engaged, the more likely they are to hire you.

• *Repeat what the potential client says in your own words.* Let him know you have heard his message and understand his needs by repeating whatever he tells you, but in your own words. Don't just parrot it back to him or you'll come off as insincere.

"My first priority for this catalog is to show all the different colors the widgets come in. I want the widgets to look as large as possible. And we need to be able to show them in a way that

makes them look special, because people see widgets everyday and they look at them without really seeing them."

"I understand. We'll highlight all those designer colors, and we can get a hand model who has very small hands—that will make the widgets appear bigger. And you want us to shoot the widgets in a very graphic, dramatic way, so that the widget buyers actually stop to look at them and appreciate them instead of glancing right over them."

• *Share a tidbit of information about yourself.*

"I have a collection of antique widgets I inherited from my grandfather."

"When my daughter was your daughter's age, she liked to ice skate, too."

"I started shooting with a Brownie when I was only six months old."

Sharing information about yourself helps the potential client see you as a person, identify with you, and feel a connection.

• *Don't accept calls when you can't give the caller your full attention.* In these days of the cell phone, it's tempting to take calls in the field or at your job. But the only thing worse than getting a message machine is getting, "Oh, hi, I'm on a shoot, I can't talk right now, I'll call you back," a lot of ambient noise, a connection that's cutting in and out, or a distracted photographer who's trying to drive, groping for her palm pilot, and cursing other drivers all at the same time. So unless you can devote your full attention to a call, let the machine get it. But when you return the call, make it worth the wait.

And here's my pet peeve: When you do answer the phone, don't say, "Studio, this is Stanley." Tell them what studio! It's another opportunity to expose them to your name. "Kowalski Photography, this is Stanley, how may I help you?" This conveys the impression that you're professional and friendly.

TAKING CONTROL

We all want control. Every single one of us, all the time. It's just that some of us take the direct approach—insist on driving, for instance—and some of us are more subtle: "Gee, why don't you drive? Oh, shouldn't we take the freeway instead of the side

roads? You might want to turn off your windshield wipers now, it hasn't rained in hours. Aren't you driving a little close to the median?" You guys who think you never really want control are the most controlling of all.

The desire for control does not make you a bad person. It does not mean you have a personality flaw or a character disorder. It just means you're human. And taking control in situations where it's appropriate is not only generally a very good idea, it's also welcomed—especially by those who are counting on your expertise.

When you are doing a proof viewing, you are the expert. You're at the wheel—you should drive, confidently and unapologetically. Yes, of course, selecting portraits is a very personal thing, but while your client knows when she has a positive emotional response to a picture, she probably doesn't know as much as you do about what visual elements make a good portrait, how to group different shots together to tell a story, or what sizes and treatments will look the best on her walls. She wants and needs your guidance. I've found very few employees who were unable to become good salespeople with training, but the ones who never succeeded all shared one thing in common: They believed nothing they could say would influence (i.e., control) the outcome of a sale.

"People are just going to buy whatever it is they want anyway," one young design consultant-in-training told me. Clearly, I needed to prove her wrong in a very tangible way. I decided to figure out what our least popular product was—our wallet prints—and instructed everyone at all the stores to sell that product hard for the next four weeks. As an added incentive, I gave away a cup of Starbuck's coffee for each set of wallets sold. We wound up increasing the wallet sales by 500 percent, thus proving to the pessimistic employee that what we say to our clients does affect the outcome of a sale. She seemed quite impressed by the exercise—shortly thereafter she quit.

The point is, we can and should take control of the proof viewing and share our professional opinions with our clients about their portraits. We'll make bigger sales, and the client will be happier with her portraits. I guarantee it.

SERVICE, NOT SELLING

It simply isn't true that we live in a classless society. We have two classes: those who expect and want service, and those who expect and want anonymity. I learned this one day from an employee who was attempting to learn sales. She was in her eleventh hour: If she didn't improve her performance soon, I was going to have to let her go. She was especially bad at information calls and walk-in visits.

"Approach them, greet them, acknowledge them, chat with them, ask them questions, tell them about the studio—engage them," I told her. "Treat them the way you would like to be treated."

She giggled timidly and said, "But I'd like to be left alone." My employee craved anonymity.

I asked her to describe how she would like the visit to go if she were a potential client who dropped into our studio to decide if she wanted to have her children's portraits taken there.

"I'd like to take a peek at the walls and see what the pictures look like. I'd like to get a price list, and maybe a brochure, and take them home with me and decide for myself whether I wanted to shoot there or not. I wouldn't want anyone schmoozing me or selling me." She viewed any greeting or attempt at engagement as an intrusion, and service people as the intruders. She couldn't imagine what life was like for the other class—those who want and value service.

"If I came into the studio and no one engaged me, I'd feel slighted," I told her. "I'd want the full service treatment—the greeting, the story of the studio, the questions about the names and ages of my children, and suggestions on creative ways they could be shot. If I were treated like that, I'd probably book a shoot on the spot."

From that moment on, I stopped telling my employees to treat people the way they'd like to be treated. I started telling them about the "two classes," and that no matter which class they came from, they needed to learn to view their actions in engaging the clients and potential clients as providing a service and not as intruding.

CHOOSE YOUR CARROT

We are all motivated by different things. Some of us are motivated by money. We have mouths at home to feed or we need a new yacht. Some of us are motivated by our own or some external concept of success, and we simply use money, or the tabulation of our sales, as a way to keep score. Some of us are motivated by the need to feel liked and to be viewed as a good person. While each of us is motivated to some degree by all of these things, we usually have one big motivational factor that overshadows the others. No matter which one yours is, you can make it work for you in creating a successful sales career.

• *Money.* It's great if the carrot at the end of your stick is the green stuff. My money-motivated design consultants tend to be extroverted and energetic in the extreme—qualities that are a real boon for people in sales. The potential pitfall for our money-motivated brethren is that they can sometimes start to see their clients as giant dollar signs. These guys need to slow down, take a beat, and remember to enjoy their relationships with their clients as much as they enjoy getting their commission checks.

• *Success.* Like money, success is a powerful motivator. The danger inherent in this carrot is that some of us simply can't figure out how to keep score. It's like bowling. You can knock down all the pins, but if you don't know how to tally a strike that follows a spare that follows a spare, you won't know the score.

For instance, it always amazes me when it's time for reviews and I offer an employee her choice of a dollar an hour raise or an extra 1 percent commission. Quite often even the highest-ranking sales people will take the hourly raise, even when the extra commission amounts to over twice as much. Clearly these guys think they're motivated by success, but they don't have the first idea of how to keep score.

• *Being liked.* Those of us who are motivated by the need to be liked can turn this desire into a successful sales career, but don't overlook this one important fact: People like to buy, and they like to buy from people they like. Inevitably it's my clients with the largest purchases who have the highest level of satisfac-

tion and who like us the most. Some overly nice salespeople seem to suffer under the delusion that people will like them the best if they help them get out of the studio the least expensive way possible. This just simply isn't true. People eventually forget what their portraits cost, but the portraits themselves are there for them to enjoy for years to come. So who is going to be happier and like you more: The person who buys one 8"x10" from you, or the one who buys a beautiful collage that shows all the moods of her children and the wonderful way in which they relate to one another?

SELLING UP

"Selling up" is a technique whereby you establish the client's comfort level—say, a certain dollar amount or number of portraits—and then guide them gently past it. My old boss at a theme party company was a master at selling up. Her clients would come to her with a theme and a budget in mind. "We want a Hawaiian Luau and we have $2,000 to spend on decorations," was a typical request.

Kristi would put together a proposal showing them what they could get for $2,000. Say, four tiki huts, four sun gods, a hundred leis, and ten floral center pieces.

"Great, we love it, let's go for it," the client says.

"I also put together a proposal showing you what we could do for you for just $500 more—it would really fill up your meeting area beautifully," says Kristi.

Suddenly the client has a visual of her party with everything included in the original proposal, plus twenty tropical colored streamers, floral center pieces with tropical fish in the vases, and two potted palms with twinkle lights.

"Wow," says the client, "It's only $500 more than we were planning to spend, let's go for it."

"And I can throw in a dugout canoe to hold your roasted baby pig for $150," says Kristi. And so on.

If Kristi had started out by telling her client, "Yes, I can do a Hawaiian Luau for $2,000, but I think you'd be happier with our $2650 version," the client probably would have insisted on sticking to her original budget. But by showing that she was

willing to do a good package for $2,000, and then showing the client what she could get for an additional fee, she was able to guide the client into a higher comfort zone.

The same principle can be applied to the selling of photographs.

MEETING OBJECTIONS

When you first start selling your product, you'll hear objections from your clients—reasons why they can't buy that specific product at that specific time. You'll probably think each objection is new and unique. But after you've been selling for awhile, you'll realize that you're hearing the same few objections over and over. With a little experience you'll be able to overcome these objections, because you'll know exactly what to say when they arise. Of course, the objections you hear will be determined by your specialty and position in your market. Don't be afraid to use the same answers over and over again to overcome objections if they work for you. You may feel like a broken record each time you repeat yourself, but you have to remember that it's news to your client. To give an example, a common objection heard by any photographer/designer who sells wall art is, "Oh, a 16"x20" is just too big. I only want an 8"x10"."

A possible response: "Well, it's interesting about sizing for wall portraits. Most people hang pictures that are way too small for their walls, and the portrait looks like it's just swimming there all alone. An 8"x10" would be an appropriate size for a powder room or as an easel back for a desktop or shelf, but you said you were planning on hanging this portrait over your couch? An 8"x10" would really get lost."

That's a mouthful, and you may feel silly repeating it to every client who's size-impaired, but it's true. The client will understand what you're saying, and you'll sell them a 16"x20" that will look dynamite on their walls and they'll send you endless referrals.

LOOK AND LISTEN

If you listen carefully and pay attention to body language and attitude, your clients will actually communicate to you exactly

what it is they want to hear. Think of their words as the text, and their other, nonverbal cues as the subtext. There is as much, if not more, to be learned from the subtext as from the text.

MIRRORING

Often, when two people are getting comfortable with each other and start to establish a rapport, they will start "mirroring" each other—one crosses her right leg over her left, the other crosses her right leg over her left; one leans in, the other leans in; one scratches her nose, the other scratches her nose. It happens all the time, but we hardly ever notice it. Start to look for examples, and you'll be amazed at how often you see it. Usually it is impossible to tell who is originating the action and who is mirroring it. After a while it becomes like a dance, and the action flows back and forth between the two people.

SETTING THE TONE

Instead of falling into the mirroring dance unaware, begin the client contact with the intention of setting the tone and creating the mood of the meeting yourself. Encourage a feeling of rapport by smiling, leaning in toward your client, and making a comment to which the client will likely respond by nodding or agreeing. (Isn't there a nice breeze out today? Are you going to the fair this year? Isn't it easier getting downtown now that they broadened the freeway?) Ninety percent of the time, you'll find that the client will follow your lead and mirror your rapport-fostering behaviors.

This was graphically illustrated for me once—by, of all people, a graphic designer. I was half an hour late for my appointment with her, the air conditioning in my car was on the fritz, and I'd been stuck in traffic on the way to her office. When I got there, I was agitated, hyper, and smelly. But after spending fifteen minutes with her, I felt strangely calm and unstressed. I commented to her on my way out the door that she must be an unusually calm person to have had that affect on me. She laughed so hard she snorted through her nose. "I'm sorry!" she said, "I'm not calm by nature—I'm a bundle of nerves! But when you came in I knew you were wound up, so I intentionally visualized myself calm and

at peace, and I deliberately behaved in a calming manner."

Her graphic design was almost as good as that one little piece of insight she shared with me.

DEVELOP YOUR OWN STYLE

I have seven different design consultants who sell portraits at my various studios. They're all excellent—and they're all very different. One gal struck me as too timid to do sales and I instructed her store manager not to let her do any design consultations. But as fate would have it, we were short-staffed during the holiday rush and the manager had no choice but to call upon this employee to sell. I bet you can tell where this is going—the employee had the highest sales average of the company. Her soft spoken manner and genuine love of her child subjects helped her create instant rapport with the clients and inspire absolute trust.

Another design consultant with a great sales average teases the clients and uses something of a harder sell, but in a joking way. "Oh, come on, how can you live without this shot?" is one of her common comments. Our clients love her—they ask her to come to their houses for dinner and tell me that whatever I'm paying her, it isn't enough. Now, if one of these gals tried to imitate the sales style of the other, I'm convinced that her sales average would drop precipitously.

"You have to do it your way, or it's not sincere and it won't float," says Abby Grossman, a photographer/manager at my Tiny Acorn Studio.

Shannon Lee McNeely, another of my Tiny Acorn photographer/managers, agrees. "If it's not you talking, and if you're not talking from the heart, you won't sell anything," she says.

ASSESS YOUR PERSONALITY

Think about your personality traits that you consider assets: are you funny and outgoing, serious and compassionate, supportive and encouraging? Use these assets to find your own personal ways to develop rapport with clients.

People buy from people they like, as Bryan Peterson said in his profile in chapter two. And people like people who like

them. I look at every stranger as my friend—I just haven't met them yet. I use my natural enthusiasm and silliness to establish bonds with my clients. You need to define your major personality traits and cultivate them. This will help you in all your relationships—not just your business ones.

PAINT A PICTURE WITH WORDS

When you're selling wedding photos or portraits, it's a harder sell than most because the very things you're trying to get people to give you money for don't even exist yet. Your client is looking at "proofs," which are either small photographic machine prints, thumbnail images on a computer monitor, or a PowerPoint presentation (slide show.) You need to be able to paint a picture with words for your client about how these images are going to look enlarged, framed, and hanging in their homes, or in photo boxes on their coffee tables.

You can't just say, "This would be a nice grouping," or "This would be a great 16"x20"."

You need to say, "Framing an individual shot of Billy and one of Debbie with the kissing shot of the two of them in the center would give you a lot of visual impact, and it would really tell a story about their relationship. If you framed them together in a vertical format, it would fit on a wing wall or in your powder room. And this family shot would be so elegant against your marble mantle piece with the earth tones you're all wearing." A picture is worth a thousand words, but when you don't have the pictures yet, sometimes you need a thousand words to describe them.

SUGGESTIVE SALES

"Do you need a little easel back shot for your husband's office? Father's day is coming up."

"Do you think the kid's grandparents would like this shot?"

"I bet you could take care of half the people on your Christmas list right here right now!"

"This would make a great Valentine's Day gift."

These are simply suggestions. There's no hard sell involved. And yet, when you plant these seeds in your clients' minds, you're sure to harvest a larger sale. My employees wait until the

client has already selected their own portraits. Then they tuck in the suggestions while they're writing up the order. This helps keep confusion to a minimum—they're not trying to select portraits for their homes, offices, friends, and relatives all at once. It also gives them a last minute excuse to pick out one or two more of the shots they liked and wanted but almost took a pass on. In my experience, the last minute shots picked out for Grandma or Dad never wind up in the hands of their intended recipients. Mom keeps them for herself.

HOW TO KNOW IF YOU'RE MAXIMIZING YOUR SALES

When I opened my studio I did my own design consultations for the first three years. I always had a great time working with my clients, they were thrilled when they got their pictures, and often they placed a healthy reorder down the road. I thought I was doing a great job. My average portrait sale was $1,400.

When my business got too big for me to keep doing the sales, I was apprehensive about delegating this duty—I didn't think anyone else could do it as well or have the kind of rapport with my clients as I did.

The first person I hired to take over design consultations had worked in the retail industry as a buyer and had never done sales of any kind, but obviously her practical experience served her well, because she quickly brought the studio's average sale up to $2,200. Still, her clients very rarely placed reorders, and with alarming frequency she'd get "morning after" calls from clients with buyer's remorse, wanting to reduce the size of their order.

I secretly thought that my result was the better one, until one day the two of us attended a seminar on portrait sales sponsored by Art Leather. The speaker asked the attendees, "Do your clients place a lot of reorders?" Many of us answered in the affirmative. "That's good, right?" he asked. "That's like extra money." He paused, looked over the crowd, and said, "Wrong. If you're getting regular reorders, that means you're not maximizing your sales. Do you ever have clients call you back the next day and wish to reduce their orders? That's good, because it means you're maximizing your sales."

LOTS OF LITTLE SALES ADD UP

Everybody loves making a huge sale. It's fun! It's exciting! And for some reason, the clients who make the really big purchases are usually the easiest to work with.

But if we put extra effort into making every small sale just a little bigger—by turning a diptych into a triptych, or a 5"x7" into an 8"x10", or getting in that Christmas gift for Grandma—over the course of a month that can add up to more than a little extra cash flow.

For example, let's say you own a portrait studio and your average sale is $100—the equivalent of three 5"x7"s. You have an average of fifty clients a month, giving you a gross of $5,000. If even just half your clients add one extra shot, upsize from a 5"x7" to an 8"x10", or add two sets of wallets, your average sale is suddenly $120—for a whopping $1,000 bigger monthly gross. It's increasing your gross 20 percent without a single additional client walking through your door.

ADD-ONS

Add-ons are additional products that compliment your portraits: pre-made frames, wallet books, photo boxes and albums, mats, greeting cards, etc. Having add-ons available for purchase can further increase your average sale and give your clients a higher level of service.

DON'T MAKE ASSUMPTIONS

I once had a woman come into my studio for an informational visit to decide whether she wanted to shoot with me. It was a gorgeous summer day—one of the three or so we get in Minnesota in a given year—and all I wanted to do was go to the lake with my dogs and enjoy the weather. The woman—I'll call her Jane—was ten minutes late. The lake was calling me. The dogs were milling around my legs and whining at the door. By the time Jane arrived, I was milling around and whining at the door. I took one look at her, sized her up, and decided she wasn't worth a lot of my time—I assumed she wouldn't spend a lot of money on portraits. So I didn't bother asking her the names and ages of her children. I didn't ask her how she'd heard about me

or where she'd seen my work. I didn't bother with relating to her at all—that would have taken away precious lake time, after all. I tried to rush her through the studio visit and I didn't even offer to schedule a shoot for her. I steered her toward the door and said, "Well, if you don't have any more questions, I'll walk out with you."

Luckily for me, Jane wasn't going to let me get away with it. "Am I keeping you from something? You seem distracted," she said.

The words "WAKE-UP CALL" flashed across my brain in giant letters. I suddenly was able to look at my behavior through Jane's eyes, and not mine or my dogs—and the picture wasn't pretty.

"I am so sorry," I said. "Please, let's sit down and I'll go over the information packet with you and we can look at the schedule book." I backed up, took a breath, and asked her to tell me about her kids, and who referred her to me. We had a nice visit, she booked a shoot, and the woman who I had assumed wasn't going to purchase a lot wound up being my biggest sale of that year. And came back in subsequent years until her kids graduated from high school.

Ultimately, to be successful at sales, you need to be good at relationships, expressing yourself verbally, and listening—to the text and the subtext. You should be able to take control, to be self-motivated, and to both lead (set the tone, guide the client to the best purchase for her) and follow (repeat to the client in your own words what you hear that they want.) If you can do all of this, not only will you benefit financially, but you'll have lots of happy repeat clients as well.

Opposite: Even the most adorable children's portrait won't earn money for you if you aren't ready and willing to make the sale. © Vik Orenstein. All rights reserved.

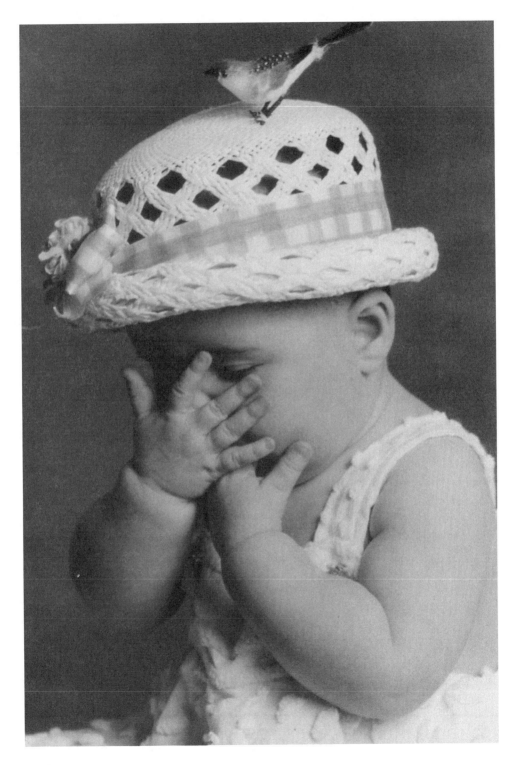

Public Relations

Public Relations, or PR, is all about community—your city community, your professional community, and your neighborhood or merchant community. By becoming involved in all these communities via your business, you get to do some good works, get the story out about your business, network and get face time with potential clients, and interweave your own history with the history of these various communities.

HIRING A PR FIRM

When you hire a PR firm, you get to take advantage of all of their contacts. And that old cliché—it's not what you know, it's who you know—well, it's true.

It All Boils Down to Relationships

I can write a press release with the best of them. But all my best exposure (local newspapers, speaking engagements, and magazines) have all come through PR guys, not when I was going solo.

PR people have established relationships with reporters, editors, club presidents, and even often such dignitaries as your mayor. Tribalism is simply human nature—we take care of our own. We're much more likely to do a story, engage a speaker, or promote a cause if it comes to us via someone we know. When

Opposite:
A publicity shot
for the Children's
Theater Company,
Minneapolis.
© Rob Levine.
All rights reserved.

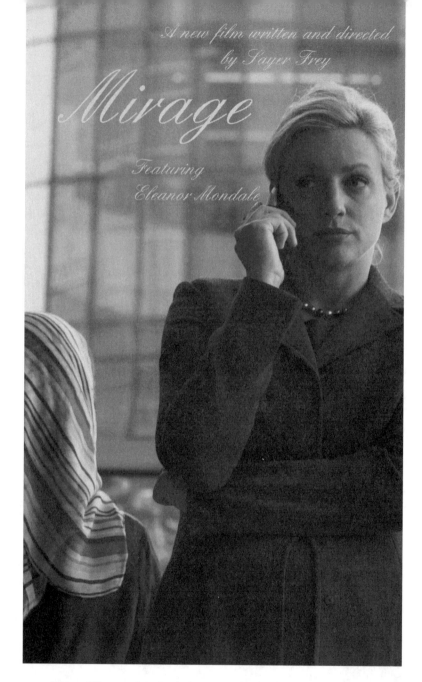

A new film written and directed by Sayer Frey

Mirage

Featuring Eleanor Mondale

you hire a PR guy, his friends are your friends. It's a pretty slick arrangement. But professional PR help doesn't come cheap. And since the goal is to make contacts—to plant seeds, as commercial shooter Patrick Fox says—it's more difficult to track the results than it is from a direct mailing piece or a marketing brochure.

Here is an example of a digitally captured editorial shot. Greener, like most photojournalists today, shoots almost exclusively in digital. © Stormi Greener. All rights reserved.

The Place Where Stories are Born

Pick up your local newspaper and look at the business section. You'll see articles featuring local businesses. The stories will have different spins on them—the angle at which the story is approached. They may be about women in business, or small companies with unusually large growth rates, or successful franchisors. Now look at the variety section: You'll see stories about local moms who have turned their hobby of recycling used mittens into teddy bears into businesses grossing $2 million a year, profiles about local children's book authors and illustrators, or stories about local organic farmers.

I used to think there were ambitious reporters out pounding the pavement, researching their local markets to ferret out these stories. I was wrong. Almost all these stories were pitched to the reporters and/or editors by PR guys. The reporters don't go out to find the stories—the stories find them. This being the case, it seems that if you want to have a chance to have a story written about yourself or your business, it would behoove you to have a professional to pitch it.

How to Find a Great PR Guy

Just as when you're shopping around for any other professional service, get referrals. Word of mouth is not only the best way to build your business, it is the best way to find other people to do business with. Ask for references, and don't just ignore them—check them out. Make a few phone calls, and see what kind of goodwill the PR guy has generated for himself among his own clients.

DOING IT YOURSELF

It's possible to do your own PR and get adequate results, but you'll have to be self-motivated. Just as it's difficult to track the results of a hired gun, it'll be difficult to track your own. And be prepared to reinvent the wheel—whereas a professional PR guy has already got contacts at every local newspaper, magazine, and professional organization, you're an unknown quantity and will have to seek out contacts of your own.

A hired gun can pick up the phone and call the editor-in-chief at *Townsville Magazine* and say, "Hey Brian, how've you been? How does Petey like going to college in Boulder? I've got a really interesting local photographer I'd like you to meet, and I want to show you her work. Her studios have set a new industry standard, and I think there's a story here your readers would be very interested in."

This call is going to go very differently if you make it yourself.

"Hello, this is Vik Orenstein, may I speak to Brian Jackson, editor-in-chief, please?"

"One moment, please." Whereupon you're connected to his voice mailbox. You struggle to think of a message that doesn't sound dopey.

"Oh, hi, this is Vik Orenstein, I'm a local photographer—I own KidCapers and Tiny Acorn Portrait Studios. I'd like to show you my work and discuss a story I think your readers may have an interest in." (If it sounds like I know of what I speak, it's because I do.)

If you're lucky, your call will be returned—by his personal assistant—who will inform you that you need to contact the story editor. So you contact the story editor, who tells you well, no, the person you really need to speak to is the photo editor, who's out of town until after July 4th, 2008.

If your timing is excellent and the magazine is hungry for stories, you'll most likely be asked to send a query letter, or proposal, before you ever get any face time with anyone.

So you can see that being your own PR guy can be done, but it's not the most efficient route.

Two examples of oil portraits created using a digital print directly on canvas as a sketch for the painting. Although the digital print becomes completely covered underneath layers of opaque oil paints, it helps the artist create the closest possible likeness to the subject while allowing a looser, more impressionistic treatment in the other areas of the portrait.
© Vik Orenstein.

PRESS RELEASES

Press releases are very brief announcements that are sent out to newspapers and magazines to cultivate stories about your business. If you want to try to write your own, Max Fallek, of Fallek and Associates Public Relations, gives us the elements of a basic press release:

- Centered at the top in bold, 16 to 18 pt. font, the words: NEWS RELEASE.
- Below that and flush left, a line that tells the recipient when the story should be released, i.e., FOR IMMEDIATE RELEASE, FOR RELEASE JUNE 1st, etc.
- Directly across from the release date, flush right, is a line that says, "For further information," with a contact name, phone number, and email address.
- Next, flush left, is the headline. The headline should never extend past the center of the page, so if it's longer than half a page, go back to the left and add a second line directly underneath the first. The headline should never be more than two half lines long.
- Below the headline, flush left, is a line that tells where the story originated, i.e., Minneapolis, Minnesota.
- The body of the story should be double spaced, with three to four spaces between paragraphs. A press release should never be more than one and a half pages long.
- Whenever possible, a photo should be sent along with the press release, with a caption running along the bottom describing the subject(s), i.e., "Stanley Kowalski, owner of Streetcar Named Desire Photography Studio."

"You can write your own press releases and have some success at it, if you remember two things," Fallek says. "You have to have a great headline—it should be a real attention-getter, it should be bold. And second, you should be fearless! Publications need you more than you need them—they have to have stories or they're out of business."

If you decide to go solo on the press releases, there are two services Fallek recommends that list every single periodical publication in the country: Standard Rate and Data Service and Bacon's Publicity Service, both out of Illinois.

The first three images were merged together and the adult body parts removed using Photoshop to create the final, composite image. It was the only way we could get a shot of the three kids hanging upside down. (Though they were happy to perform this feat without assistance while dangling from the monkey bars at preschool, they refused in the studio unless their parents—and the photographer—were holding them.)

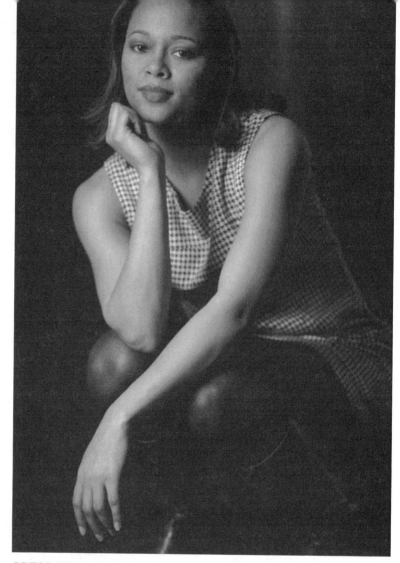

A studio portrait, such as this one, could be made by the photographer in exchange for a credit line. The subject gets a photo she can use for promotional purposes and gets the photographer's name out to the public, as well.

PRESS KITS

Once you've gotten a few articles, speaking engagements, and publications under your belt, you might want to put together—or have your PR guy put together—a press kit. A press kit is like a press release on steroids. Rather than just a single page announcing one event or story angle, a press kit is a folder (embossed with your logo or sporting a sticker with your logo) which contains any and all of the following:

- copies of recent articles written about you/your business, or that you have written for publication;
- photos of you, your place of business, and/or any recent newsworthy special events you/your business has hosted;

- your half to one page biography, including a list of any public speaking and charitable and pro bono work you've done;
- your business card and your PR guy's business card tucked into the handy-dandy little precut slots on the pocket of the folder;
- and of course, a one page or less time-sensitive press release of the type described above.

CHARITABLE ACTIVITIES

A great way to generate a good buzz about yourself and your business is to sit on a board for a charitable organization. Try to find a charity that affects your client base. If you are a family photographer, try looking for an organization like a crisis nursery or a children's hospital—a charity that makes life better for families.

"Yeah right, in all that spare time I've got," you're probably thinking. "Maybe I'll just make a donation." But while a donation is better than nothing, remember that your main goal is to make contacts, to network, to get to know people and let them get to know you. A donation gets your business name out there, but heading up the decoration committee for the annual ball or editing the newsletter will get you out there where people can see you in the flesh, and put a face with your name.

PUBLIC SPEAKING

I enjoy public speaking about as much as I enjoy putting a lighted sparkler up my nose and twirling it around. Perhaps I exaggerate. It's the anticipation of the public speaking, not the act itself, that I can't stand. Beginning about three days before any such engagement, I fret. I sweat. I worry. I get stomach aches. I practice my delivery and fret some more. The morning of the engagement I mentally berate myself for getting into such a horrible situation. I promise God that if only He allows me to survive this speech without making a total fool of myself, I'll do good deeds, be wise and kind to children and small animals, and lose ten pounds.

But then I get to the hotel conference room, or ballroom, or church basement, or women's club, or wherever the meeting is held. I see all the faces—friendly faces—and I relax a little. Then

I start my speech with a joke and I get a laugh (which is one of the things I live for), and suddenly I'm having fun. My cotton-mouth miraculously goes away, my lips stop sticking to my teeth, and when it's all over I think, "Gee, that wasn't so bad." The deal with God is forgotten. And I stick around for the snacks or lunch that always follows these things and jaw with all my newfound friends.

If you share my secret shame—the unnecessary fear of public speaking—there is help for you. Toastmasters International, among other groups, can help you overcome the fear of opening your mouth and winding up with one of your feet in it.

PROFESSIONAL GROUPS

Instead of just speaking to professional groups, you could actually join one. Pick a group that has members from all different industries and businesses. That way, not only will your fellow members think of you when they need photographs, you'll be able to chose someone who you know and trust next time you need a CPA, a lawyer, a PR guy, etc.

PRO BONO WORK

Doing pro bono work is a nice way to give something back to the community that's helped make your business such a success. As a photographer, your work will always be appreciated for use in annual reports, promotional material, newsletters, posters, press releases, and even wall art. Again, choose charitable organizations that serve in areas complimentary to your specialty. If you're an architectural photographer, shoot pro bono for a group that advocates for the preservation of landmark buildings. If you're a nature shooter, do something pro bono for a conservancy group, such as shooting a local landscape destined to become a strip mall.

There are different ways to become involved in your community, generate some goodwill for your business, and do some good deeds in the bargain. Whether you go it alone or hire a professional, the benefits will be many.

Opposite:
These four examples of the first digital capture product I offered at my Tiny Acorn Studios in 1999 helped illustrate a new service to my customers. Whenever technology allows you to offer new services, you need o get the word out to the public.
© Vik Orenstein.
All rights reserved.

Hello, Dave … The Pros and Cons of Technology

When my daughter was three she came home from daycare one afternoon and announced, "We got to play with antiques today!" Imagining twenty tiny tots experimentally banging on 200-year-old Chinese vases and batting each other with Tiffany lamps, I queried, "And what kind of antiques were those?" "The kind for writing stories," she answered. Ah, I thought, they probably brought in woodblocks from a printing press. The next day when I dropped her off I asked a (teenage) assistant teacher if I could see the "antiques." She showed me three typewriters. They were electric Smith Coronas—complete with changeable daisywheels to allow the use of different type faces. (Do you remember when type faces were called type faces and not fonts, and there were exactly two—pica and elite?) One of the typewriters even had a tiny one-line sized screen that allowed corrections to be made to the text. These were no manual Underwoods.

My definition of an antique reads as follows: it has to be older than me. These typewriters were only around twenty years old. Less than half my age. This could only mean one of two things. Either I had to change my definition of antique or I had to include myself in that category. I chose the former.

My new definition: Nothing counts as an antique unless it's at

least one hundred years old, with the exception of technological items, which are antiques (or more to the point, out-modeled junk) as soon as I purchase and/or learn how to use them.

I have an antique hard drive that's four years old. I have an antique digital camera that's two.

I'm never the first kid on the block to buy new technology. I'm of the "let's wait and see" school: Let's wait and see if it works; let's wait and see if it gets better; let's wait and see if it gets cheaper; let's wait and see if it'll just go away if I ignore it.

I always have that scene from *2001: A Space Odyssey* in the back of my mind—the one where HAL the computer says ominously, "Hello, Dave…," and you know he's gone rogue and Dave is in serious trouble. The lizard part of my brain believes technology is inherently evil.

And yet, technology delivered me from my typewriter to my laptop, making this book take only a tenth of the time to finish than it could have and allowing me to write at Starbucks and the beach. Technology delivered me from manual to auto-focus (yes, auto-focus is a good thing, even if it makes you feel as if you're cheating.) It allows me to book-keep, bill-pay, invoice, and run four studios in the time it used to take me to run one. It allows me to talk on the phone while cruising the Internet doing research and teaching courses in photography to people all over the world at one time.

So maybe technology isn't all bad. Maybe technology is like power—it can bestow great good or great evil. It's up to you, it's in how you use it.

This is perhaps nowhere more true than in the case of the new digital technology, and specifically in the impact that it has had on the business of photography.

WHAT DIGITAL TECHNOLOGY IS

Digital capture is nothing more than a new system for the storage and management of information. Good old-fashioned film is an information storage system. In film, the visual information is stored as grain. The quality of the grain gives the image its character. Digital capture stores information as pixels. The quality of the pixels gives the image its character.

WHAT DIGITAL TECHNOLOGY ISN'T

Digital capture is not a magic trick that makes it easy to make great images, or turns a mediocre photographer into a good one. It is not (yet) a substitute for film. It is not a guarantee to instant higher profits or even an assurance of less labor or lower media costs.

VIVA LA DIFFERENCE

The big difference between digital and film is that digitally recorded information is easily and instantly manipulated, stored, interpreted, printed out, and sent via computer. This no waiting, easy access twist to the photography business has affected every relationship, from the media companies to the labs to the photographers to the clients to the printers and even the consumers. Let's look at how and why.

A TYPICAL COMMERCIAL JOB, PRE-DIGITAL

In the olden days when there was only film, a photographer would be hired, for example, to shoot twenty-five fashion shots for a Sunday supplement. He'd receive a mock-up, usually consisting of pencil drawings or Xeroxes, which gave a general idea of the look or feel the art director wanted to achieve. He would also get a rough layout indicating where the photos would fall within the copy.

At the shoot, the photographer would take several Polaroids of each setup, which were scrutinized by the art director, account exec, and sometimes the ultimate client to ensure that the shots approximated the required look. Since Polaroid film is often of a different character, ISO, and grain from the film used for the end shots, the Polaroids were simply a tool to gauge whether the exposure, lighting, styling, and composition were in the ballpark. No one saw the actual results until the film came back from the lab.

Often transparency film was used for commercial jobs, which requires very exact exposure, so the photographer would request a "clip test" from the lab—that is, he would have just a few frames of the take processed so he could see the film and adjust the processing on the balance if necessary. An E-6 clip

took around five hours to process; for a 50 percent surcharge it could be rushed to two and a half hours. In any case, the client(s) was long gone and the photographer was left in peace to study the clip and instruct the lab on the processing of the balance. The client, then, would frequently not receive the film until a day or two after the shoot. It wasn't unusual for the photographer to follow the production of the job to the printing house, where he could work with the printers for the best result, thus maintaining some control of the final product.

A TYPICAL COMMERCIAL JOB, POST-DIGITAL

The same job, post digital, proceeds in a similar fashion until the stage where the Polaroids used to come in. Remember, the Polaroid was only a tool to help anticipate the outcome of the shot. But with digital capture, the take is immediately available to everyone—even if they're not present, thanks to high-speed Internet technology. And what you see is what you get. The final work can be viewed instantly, while the talent, stylists, make-up artists, etc. are still there, allowing endless changes to be made to the image, both small and large. This necessarily makes the process more collaborative.

"Now they can noodle a shot to death," says photographer Paul Irmiter. "This technology was supposed to shorten production time, but you get bogged down in the course of a shoot when the client is collaborating. It can take twice as long. Which is ironic because didn't they hire you for your professional expertise in the first place? Now that's totally out the window."

And remember how in the old days the photographer got some time alone with the take to adjust and edit? Now there's no lab time, so at the end of the shoot the client can go skipping off with a CD in hand, and the shooter has no say in the ultimate look of the finished work. "I almost never work with the printing house anymore," says commercial shooter Bob Pearl. "The client is in love—they leave with the disc and they can manipulate the images any way they want." But Bob is less than thrilled. "It was nice to be able to see a project out to the end and exercise some artistic control. Now I could see an image I shot and not even recognize it."

While this faster turn-around time was supposed to make a photographer's life easier, all it's done is shorten deadlines because the client's expectations sped up along with the technology—and then some.

"Everyone used to factor in lab time, messenger time," says Pearl, "but now they expect to take their disc with them when they go. So when you do have to shoot film—and sometimes you do, some things just look better on film—they just don't want to wait. They want that immediate gratification." All this seems dire. But there are some photographers who love to shoot digital.

PHOTOGRAPHERS WHO LOVE DIGITAL AND WHY

"You can make beautiful self-promotion pieces quickly and easily, in as small a quantity as you need, with total control, in house, no waiting, for very, very low cost," says Pearl. He also notes, "And there are beautiful papers you can use, so it's not just a visual thing, there's a feel in your hand of the paper that's great, it really appeals to the clients."

Commercial shooter Patrick Fox makes many of his images with digital capture. He doesn't feel his creative or production process has changed much as a result of the new technology. And though he likes digital, he's equally at ease with film. "I have clients who swear by digital and don't want me to shoot anything else. I've got clients who hate digital and would never accept it. Usually my clients just trust my judgment on what to shoot, just like they did before digital," says Fox. "And another plus is showing my work to potential out-of-town clients. Before I'd have to FedEx my book. Now they can get it on the Web."

"I'm a convert," says NBA/Timberwolves team photographer David Sherman. "I shoot all my hand-held work digitally now. As soon as the high-end digital system I want becomes affordable, my (Hassel)Blad will be a thing of the past."

But while David embraces digital media, he also is realistic about his limitations. "It doesn't necessarily ease up your work load. In fact, I'll sometimes shoot film for wedding clients because it's faster and easier to create a proof book than it is on the computer."

And David cautions photographers on how they present

information about digital media to their clients. "I think photographers should stop discussing their technology so much with their clients. They should just shoot what's right for the job. That's what they're hired to do."

Stock/portrait photographer Jim Miotke likes the advantages digital technology offers him in terms of storing and cataloging stock images and money saved by avoiding film and processing costs. "It's handier to mange files than slides. And it's just easier and cheaper to get your work out there to potential clients."

Bob Pearl notes that, while digital media is not the big money saver for commercial shooters that it was once touted to be, "You can still save your clients money depending on what you're shooting. If it's a whole boat catalog or something like that, for instance, the savings over film is pretty noticeable."

Architectural shooter Peter Aaron doesn't use digital capture yet, but he embraces the ability to improve images through the use of Photoshop. "You can make improvements on the pictures. Lots of improvements," he says. Unfortunately, many of the publications for which he shoots are not happy about receiving digital files. "It's a tough time learning the (digital) system, and I believe the magazines were disillusioned by photographers who thought they had achieved Nirvana through digital, but actually didn't know how to make good digital images. But the trend is in the right direction. *Architectural Record* and *Interior Design* magazines are now grudgingly accepting digital files."

"Look at this!" says former photojournalist turned commercial photographer Rob Levine, displaying a theatrical still of a boy in a hat at 100 percent enlargement on his computer monitor. The shot is beautiful. Even at that enlargement the pixels are not apparent, and it's hard to tell that this is a digitally captured image, and not film. "This was shot with a Nikon D1," he adds, pointing out that this was not a $16,000 medium-format digital back, but rather a $1,600, top-of-the-line consumer grade camera. And the shot wasn't even captured at the highest quality setting; it's only a fine JPEG, and yet you can even see blond hairs on the boy's arm. "These look gorgeous printed with a plain old ink jet printer. "This why I love digital." But even Rob sees some drawbacks to the new technology.

"I think a huge expense that used to be passed on to the client is now being foisted back onto the photographer. It used to be the client paid for the expense of film and processing. Now, sure, digital media costs next to nothing, but the equipment costs a whole heck of a lot more. And the client doesn't want to help shoulder that expense. They want to be able to pay the same day rate they did pre-digital."

PHOTOGRAPHERS WHO HATE DIGITAL AND WHY

Fashion/commercial photographer Lee Stanford postulates that it's not so much digital capture that has changed the face of photography, but Photoshop and other software that allows manipulation of images easily and instantly.

"You just don't have to be as good anymore," he says. "If you shoot an image and there's something wrong with it, you just go into Photoshop and fix it. You don't even have to be as good at Photoshop itself anymore, since with each new addition it becomes more and more user-friendly." But is a mediocre or bad shot revised in Photoshop as good as an image that was shot right in the first place?

"It's good enough," says commercial photographer Paul Irmiter. "People are looking for value in photographic work in an entirely different way post-digital. Before, they saw your work, they liked your style, so they hired you to shoot their product. They paid the photographer to dork around with things until they looked cool. Now everyone has a little consumer grade digital camera. They shoot their own images and say, 'Oh, isn't this great? Sure, there's a nasty ol' shadow here, but I'll just take it out in Photoshop.' So now, the value for them is in spending less money and just getting a kick out of doing it themselves. The quality isn't the main goal anymore."

Says one commercial photographer, "Digital opened up the business for anyone who wanted to be a photographer. I saw one guy get into the business with a (Nikon) D100, shooting stuff for Web sites. I've had designers, people who where previously my clients, call me up and ask me what camera they should buy, or how I would light a certain set-up. I don't know if its audacity or naivete."

Another way digital technology has taken the artistry out of commercial photography is by making it easy for art directors and designers to use stock photos for mock-ups.

"There's no key-lining, no story boards, no skill in it anymore," says Stanford.

Irmiter adds, "They go online and pull stock photos to use in their mock up. Then they come to me and say, 'I want this exact look, this exact picture. Shoot it this way.' Once I asked a guy, 'Why don't you just buy the stock photo?' He said it was cheaper to have me reshoot it. So essentially, he was using me as a Xerox machine. And any time any photographer recreates someone else's work like that, it can only be a pale imitation. Not to mention the potential for copyright infringement."

Advertising/architectural photographer Karen Melvin dislikes digital and doesn't use it. "In terms of ease of operation on a location shoot, digital technology just isn't there yet. I'm way behind the curve on digital shooting and post-production, mainly because computers frustrate me and finding time to sit down and learn it is a problem. Digital just isn't worth the investment for me yet. I'd rather move that bowl of cherries on the shoot—not after."

My personal peeve about digital is the issue of matching color balance and contrast. When you shoot film, what's done is done. There's no room for interpretation—the color balance and contrast are what they are, and there's no way to mess it up. But when you're dealing with digital files, first you view them on your monitor. Then you give them to the client and they view them on their monitor. Then they give them to their printer and they view them on their monitor. None of these monitors are calibrated exactly the same. There's a lot of room for mistakes to be made, and when photographs are your product, the quality of the final product always reflects back on the photographer, whether he had any control of the outcome or not.

Many photographers deal with this by presenting the client with a digital color proof. Labs and printers try to mitigate the potential for miscommunication by calibrating the monitors of their regular clients to match their own.

Creative issues are not the only ones complicated by digital.

THE DIGITAL IMPACT ON PHOTO LABS

The new digital technology has caused a lot of changes in the photo lab industry. Formerly, professional labs typically had a black and white department for hand-line and machine processing and custom and machine printing; an E-6 (transparency) department for all formats; a mini-lab for color processing and "proof" or 4x6 prints; and a color printing department offering a variety of types of prints. They may have also had a variety of other products and services, such as copy stand, Kodaliths, color Xeroxes, and other photographic goodies. All the equipment to support these services takes up space and costs money.

When digital technology arrived, labs were forced to make their existing equipment share space with new digital scanners, computer systems, and printers—some of which fill up a whole room. Adding digital services wasn't as simple as one might imagine—different printers have very specialized applications. Some make over-sized prints on art paper using archival pigments, some make photographic prints from digital photo files, some make digital prints from photographic originals... and list goes on. Many labs ditched their old, time-honored services to provide the most comprehensive digital services. This was good news for the small, independent black and white labs, which now dominate the custom black and white market.

Why would these labs forsake the old tried and true in favor of a new and constantly changing—not to mention expensive and largely unproven—technology?

"We want to offer our clients the newest and the best products," says Scott Worrell of Pictura Lab in Minneapolis. "No one wants to lag behind."

Has this commitment to digital paid off?

"It was really hard on everybody in the industry for a while," admits Chip Specht of Pictura Lab, "just as any big transition will be. Used to be, you could buy, say, a horizontal enlarger for around $80,000. Now a digital system is $400,000. So there are larger capital expenditures up front, but ultimately you can have lower labor costs, and, once you earn back your initial investment, better margins."

Not every lab survived the transition from analog to digital.

Specht has a few ideas about what helped his lab make the leap. "Our move to digital has been an unqualified success. It's partly good luck, and partly just getting really excellent people who are technically savvy to run the show. Our people are the greatest at every aspect of digital work and at keeping a very high volume of information flowing smoothly. Effectively moving files around is an art."

Digital has obviously been good for Pictura Lab economically. But does Chip pine for any of the good old-fashioned ways of doing things?

"No! We had our technology pains and growing pains, but where we've wound up is better than the old days. Some people who like the idea of the hands-on, craftsman sort of work think this step is wrong, but I don't think it's wrong, it's just different."

THE CLIENT'S TAKE ON DIGITAL

Cynthia Gerdes shoots has all the promotions for her national chain of toy stores and for her national toy catalog shot on digital. "Digital is wonderful!" she says. "We can see what we've got right there at the shoot. We use kids of course, and now we can get them in and out of the studio in 10 or 15 minutes because we know what we've got, we even know which shot we're going to use before they leave the studio."

MY OWN DIGITAL STORY

My own attempts at offering my portrait clients a digital product have been exercises in frustration. All along I had kept my finger in the pie, following the digital revolution as it unfolded and dabbling in scanning, Photoshop, and digital printing with various media and techniques. None of the results were consistent or good enough to justify choosing digital over our old reliable film. It was five years before I was able to create a product I could stand behind. I finally developed a nine-layer Photoshop process that allowed us to create beautiful, moody duotone, sepia, and digitally hand-colored prints that had the richness of film, though with a different enough character to be distinct from our other portraits. We found a lab that promised us that, once our monitor was calibrated to theirs, we'd never get an

unpredictable result. They lied. Of course I initially blamed this on the lab. I always like to establish blame—it's the cornerstone of a good management style. Ultimately, after exhaustive study, I realized the inconsistency in our product was due to a combination of variables that occurred during capture, and that we either had to have two totally different lighting set-ups and new lenses or we had to withdraw the product. We elected to withdraw the product. I am still keeping my finger in the digital pie: one of these days I will develop a digital product that will be everything I want it to be.

HOW THE DIGITAL REVOLUTION HAS AFFECTED INTELLECTUAL PROPERTY LAWS

Even before digital it was sometimes tough to help people understand copyright infringement and intellectual property law. They hired you to make a picture, after all, so shouldn't it be their property? Shouldn't they own it? Shouldn't they have all the rights to it?

In the old days I would occasionally encounter a client who took their proofs and went directly to the corner photo store to have copy negatives and prints made, thinking they were getting a steal. It was a steal all right, but really was no deal. The quality of prints made from 35mm copy negatives made from 2"x3" proofs was abysmal and satisfied only the most unsophisticated clients.

But then along came digital scanners and suddenly I'd receive Christmas cards from my clients made from scans of my portraits and proofs, and while these were nowhere near the quality of a custom hand print, they were good enough to be passed off as such to doting aunts, uncles, and grandparents. And then a funny thing began to happen. We started hearing from recipients of these "black market" computer prints from people who thought they were the work of my studio. "You photographed my grandson last year and my daughter gave me a hand-colored print, and it's fading already. I thought you people were supposed to do archival work," was how the conversation usually began. Then I had to explain to them that there'd been a miscommunication between themselves and the portrait-giver, and

that the print was actually made from a computer scan, was not an example of our work, and in fact was in violation of our copyright. Often there was a stunned silence. I could only imagine what went on between these family members once this little tidbit of information was out of the bag.

We try to deal with this problem by asking our clients to sign an informal letter stating that they understand that KidCapers Portraits retains the copyrights to all images and that they are not to be copied or reproduced in any way without our written permission. Though we try to be as clear as possible, we still sometimes get the question, "But I can scan them, right?"

Its human nature: You own a scanner, and you own a photo, and when you get them both in the same room it's hard to restrain yourself.

The ease with which stock photos can be downloaded—at relatively little expense—has also served to make the average person's view of copyrights more cavalier.

CHOOSE YOUR WEAPON—DIGITAL OR FILM?

So when and why should you go digital? With a digital back for a Hasselblad going for around $16,000 new, the cost of making the leap can make one pause. Complete systems can top $200,000. What makes it worth it to take that kind of financial risk?

You've heard the old slogan, "digital or die!" A lot of people believed it. But time has taught us that, while even devout film shooters agree digital is the future, the future is not now. "If you're not busy shooting film, you won't be busy shooting digital," says Fox. "Don't waste your money."

It's simple business sense: Don't make an expenditure for your business that won't pay itself back either in increased business or in savings on the cost of doing business. In other words, if you buy that $200,000 system, you want to be awfully sure that having that system will either bring you $200,000 worth of extra business or will save you $200,000 in media costs.

Patrick Fox got into digital cautiously and methodically, and for him it has paid off. "I wasn't the first one on the block to get digital, but I wasn't the last, either. I've got some very high-end equipment that I paid very little for because I bought it from

other studios that were going out of business."

• *Is digital getting better all the time?* Yes. That's the good news and the bad news, financially speaking.

• *Is film dead?* No. But digital is the future. Fashion photographer Lee Stanford postulates, "Someday darkroom hand printing will be a curiosity, a lost art. It's sad. I love the darkroom. A good gelatin print is a gorgeous thing."

• *Are digital systems getting cheaper?* It depends on how you buy it. Like old Gramps always said, "Never pay retail."

• *Is digital capture as beautiful as film?* Again, it depends. It depends on who is managing the files and on the subject matter—some things just don't look good captured digitally, just as some things don't look good on film.

• *Is digital a magic bullet that will bring automatic success?* No. Photography is the destination, and the destination hasn't changed. Now we just have another path to get there.

Above: Two shots that demonstrate an example of how Photoshop can be used to combine images. Publicity shot for The Children's Theater Company, Minneapolis. © Rob Levine. All rights reserved.

The Life Cycle of a Small Business

A small business goes through growth stages similar to those of a child. Each stage has its unique joys and challenges. Parenting demands that you be able to adapt to the wildly fluctuating needs of the child—there are times you have to do absolutely everything for the child and completely control his environment, and there are times when you have to let go of the control and let the child function on his own. Most of us are best at one stage or another; those of us who are great at caring for a baby, for instance, probably have a harder time allowing their child to spread his wings and take risks when he's older. These parents will also be the business owners who will have a difficult time learning to delegate responsibility and let go of control when their business reaches the stage of development that requires it. On the other hand, those who are good at relinquishing control will be especially challenged by the stages when their businesses require their absolute attention to even the smallest of details. So no matter what type of parent/small business owner you are, you will find some periods of growth difficult and some rewarding.

GESTATION

Gestation is an exciting time. You're picking out names and furniture, making grand plans, and you're full of hope for the

future—whether you're expecting a baby or starting a small business.

There's also trepidation: What if something goes wrong? What if this is the wrong time? What if you can't handle the responsibilities, the changes this new addition will bring? What if you fail? What if your dreams are dashed? You really do want to do this—or do you?

You have to make a conscious effort not to let your doubts get you down. I once asked a pastor if he ever had doubts about God. He said that doubts are to belief as ants are to a picnic— you can't have one without the other. You just need to keep the ants off your food.

In spite of ants, gestation is one of my favorite stages of business. I like it so much I go through mini gestation drills when I need to recharge my batteries. I create an entire new studio: I pick a name, a market, a location, a corporate image, promotional material and a marketing plan, products, fee structures and price lists, type of business entity, and so on. Some of these little drills result in actual marketable concepts, and I file them away for future reference, just in case I ever think I'm ready to run more than four studios. Some of them are just plain clunkers. But it allows me to flex my business and creative muscles, keeps me thinking on my feet, and lets me spend a little time in that wonderful gestation reverie.

INFANCY

When I was expecting my daughter I made some grand plans for all the things I'd get done while I was at home with the baby. I was going to get twenty years worth of snapshots labeled and into albums, clean and organize all my kitchen cupboards and closets, write a book, and catch up on my reading. I mentioned this to a client, a mother of four, and she laughed so hard she nearly wet herself.

"Darlin'," she told me, "you won't be able to do anything except take care of your baby. Even Wonder Woman wouldn't be able to do all that."

I smiled politely and nodded, while I secretly tagged her as a wimp.

As it happens, she was right. All I did for the first three months after my daughter was born was feed her, sleep when she slept, change diapers, bathe her, and accept hot dishes from charitable neighbors, friends, and family. I guess that's not all I did—I actually got to watch reruns of Gun Smoke when I was feeding her once in a while.

The drill is the same for a newborn business. It will consume all your time and energy. If you don't like hard work, don't start your own photography studio. Because during this phase, you'll be doing almost nothing but working.

"There's a reason why employees account for 90 percent of the population," says CPA Jim Orenstein. "That's not bad, it's just how it is. Not everybody has the drive or is willing to live with the risks of starting their own business. Some people like to leave their work at 5 p.m., go home, and not think about it again until 8 a.m. the next day."

In the infancy of my first studio, I often worked sixty to seventy hour weeks. I hadn't yet learned the value of delegating or the way to go about it. My business fluctuated seasonally, so I knew I couldn't commit to permanent employees, but many of the functions I needed to free myself of were simply not those that could be technically considered for independent contractors. I ultimately suffered from burn-out, and with my 20/20 hindsight, I realize that if I'd gotten things into balance earlier and worked smarter, not harder, I could have been more profitable earlier. And yet, when I look back at that time of my life/business, I look back with fondness—nostalgia, even. Possibly I'm experiencing selective amnesia, and I've simply blocked out the agony. But it was a happy, exciting time for me, if indeed I'm remembering it correctly. Not that I would choose to go back and relive it in exactly the same way.

POST-INFANCY

Toddlers are dangerous to themselves and others. Their foreheads are exactly the same height as the edges of table tops, and they never look where they're going. They fear monsters under the bed, but not a twenty foot drop from a window. Biting and hitting are parts of a normal developmental stage. It's amazing

to me that any of us survive into adulthood at all, let alone without facial scars.

The toddler stage of business is equally fraught with dangers. This is when we entrepreneurs have enough mobility and can get enough momentum going to plow our heads smack into that table edge.

When I was a business toddler I had enough capital and enough knowledge to feel a little cocky and make some very costly mistakes.

I'd had good responses to several direct mailings. I'd been conservative and mailed to only 2,500 highly targeted families. I'd used 4"x6" postcards sent at the bulk rate, and meticulously followed tried and true marketing wisdom, including a special offer, call to action, and timely expiration date.

In good old American fashion, I figured if some was good, more was better. I created a new, 6"x9" postcard. I broadened my target and mailed the postcard to 10,000 families, even though most didn't fall into my prime demographic. I neglected to include a special offer, call to action, or expiration date. If all that wasn't enough, I also got really lazy, and rather than go to the trouble of the pre-sorting and bundling necessary to mail at the bulk rate, I went first class. Can you see where this is going? The previous mailings had cost about $1,500 each total, and had resulted in about $9,000 of additional business. The 6"x9" postcard mailing cost $4,200 all told, and resulted in three—yes, three—inquiries. I don't remember if any of those callers actually booked. It was a disastrous result. According to direct mailing expert Rick Byron, even the worst mailing piece sent out to households randomly selected from the phone book should result in a .05 percent return. So I'd set a new record—but not the one I was hoping for.

That was the dangerous to myself part. The dangerous to others part involved the entrepreneurial equivalent of biting and hitting. At a certain point, after I'd had steady growth for awhile and felt confident that it was going to continue, I decided that if I didn't like a client, I didn't have to give her good customer service. In some cases I even decided I didn't have to work with people I didn't like. Fortunately, just as with real toddlers, this

stage didn't last long, and I quickly came around to realize that everybody deserved great customer service and that I really could get along with and even like anyone if I wanted to. It's interesting to note that many small businesses fail in their second year—when they're two. Toddlers are reputed to be most difficult at the same age, hence the phrase "the terrible twos." Coincidence? I don't think so.

THAT AWKWARD STAGE

I love to photograph preteens—ages nine through twelve are especially delightful. The kids are all elbows and knees, their faces haven't grown into their teeth, and they're not sure whether they want to be treated as grown-ups or little children. Their mothers describe them as "Jekyll and Hydes," alternately disdaining their parents and craving their affection. They're as likely to bring their favorite teddy bear to a shoot as to polish their nails, beg their mothers to let them wear make-up, and try out some Britney Spears poses in front of the camera. They're alternately insecure and full of themselves.

Businesses go through a similar phase. Sometimes you feel like the new "it" girl—you're the wunderkind, the precocious youngster who broke away from the pack to bring your new product and your new voice to your market. Lots of people know who you are and some of them tell you they love your work. Others see your book, they're impressed, and they say, "Gee, why haven't I heard of you before?" You're confident.

Sometimes, though, you realize there's a lot you don't know. You lose out on a job and you wonder if the potential client saw through you—if he figured out that you're really an impostor, that sometimes you're out of your depth technically and you're making it up as you go along.

Everyone goes through this—you're not alone. It's the preteen version of the gestation parable of the ants at the picnic. Keep them off your food and you'll be okay.

YOUNG ADULTHOOD

Now you're not having the mood swings, doubts, and insecurities you experienced in earlier developmental stages. Your busi-

ness is stable, but you're still excited and engaged. Each job is a challenge. You realize you don't know everything, but you also realize you can learn whatever you need to know to meet the demands of each new job. You're still experimenting with new products; nobody has to remind you to change out images to freshen up your book; you look forward to visiting with your old, loyal clients, and marketing to new ones. Your business is still growing, although not at the rate it once was. Still, there's enough growth that you feel strong, and life is good.

MIDDLE AGE

Yawn. You're coasting. Everything any job requires of you you've done successfully many times before. Your growth topped out some time ago, so while you're making a good living, you're not increasing your income level each year like you were before. You can't remember the last time you put new shots in your book—you can't remember the last time you showed your book. You're content to work with the clients you long ago established relationships with. Long ago you forgot that happy feeling you got when people asked you what you did for a living and you got to say, "I'm a photographer!"

You're still at the picnic, but there are no ants, and you can't believe you miss them but you do. This is the time you need to create new challenges for yourself. You need to bring back the risk that you might fail at something. That's what keeps life interesting. Some suggestions are listed in the appendices at the end of the book.

THE GOLDEN YEARS

Now you're winding down. Unlike other types of businesses, yours probably isn't salable. So your exit from the business you've worked in for so long might not involve that big, final deal that results in more feathers for your retirement nest. It'll be more a matter of riding out the end of your lease and selling off your equipment, props, and backdrops. Ideally, you'll have planned for this likelihood and you'll have saved enough money to keep yourself comfortable.

This could be an anticlimactic ending. When you're self-

employed, there's no one standing at the end of the road holding out a gold watch or serving cake and punch. You might want to plan your own retirement party, some way to mark this milestone for you, your family, your clients, and vendors. Or perhaps you want to celebrate a business life well-lived by taking a special vacation.

There you have it—cradle to grave. If you're lucky and you work hard, your life as a photographer will probably look something like this. If this picture looks good to you, you're in the right place.

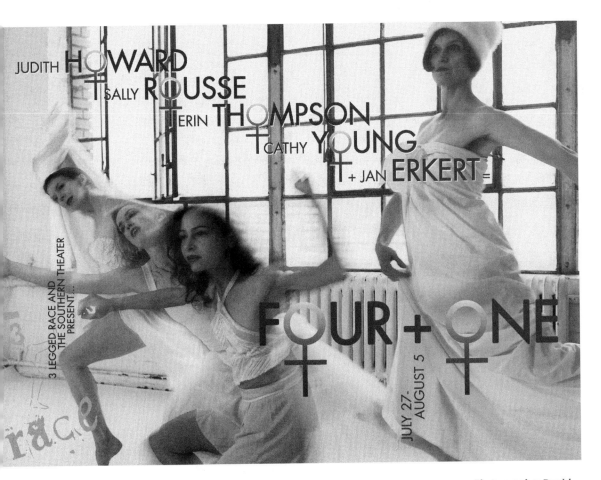

JUDITH HOWARD ☿ SALLY ROUSSE ☿ ERIN THOMPSON ☿ CATHY YOUNG ☿ + JAN ERKERT =

3 LEGGED RACE AND THE SOUTHERN THEATER PRESENT...

FOUR + ONE

JULY 27- AUGUST 5

Photographer David Sherman is an excellent example of a photographer who has ridden the ups and downs of a small business cycle. He remains successful with photos like this one because he pays attention to the needs of his clients.

Lawyer Jokes: Legal Issues

t's fun to make jokes about lawyers—until you need one. Then the fun is over. The fact is that a good lawyer is like a good friend: You tend to take her for granted until you really need her.

COPYRIGHT AND INTELLECTUAL PROPERTY LAW

"The entire premise of copyright law is that if you don't give artists protection, they will have no incentive to create," says business attorney Janet Boche-Krause. "Unfortunately, there is more copyright infringement going on now than ever before. The new digital technology just makes it so easy to copy that users don't stop to think, 'Oh, is this a copyright violation?' I am convinced that there are a whole lot of people out there who really do want to do the right thing, and are not intentionally stealing intellectual property."

Similar transitions affected the movie business with the advent of VCR's, the music business with the advent of CD burners, and the publishing business with the humble Xerox machine. That there are still film makers, music CDs, and books gives me hope that photographers can ride out this transition, too.

Just as the buyers of photographic images contribute to the increase in copyright infringement, so do photographers ourselves.

"You must be vigilant and informed as to the rights you are giving away when you sign a usage agreement," says Boche-Krause. "For instance, when you sign off on print rights, what does that mean? Perhaps you believe you're only selling the rights to paper prints, and the user believes he is buying e-print rights, as well. If the agreement is full of broad, all encompassing language, the buyer might be right."

Boche-Krause recommends making the agreement as specific as possible, such as, "… I grant Doe Company, Inc., the right to use said images in this issue of this magazine." That way, there is little room for dispute.

But what if there is no contract?

"If there is no written contract, then we go back and look for what is called a verbal contract. "Okay, I'll shoot these dog treats for you and you can use them in your dog treat brochure," is an example of a verbal agreement.

"It can be very difficult to go backwards and piece together a verbal agreement," Boche-Krause says. "Get it in writing."

What should you do if someone violates your copyright?

"Invoice them. Call them up and say, 'My image ran in your magazine on such and such a date without my permission. Normally I'd charge you $300 for this, so I'm sending you a bill for $300.' Since most people do want to do the right thing, you'll probably get results this way," says Boche-Krause.

What if the client is still uncooperative?

"Then let them know you'll need to address the issue of their copyright violation," she says.

When someone uses your work without your permission, it's easy to feel violated. But you should always try to negotiate some resolution. Litigation should be a last resort. As Boche-Krause says, it's very expensive to sue and win. And winning the case and collecting your winnings, which may not even cover your court costs, are two different issues.

Most clients doesn't sneak behind your back and steal your copyrights—some of them just try to take them up front.

"It's certainly become more Draconian," says mountain-climbing shooter Beth Wald. "It used to be that most magazines were small companies with whom you could trust a gentlemen's agree-

ment. But today, most magazines have been bought out by huge corporations. There's less personal responsibility. Some magazines will try to get you to sign away your copyrights after you've already been given the assignment, and some will even try to make this a condition you have to meet in order to get paid."

Hmmmm. Well, these tactics are largely illegal. But obviously they work some of the time, or magazines wouldn't be employing them. When in doubt—contact your attorney before you sign.

EMPLOYMENT LAW

Whether you hire independent contractors or employees, there are important tax and legal implications to consider. To start with, you need to know the difference between a contractor and an employee. An employer's obligation to an employee is greater than his obligation to a contractor. You may have someone working for you who you believe is a contractor, but if this is ever disputed and the state decides that the individual was actually an employee, you may be liable for taxes, penalties, unemployment insurance, worker's comp, and more.

Even if you have an employee and you both know he's an employee, there is still the question of what type of employee he is—different types have different rights under the law. Is he full-time? Part-time? Temporary? Seasonal? Hourly or salaried? The category into which he falls will determine if or how much paid time off, medical coverage, overtime, and other perks he is entitled to by law. These distinctions are all important. For instance, you are not required to pay a salaried employee overtime. However, you also cannot require this salaried employee to work certain set hours—he is supposed to be able to get his job done and receive his set pay whether it takes him twenty hours this week or eighty. On the other hand, you are required to pay an hourly employee time and a half for hours worked over either 40 or 48 hours in a given week, depending on the size of your gross, except on Tuesdays during a full moon if you twirl three times and spit over your right shoulder.

All this sound confusing? And that's just the tip of the ice berg. Yes, if you're diligent and know what questions to ask and are willing to wait on hold for hours at a time, various government

agencies can answer your questions regarding employment issues. But in my experience, it's easier, faster—and if you factor in the value of your own time, cheaper—to consult a business lawyer.

Your friendly neighborhood attorney can provide you with a boilerplate employment agreement or customize one as needed to reflect your situation. He can provide you with incomplete agreements, and these little documents can be very important to photographers who are hiring other photographers. He can help you determine what category of contractor or employee you can/should hire for maximum profitability and minimum risk. He can also help you avoid potential lawsuits by advising you on how to handle such delicate situations as interviewing, hiring, disciplining, and firing employees.

TRADEMARKS AND SERVICEMARKS

Some people neglect to protect their business name, much to their detriment. Perhaps they don't understand the necessity, or maybe they simply don't want to spend the money. While it isn't cheap—the name search alone (to establish whether someone else already owns the rights to the same or a similar name) runs about $400—it's money well spent.

HOW TO FIND THE LAWYER WHO'S RIGHT FOR YOU

Like photographers lawyers can be very specialized, or maintain more general practices. What type of lawyer you'll be most compatible with is something you need to explore for yourself. I once had different lawyers for trademarks, employment law, tax law, real estate law, and corporation partnership issues. I now have one lawyer who handles 95 percent of my legal work. If I have an issue that is outside of her specialty, she refers me to someone else, and I've always been happy with her colleagues. I'm thrilled with her! Her philosophy and her approach to my legal issues are practical, straight forward, and firm but non-combative. She saves me money, rather than costing me money. I have not always been this lucky.

The first attorney I used for employment law was with a huge firm that had a great reputation. He most certainly knew his stuff, but dealing with a case of employee theft cost me

$8,500—slightly less than the employee absconded with. When I questioned his bill, he immediately knocked $1,000 off of it. Maybe I'm perverse, but this made me feel less trusting of him, as if he were padding the bill and chalking the effort up to the "you can't blame a guy for trying" school of thought.

Then when I asked him for a basic, generic employment agreement, he fired off an eighteen page document to me. No, I'm not exaggerating. If I were a potential employee I never would have signed it, so I couldn't in good conscience ask my potential employees to sign it.

While the big firm legal eagle was not a good fit for me, I stayed with him for a number of years because I didn't realize there was anyone out there who practiced law differently. It wasn't until I worked with my second lawyer on employment issues that I realized lawyers are as different as snowflakes. Do a little shopping around, and you'll find one who's right for you.

TAX LAW

A tax attorney is the specialist you'd consult when choosing what type of entity your new business should be. (Your CPA can assist you here, too—see chapter 16.)

And if you're ever audited by the IRS or the sales tax division of the state in which you live, you may want to consult this specialist—even if your nose is clean! It's nice to have a professional advocate when you're venturing into an area in which you have little or no experience.

REAL ESTATE LAW

My first three studio leases I signed without the benefit of consultation with a real estate lawyer. I lucked out: My landlords were fair, the lease agreements were standard and relatively easy to understand, and they were based on rent per square foot plus CAM (common area maintenance) charges. Whenever one of them came up for renewal, there was a reasonable percentage increase that reflected the state of the market, and I signed again, and that was that. But then lease number four came along. This landlord was considerably more ambitious. He wanted major concessions I'd never even heard of before: a

deposit and a personal guarantee, a percentage of profits, the right to enter the premises and examine my books at any time, and the list went on. My initial response was to stomp my foot and walk away. But the space in question was perfect for my studio—it needed hardly any build out. And the location was primo. So I was stymied. I finally consulted a real estate lawyer who assured me that while the lease was heavily weighted to benefit the landlord, the terms and dollar amounts were not unreasonable for this prime retail location. He recommended a few changes (the deposit or the personal guarantee, not both), I signed the lease, and all is well. Yes, it cost a couple of hundred dollars to have the lawyer read the lease, but it probably saved me megabucks in aggravation and worry. So whether you're renting or purchasing your own commercial property, a visit with a real estate attorney can grant you great peace of mind.

PONYING UP

There are as many different fee structures for lawyers as there are, well, lawyers. Most charge by the hour, with rates ranging from $100 to $700. Generally lawyers with the big firms charge the highest rates. You can find excellent lawyers in smaller or solo practices who charge less than $250 in most areas. As with other expenses, fees tend to be higher in bigger cities. Lawyers with a particular expertise may charge more than general practice lawyers.

WHEN TO LAWYER UP—AND WHEN TO GO IT ALONE

Possibly because we're Americans we tend to glamorize the "Little Guy all Alone Against the Big Guy" approach to life. We love the idea of a lone photographer going into court and facing off against a big ad agency and winning. I admit I know a couple of photographers who have done just that. But generally, if you're going anywhere but conciliation court (where you're not allowed to bring a lawyer), I personally believe you're doing yourself a disservice by not having professional counsel. A photographer going into civil court without an attorney is a lot like an amateur with a snap-shooter trying to take professional portraits. Quite frankly, if I were a judge sitting on a case where one

of the parties showed up without representation, I would think said party wasn't taking the proceedings very seriously. If you do decide to represent yourself in court, either due to financial necessity or personal choice, take time and make an effort to prepare yourself. Learn the court rules and procedure—you can get information on these from the court clerk and from the Internet. Don't hesitate to ask questions in advance. Bring your evidence, witnesses, and be ready to explain your side of the story clearly and succinctly. Stick to the legal issues, and check your emotions at the courthouse door.

Short of going to court, I've discovered that a letter from my lawyer gets a quicker and more desirable response than a letter from little ol' me, especially when the topic is copyright infringement or uncollected fees. Go figure.

Now that I have an attorney I like personally and professionally, I find lawyer jokes a lot less funny. So hold the humor, and find a good generalist with a small—even a one-horse—operation, who can help you with your day-to-day business issues and point you to a specialist for those occasions when it's called for.

Whether you put yourself in the path of danger to get the perfect sports shot or you simply need to protect your copyrights, a lawyer can be as essential to a photographer as a camera and light meter.

Accountant Jokes

I don't know why there are so many lawyer jokes and almost no accountant jokes. My Certified Public Accountant (CPA) is a pretty funny guy. His name is Jim Orenstein—no relation, but before we'd even met, we'd both often get asked, "Are you related to that Orenstein who's an accountant/that Orenstein who's a photographer?" We both, of course, said no, we weren't. When I first started working with him twenty years ago, I had just opened my first studio and my gross that year was about $9,000. A couple of years later, he said, "Hey, I think you're going to break six figures this year." A couple of years after that, he said, "Looks like you're going to break half a million this year. If you do that, I'm going to start telling people that we are related."

I think that's funny. But I guess that's not an accountant joke, it's an accountant making a joke. Maybe there are no accountant jokes because having a good CPA is the keystone to building your successful business—and that's not a laughing matter.

GET THEE TO A CPA

"Most people go to a lawyer first when they're looking to start up their own business," says Orenstein. "That's a mistake. You need to start with a reputable CPA who specializes in small businesses. He can start you out from ground zero, getting a tax ID

number, helping you structure your business, choosing what type of entity you should be ... going to a CPA first can save you some needless expenses. Then when he's got you up to speed, he can refer you to the other professionals you'll need to help make your business successful."

IT TAKES A VILLAGE

Orenstein says you need a team of advisors to help you in your business. Your CPA should be the director of this team. "He's the one you see the most—well, hopefully he's the one you see the most, if you see your lawyer the most there's probably something wrong," Orenstein says, exhibiting that accountant humor once again.

Who comprises the rest of the team?

YOUR FUTURE: BE SURE YOU CAN BANK ON IT

"Your banker is very, very important to the success of your business. Not just the bank, the institution, but the person," says Orenstein. "You should get to know him, socialize with him. This is one guy you should take out for lunch and establish a relationship with so when you need him, he already knows and trusts you and he'll help you out." Most people never talk to their banker until they're in trouble, and that's a less than ideal time to establish rapport. Pick a banker who will be around for a long time. Typically, larger institutions have higher turn-over. So choose an established individual who's affiliated with a small to medium-sized, service-oriented bank.

SOMEONE TO KEEP YOUR DUCKS IN A ROW

Perhaps as important as your banker is your bookkeeper. "In all likelihood you won't need a full-time bookkeeper, you just need an independent contractor.

"You need someone called a 'full charge' bookkeeper. Not someone who used to foot columns for [a department store]," says Orenstein.

There is no "full charge" certification for bookkeepers, so you'll have to rely on your CPA to tell you who to hire.

And beware the CPA who offers to do your bookkeeping for

you himself—a full charge bookkeeper can do anything your accountant can do for you for much less.

What about all those stories about people's bookkeepers running off to Brazil after embezzling all their company's funds?

"You never give the bookkeeper access to cash—never," says Orenstein. He also advises keeping separate duties. The person who collects the money shouldn't also be the one to disburse it. People are less likely to collude than to act on their own to siphon off funds.

What about playing the nepotism card?

"People will come in here and say, 'Oh, my wife is going to do the books, we bought QuickBooks, and that's going to save me loads of money over having to hire a bookkeeper.' But that's penny-wise and pound foolish. Doing bookkeeping is not where you make your money. Creating, marketing, and selling your product is where you make your money, and where you should focus your time and energy." Your bookkeeping is best done by a hired hand.

But that QuickBooks, geez, that looks so easy, and it almost looks like fun to use!

Orenstein squirms and grimaces at the mention of QuickBooks. "Sure, it's a lot faster and easier than doing your books by hand. But I think the marketing for this product does a disservice to the consumer. It's just not where you should be spending your time."

SPECIAL AGENTS

The next folks to add to your village are insurance agents—several of them.

Life Insurance and Disability Insurance. What do you think you need more—life insurance or disability insurance? Yes, this is a trick question. "Everybody thinks they need life insurance," says Orenstein. "Everybody has life insurance. Hardly anybody has disability insurance. But you are much, much more likely to become unable to work than you are to die prematurely. So disability insurance is much more important to have. You need an insurance agent who will assess your personal needs and honestly guide you to the best products for you. Buying insurance is

like buying a car: They can load it up with accessories that drive up the cost unnecessarily. For instance, you can buy an inflation rider. But that's ridiculous. Because if inflation goes through the roof, wouldn't you just buy more insurance? They're asking you to insure your insurance! That's why you need an honest agent, someone who will tell you when you really don't need the bells and whistles."

Business Insurance. Worker's Compensation; Unemployment Insurance; Liability Insurance; Health/Medical insurance, and Casualty Insurance. "You want a good agent who knows how to write a plan that covers everything you need covered," continues Orenstein. "For instance, let's say all your cameras are stolen or destroyed. You go to make a claim, and you find out your cameras weren't covered—your most important tool for your business! That would ruin your whole day, wouldn't it? So again, you need a good, honest agent. One who will give you the coverage you need and be there when you have a claim."

No matter what type of insurance you're buying, you need an agent who isn't loyal to just one company, because he only gets paid if he sells you their products. And you want someone who stays in touch with you, who calls you now and then and checks to see if your situation has changed—your needs can change, and insurance products are changing all the time. Sometimes new and better ones become available, and your agent can tell you about them.

LEGAL EAGLES

You will need a lawyer or lawyers. There's a whole smorgasbord of different specialties, including employment law, tax law, and others. Is it okay to use a generalist for your business law needs?

"I think its fine to do that," says Orenstein, "because a good, reputable generalist will point you in the direction of another professional if they find themselves in over their heads." Another advantage to using a generalist is that you'll see them more frequently than if you have a whole stable of attorneys for different issues, and you'll establish a better relationship.

Who else do you need on your list of advisors? What about a financial planner?

"Ideally your CPA also acts as your financial advisor. I don't believe in financial planners—the person advising you shouldn't also be making commissions on investment products he's selling you. Often the brokerage houses underwrite the stocks they're selling. All the brokers go into a meeting Tuesday morning and they're told which stocks to push. Then you get a call, 'Hey, I've got a few shares left of such and such company, but you have to act fast!' Unless you're Warren Buffet, you have better odds at a Vegas Casino than in the stock market."

That's not to say that Orenstein doesn't believe in buying stocks. He recommends picking a solid-performing stock in each of several different industries: Energy, Medical, and Technology, for instance. Then buy the shares, stick them away in your safe deposit box, and forget you have them. Stay in for the long haul—the only person you'll make rich by doing a lot of buying and selling is your broker.

"The best place to invest your money is in your own business. That's where you're big returns will be," Orenstein concludes.

Other general advice for new business starter-uppers includes:

GET A CREDIT LINE BEFORE YOU NEED ONE

Early along, when your business is showing a healthy profit and regular growth, you should establish a line of credit. It doesn't cost you anything, and you may never use it, but it should be there if you need it. If you wait until you're in trouble, no one will extend you credit. It's the old "you can get it if you don't need it, but you can't get it if you need it" routine.

TO BORROW, OR NOT TO BORROW

Let's say you want to open a photo studio and you've already got some adequate camera and lighting equipment. It's not pretty, but it does the trick. Thing is, you'd like some nicer, fancier stuff so you can put your best foot forward when you open your new business. Is it justifiable to take out a loan to cover this expense?

"You have to make realistic projections," says Orenstein. "People get very excited about starting up businesses in some very tough industries. Often, they have no idea what it takes to be successful. Like the restaurant business, for example, a very

tough industry, because you're combining manufacturing and retail. A person might come in to see me and say, 'My mother loaned me $150,000 to open a restaurant, and I'm going to pay her back in three months.' This person doesn't have a clue. They haven't made realistic projections—or they haven't made any projections at all. Then I have to try to gently bring them down to earth without destroying their dreams. I ask them, 'Do you know that your food costs and labor costs combined have to be no more than 70 percent, or you'll go under? Do you know how to price a menu—you do it by the weight of the food ingredients. Do you know what typical [profit] margins to expect?'"

"Back to the photo business. Let's say you've been working at a big studio for a while, and you have some loyal clients who will follow you when you open your own place. They amount to maybe $30,000 worth a business a year. You figure that to make your business expenses that first year, and to feed your family and have enough to live on, you need to make $75,000. Then you go month by month and figure out what gross you can expect. $1,500 the first month, because it'll be slow to begin with. $2,500 the second month, because that's the beginning of your busy season. $3,500 your third month, because you'll have picked up one new client by then. With some luck, hard work, and marketing, you'll be able to realistically turn that $30,000 worth of clients into $40,000. That still leaves you $35,000 short. So you march down to your banker and you get yourself a line of credit, but you don't use it if you don't have to. Wait on that fancy equipment until you see your projections and your basic expenses being met. Then you'll be able to justify that kind of equipment purchase. But not right away. You need to prepare yourself for your worst case scenario."

If you've never opened a photo studio before, or any business for that matter, and you're unfamiliar with the industry, how do you go about making realistic projections?

"That's one of the things your CPA should help you with," says Orenstein, coming full circle. We're back to our trusty CPA, and we need to find a good one.

NOT JUST ANOTHER PRETTY FACE

You don't just want an accountant, you want a CPA. And you don't want just any CPA, you want one who specializes in small businesses like your own. Preferably someone who's firm is also relatively small.

"Larger firms sometimes try to create divisions that specialize in small businesses, but they're typically not successful because of their fee structure," Orenstein explains. "They have pyramids of young accountants just out of school, with no experience, whose time they bill out at $200 an hour. They can't afford to put experienced CPA's in their small business divisions because they can't charge them as much as they do their big clients, so the small business person gets the newbie, who can't offer the same level of service a more experienced person would bring to the table, and who might not even be at that firm next year.

"If you choose a CPA with a small firm, you'll pay less for a higher experience level."

HOW NOT TO FIND A CPA

- Do not pick one randomly out of the yellow pages. That's only begging trouble.
- Do not pick one because he's in the neighborhood. So his office is convenient. So what. You don't pick your doctors or your dentists because they're close-by—you pick them because you trust them with your health and your teeth. It should be the same with your CPA.

WORD OF MOUTH

The only way to choose your CPA is through word of mouth. Get referrals from people who you know and trust, and who have businesses of a similar size to yours. Then once you have your CPA, he can help you assemble that team of advisors you're going to need.

Do you dream of
the wealthy and
extravagant lifestyle
of a photographer?
Well, so do most
working photogra-
phers. Do yourself a
favor and find a CPA
specializing in small
businesses, so you
can keep a larger
percentage of your
hard-earned money
without committing
tax fraud.

Image © Rob Levine.
All rights reserved.

Specialties

We have covered the importance of finding your niche and specializing in previous chapters, but in this chapter we take a much closer look at the most common specialties and the requirements/expectations for each.

WEDDING PHOTOGRAPHY

• *Location/studio*. Often strictly location, although wedding photographers who have studios typically include studio engagement shots and bridal shots as part of their services and packages.

• *Cost to break in*. Minimal compared to other specialties, since you don't necessarily need to lease and outfit a studio. You need 35mm- or medium-format cameras; portrait and zoom lenses; a camera-mounted flash unit with extension cord and bracket; and it's also a good idea to have a set of portable lights (strobes or hot lights) with stands and modifiers.

• *Digital/analog*. Many wedding photographers are still shooting film, but the trend is strongly moving toward digital.

• *Average income/average rates*. Income varies; flat fees for wedding, groom's dinner, and reception range from $1,000 to $6,000, with the average falling at $2,500 in an average city.

• *Industry trends*. As is commonly the case today, this market is crowded and soft.

Opposite:
An example of an editorial style wedding shot.
© Hilary Bullock.

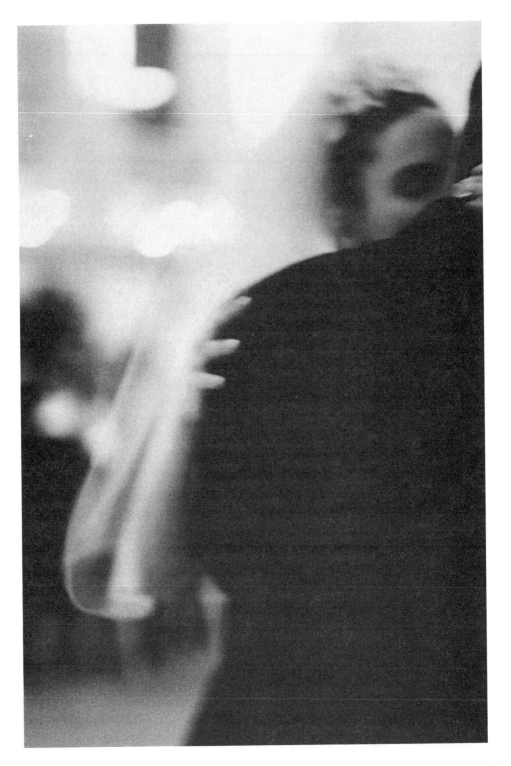

- *Where the money is.* With the practice of giving away copyrights drawing the profitability out of the wedding photography market, many wedding photographers are exploring other complementary markets, such as commercial/lifestyle or portraiture.
- *Type of portfolio/sampling of work.* Photo CDs, proof books, framed wall portraits, albums, Web sites.
- *Promotional material.* Ads in general-interest and trade magazines; advertisements on Web sites such as Knot.com; direct mailing postcards
- *Pre-production/post-production.* May require some scouting, although once you've been in business in a certain area for a while, you become familiar with the popular churches, synagogues, reception halls, hotel ballrooms, etc. Post-production can be very labor intensive or very simple, ranging from simply burning photo CDs to compiling proof books and producing print orders.
- *Cons.* Physical demands; no do-overs; working evenings and weekends.

NATURE PHOTOGRAPHY

- *Location/studio.* Strictly location.
- *Cost to break in.* Start-up costs are low, given that this specialty does not require studio lights, backdrops, or other related equipment; fixed overhead is low because of the lack of a need for a studio; essentially all that is required is camera gear—35mm, medium format, large format, or a combination of these; and a darkroom for those who do their own printing.
- *Digital/analog.* It is impractical at this juncture to use digital for 4" x 5" and larger formats; 35mm- and medium-format shooters can choose film, digital, or both; regardless of which type of capture used, nature photographers should have the capacity to scan to CD and should be conversant with Photoshop.
- *Methods of advertising/promotion.* Nature photographers are often represented by stock agencies, galleries, and some work with photographer's reps. Many do their own pavement pounding, marketing their work to corporations, hospitals, dentist's offices, and other entities that purchase calming, non-threatening wall art.

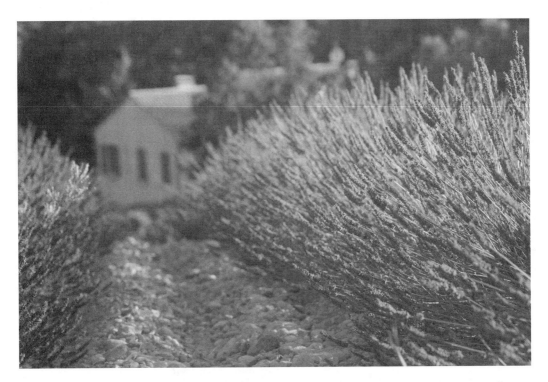

• *Average income/average rates*. Potential income varies too much to postulate an average. Greeting card and calendar companies pay $75 to $175 per image; fine art prints vary depending on the size and type of print and the popularity of the artist/demand for his work.

• *Industry trends*. Like most other areas of photographic specialty, this field is crowded. And, just as in other fields, a higher and higher level of specialization is becoming required—while most would-be nature photographers imagine traveling the country or the world shooting exotic locales, the reality is that shooters have been forced to regionalize; for instance, Craig Blacklock, who in the 1970s traveled the country in partnership with his father, Les, shooting anything and everything, now specializes in shooting the scenes of Lake Superior. The events of 9/11 caused a downturn in this market. Clients once willing to pay $2,000 for the use of an image will now often use images from royalty-free CDs. There has been a slow, steady erosion of the market as amateur photographers gain access to better and better equipment—talented hobbyists who don't need to make a

living from their work will often sell an image for little or nothing just for the pleasure of seeing their image and photo credit published. Those who need to make a living from their nature photography must maintain integrity when pricing their work.

• *Where the money is*. During hard economic times, the fine art market for nature photography suffers in comparison to the market for stock. But the stock field is so saturated and royalty-free CDs so readily available that it seems likely the fine art market will be the place to be during economic rallies.

• *Type of portfolio/sampling of work*. This will vary depending on whom the photographer is marketing to. Commercial clients using the work for print will often expect to see a bound book of the type described in Chapter Ten. Those interested in purchasing the work for decorative art may want to see finished, framed pieces. Stock clients view the work on the Internet.

• *Promotional materials*. The standard leave-behinds, direct-mail postcards, and Web sites.

• *Pre-production/post-production*. Very little pre-production, since most nature photographer's work primarily on self-assignment. Post-production will involve either creating or overseeing the creation of fine art prints, either digitally or by traditional methods.

PORTRAIT PHOTOGRAPHY

• *Location/studio*. Either or both; some portrait photographers have regular retail or point of destination studios; some shoot in their homes; some go to the clients' homes and shoot editorial style portraits of people in their own environments; some go to the clients' homes with a portable studio—backdrop, lights, etc; still others use scenic locations, such as orchards, rose gardens, beaches, and the like.

• *Cost to break in*. Can be as little as the cost of a good used 35mm camera and a portrait and zoom lens, to upwards of $50,000 for a fully outfitted, retail studio.

• *Digital/analog*. Both.

• *Methods of advertising*. Ads in general-interest publications; displays in complementary retail establishments (hair salons and children's clothing boutiques, for instance); direct

Opposite:
A standard
landscape shot.
© Leo Kim.
All rights reserved.

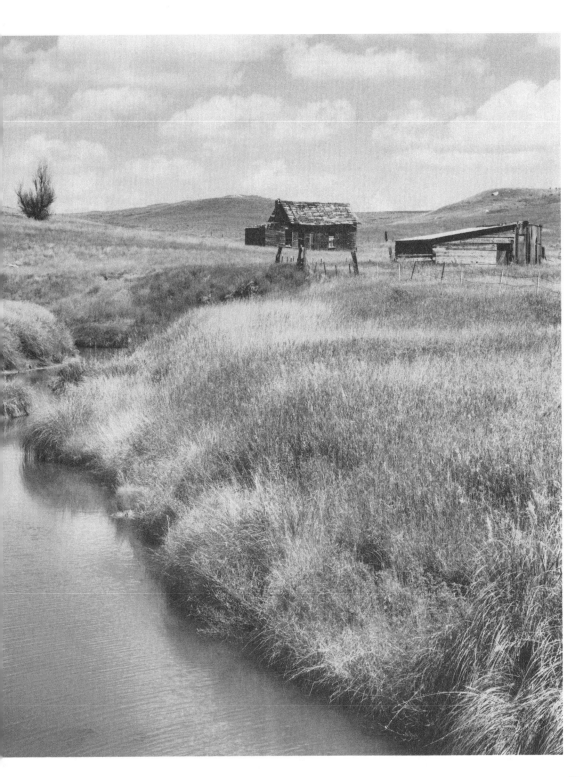

mailings; client newsletters.

• *Average income/average rates*. Income varies; rates range from $49 to $400 for a basic sitting.

• *Industry trends*. Another crowded market; there seem to be more editorial-style portrait photographers; the traditional, in studio, posed, medium-format style is fading. One should have a specialty in order to stand out from the competition.

• *Where the money is*. It's impossible for a small business person to compete at the low end of the market against national chains, so it's a good idea to position yourself in the middle to high end of your marketplace.

• *Type of portfolio/sampling of work*. This will vary enormously, with photographers who have their own studios showing finished, framed wall art, and those who work exclusively on location showing portfolios or proof books.

• *Pre-production/post-production*. Shooting in a new location will require scouting—otherwise, preproduction is minimal. Post-production involves producing portraits, either in house or through a lab.

COMMERCIAL PHOTOGRAPHY

• *Location/studio*. Both.

• *Cost to break in*. This specialty can be expensive; medium-format cameras are the industry norm, with many shooters using 4 x 5 cameras and the occasional 35mm as well; if you choose to shoot digital, just the medium-format digital camera back alone costs $16,000, and that's just one element of the system.

• *Digital/analog*. The most successful commercial shooters are at ease with both; there are still some very successful film diehards who have not made the leap to digital (and may never); most will shoot film at least part of the time, even if they are digital diehards.

• *Methods of advertising*. Creative sourcebooks; direct mail pieces; Web sites; ads in trade publications.

• *Average income/average rates*. Income varies; day rates range from $1,800 to $6,000 depending on the area and the market.

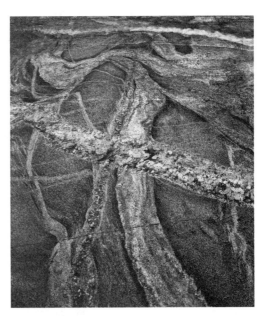

- *Industry trends.* Unlike other specialties, this market has become a little less crowded, now that the bad economy—combined with over-expenditures on new digital equipment—has driven some studios out of business. While there are fewer shooters, there are also fewer jobs.

- *Where the money is.* Resist the temptation to enter the price wars and low-ball bids just to get jobs—the busiest studios right now are the moderate- to high-end ones who have stayed the course and resisted the urge to compete with the masses at the low end of the market.

- *Type of portfolio/sampling of work.* The bound book-type portfolios described in depth in Chapter Ten.

- *Pre-production/post-production.* There is a lot of pre-production, or leg work involved in this specialty; just working out the cost estimate alone is time consuming. Often locations must be scouted, sets built, props and accessories selected and rented or purchased, and talent cast. Sometimes the photographer even has to help the client refine or create a concept for a shoot. Established shooters farm out much of the pre-production to location scouts, casting directors, prop stylists, and other professionals. Post-production can be as simple as handing the client a CD.

FASHION PHOTOGRAPHY

- *Location/studio*. Both.
- *Cost to break in*. As little as $6,000—if you stick with 35mm format—or as much as $50,000, identical to the costs of a fully outfitted commercial studio.
- *Digital/analog*. Film is still strong with fashion shooters, since certain techniques result in treatments that can't yet be approximated in Photoshop (such as Polaroid transfers, manipulated Polaroids, and cross processing E-6 and C-41 films).
- *Methods of advertising*. Same as for commercial photographers.
- *Average income/average rates*. Income varies; day rate varies depending on the market and whether the job is a commercial shoot, an editorial shoot, or a shoot for a talent agency or a model's portfolio. Commercial jobs can pay $1,800 per day, editorial as little as $250; fashion shooters who shoot "head books" and/or large groups of models' composites for an agency generally give a volume discount; model's headshots and composite shots start at around $350.
- *Industry trends*. Just as with other specialty areas, fashion photographers feel the pinch in a bad economy; unlike wedding, portraiture, and architectural specialties, there don't seem to be any more fashion shooters flooding the market than at any other time. As in previous eras there are many fly-by-nights—only the tough survive.
- *Where the money is*. Commercial jobs pay the most; editorial work carries a certain prestige, but the pay is typically lousy. Shooting for agencies and models is a great way to earn your bread and butter in medium and large markets.
- *Type of portfolio/sampling of work*. Bound, book-type portfolios of the type detailed in Chapter Ten.

ARCHITECTURAL PHOTOGRAPHY

- *Location/studio*. Location only.
- *Cost to break in*. Typically 4 x 5 cameras and lenses are less expensive than medium-format ones, and you obviously don't need a studio, so you can break in starting for about $6,000.
- *Digital/analog*. There is no adequate digital capture for

Above: As a staff photographer for the Star Tribune, Rob Levine chased gritty realism and pretty mirages every other day. "The pretty mirages gave me the chance to work with fellow illusion spinners, stylists, and models. It sure beat hanging around the courthouse."
© Rob Levine.
All rights reserved.

Left: Yet another example of the editorial fashion specialty.
© Lee Stanford.
All rights reserved.

4 x 5 format, wide-angle lenses yet, so capture is analog, but digital is used often for scanning, altering, storing, and distributing images.

• *Methods of advertising*. Direct-mail pieces.

• *Average income/average rates*. Income varies; day rates vary according to the market; the experience level of the photographer, and whether the jobs are for editorial or commercial clients. Generally, day rates for each type of job are similar to those charged for fashion work.

• *Industry trends*. Like many other specialty areas, this one is crowded; it is necessary to refine your specialty to stand out from the crowd; digital technology is used more and more, although not for capture.

• *Where the money is*. Commercial jobs pay the best; market to ad agencies who represent manufacturers who make building and architectural supplies and materials; and to builders.

• *Type of portfolio/sampling of work*. Bound, book-type portfolios described in depth in Chapter Ten.

TRAVEL PHOTOGRAPHY

• *Location/studio*. Strictly location.

• *Cost to break in*. This will depend on the format in which you choose to shoot; for most editorial work, 35mm is the norm, so you can get in the door for $3,000 to $4,000.

• *Digital/analog*. Both.

• *Methods of advertising*. Direct-mail pieces.

• *Average income/average rates*. Income varies; day rates are comparable to those for commercial and editorial work listed under architectural photography above.

• *Industry trends*. Budgets are tight for editorial work, so sometimes you have to patch two or three jobs and grants together to make a trip happen; travel assignments which once allowed ten days to complete now only allow five to six days; magazines are asking for more and more printing rights for the same fees.

• *Where the money is*. As in other specialty areas, commercial work pays better than editorial work.

• *Type of portfolio/sampling of work*. Bound book-type portfolio detailed in Chapter Ten.

FINE ART PHOTOGRAPHY

- *Location/studio*. Usually location; some studio.
- *Cost to break in*. Varies; you could spend your whole career shooting with a pinhole camera made from an oatmeal box, or you could shoot 16" x 20" format, and anything in between.
- *Digital/analog*. Anything goes.
- *Methods of advertising*. Direct-mail pieces.
- *Average income/average rates*. Varies hugely.
- *Industry trends*. More and more traditional fine art shooters who began their careers using film are switching to digital as technology improves.
- *Where the money is*. Being represented by a stock agency, a publisher, and a gallery—and marketing to commercial clients—are all ways to help make a living in fine art photography.
- *Type of portfolio/sampling of work*. Varies.

PHOTOJOURNALISM

- *Location/studio*. Strictly location.
- *Cost to break in*. A degree in photojournalism and the cost of a good 35mm camera (digital or analog) and lenses.
- *Digital/analog*. Both, although trend is strong towards digital.
- *Methods of advertising*. N/A.
- *Average income/average rates*. Varies from market to market.
- *Industry trends*. A tough market to break into; schools turn out more photojournalists than there are jobs, so you've got to be good.
- *Where the money is*. Staff photographer for a daily newspaper in a large market.
- *Type of portfolio/sampling of work*. Photo CDs.
- *Of interest*. Photojournalism is the one area in which altering photos is strictly forbidden, so no Photoshop allowed here.

EDITORIAL PHOTOGRAPHY

- *Location/studio*. Strictly location.
- *Cost to break in*. Same as photojournalism.
- *Digital/analog*. Both.

- *Methods of advertising.* N/A.
- *Average income/average rates.* Varies; national magazines pay about $400 for a day rate, and newspapers $250 or less.
- *Industry trends.* It can take awhile for an editorial photographer to establish herself or become recognized, but this is a specialty where talent and persistence are your tickets.
- *Where the money is.* Not here. (Just kidding!) Often editorial photographers must finance their first project themselves. After they have a body of work, they may apply for grants and/or publish their work in books and/or periodicals; and they may be represented by a gallery or galleries for the sale of their work as fine art prints.
- *Type of portfolio/sampling of work.* Photo CDs.
- *Promotional material.* N/A.
- *Pre-production/post-production.* Much time is spent writing grant applications, and researching special subjects and projects; post-production usually involves creating or overseeing the creation of prints and distribution of images.

STOCK PHOTOGRAPHY
- *Location/studio.* Both.
- *Cost to break in.* Varies depending on whether you need a studio or shoot strictly on location; whether you use studio lighting and what type; and in what format you choose to shoot.
- *Digital/analog.* Both.
- *Methods of advertising.* Typically stock photographers are represented by one stock agency, and the agency promotes their clients' work.
- *Average income/average rates.* Varies; individual images can sell for as little as $50 to as much as $2,000, depending on the usage and the client.
- *Industry trends.* Both the Internet and digital image management systems are making stock photos more available than ever before.
- *Where the money is.* Again, with commercial clients, and for the repeated use of images or selling them across multiple markets.

Opposite:
The specialty of photojournalism can encompass an enormous variety of shots, as these three images illustrate.

Top:
© Stormi Greener.
Bottom:
© Rob Levine.
All rights reserved.

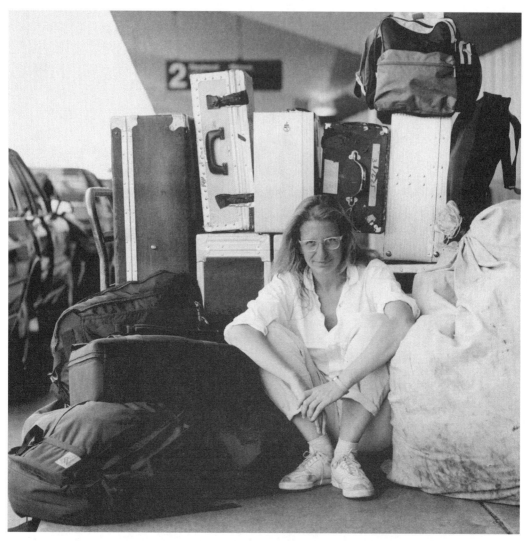

- *Type of portfolio/sampling of work*. Photo CDs, the Internet, Web sites.
- *Pre-production/post-production*. Often, stock photos result from self-assignments and require little if any leg work; post-production involves highly detailed methods of cataloging and storing images.

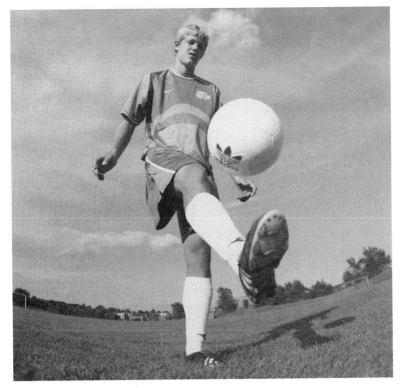

Three examples of
shots in the specialty
category of sports.
© David Sherman.
All rights reserved.

Your Life in Pictures: What Kind of Lifestyle Can You Expect?

Years ago I was at a party and someone asked me what I did for a living. "I'm a photographer," I said.

"No, I mean what do you do for a living?"

"I'm a photographer. That's what I do for a living."

"I mean, what's your regular job?"

"My job is taking pictures. I'm a photographer."

The frustrated inquisitor looked at me slit-eyed, and I could see exactly what he was thinking: "Waitress."

Most people assume that you're either Annie Leibovitz, famous and raking in the bucks, or you're dirt poor and sleeping on your sister's sofa. The reality is that many, many of us make a decent income, albeit with periods of huge fluctuation.

Another common myth is that photography is a cushy or an easy job—not very demanding mentally or physically. What could be easier than pushing a button?

While I'm sure there are some cushy photography jobs, the reality is usually quite different. I'll illustrate by describing the third-worst day of my life to you. It started at 6 a.m. when I assisted my (then) husband on an architectural exterior shoot. I then drove to my studio where I shot children's portraits from 8 a.m. to 4 p.m. From there, I went home and printed portraits until 9 p.m., when I went to meet my (then) husband for an

architectural interior night shoot. At 3 a.m., as we were packing up the (extremely heavy) gear, I repeated my mantra to myself: "I love the glamour, I love the glamour." Did I mention I had a sinus infection?

All right, all right, I don't want to scare anybody out of the business. This was a highly unusual, highly rotten day. My point is if you want to be a photographer because you think the living is easy, be something else.

Of course, within each specialty there exist very different joys and tribulations. Some of us never get out of the studio; some of us never get out of the field. Some of us deal with human subjects; some of us deal with food. Some of us never work with anyone more dangerous than a cranky two year old; and some of us have to decide which side of the road to jump into the ditch when the snipers start shooting.

FASHION

There's a general impression that fashion photographers live a glamorous life, full of parties, babes, travel, high day rates, and very little actual work.

"It's all true," quips Doug Beasley. "Except the work part. When you work, you have to work really, really hard. And sometimes you don't work at all. And yes, it pays well, but between the ebb and flow of assignments, and the turn-around for payment from some of the agencies, there can be serious cash flow crunches."

One thing many people don't realize is that the photographer, not the client, hires and pays assistants, scouts, make-up artists and stylists, and purchases or rents props and sets, and fronts other sundry costs. He ultimately passes these expenses onto the client, but ad agencies typically take ninety days to pay. Essentially, the photographer is giving his clients a short-term loan, just like a bank. That part is not glamorous.

"If you like to party and meet people and combine socializing with working, fashion is the specialty to be in," says Lee Stanford. "I really enjoy it. I've met some really interesting, great people. I met my wife on the job."

But at least one fashion shooter thinks the whole party thing

is highly overrated. "My vision of hell," says Patrick Fox, "is being stuck in a trailer full of talent on a bad weather day." Not that he doesn't enjoy the people he meets on the job. "I love my clients, they're great. They're one of the reasons I'm in this business, they're what make it fun."

Are the stereotypes of the people in the industry based on truths?

"You mean the whole stupid model, playboy photographer stereo type? Nah," says Lee Stanford, who has a wife and six-month-old daughter. "I've known models who were multilingual, very intelligent people. Sure, some are insecure and shallow, and some photographers are players. But the people in this industry are as different from one another as anywhere else. Show me a business that doesn't have egos, players, insecurities, all that nonsense."

But isn't the glamour part true? Flying to Florida to shoot beach shots in the Keys for a national client has got to be a bit of a thrill.

"Sure, it's fun," says Doug Beasley. "But it's a job. It's a fun, hard job."

ARCHITECTURAL

When you're shooting architectural exteriors, there are certain times of the year when the light is good and times when it's just unacceptable. "That's a great thing I learned from Ezra Stoller," says Peter Aaron. "He'd look at a building and determine the best time to shoot it, and then he'd say, 'Good-bye, see you next fall.' He never compromised on the quality of the light."

Spring and fall, dawn and dusk, are often the best times to shoot architectural exteriors. Although light is an important issue for architectural interiors as well, the photographer can create motivational light that mimics ideal ambient light indoors.

So architectural photographers are also at the mercy of the seasonality of their specialty. Often there are periods of very few, if any assignments, followed by periods of frenetic activity.

"My wife and daughters went to Italy in the spring and I stayed home to work," says Aaron. "That's just how it has to be."

Another aspect of an architectural photographer's lifestyle—
in fact, an aspect of the lifestyle of any photographer who goes
on location—is the physical demand of shooting at odd hours,
shooting for fourteen hours straight, traveling extensively, and
hauling heavy equipment around.

PORTRAIT

The portrait business seems to follow retail trends: my studios
are slowest at the beginning of the year, and pick up fast in
anticipation of the major holidays, starting in the late summer or
early fall. I frequently do 70 percent of my business for the year
in the three months between October and December. How does
this affect my lifestyle?

When I was single and childless, it was only an irritant. The
busy-time chaos and slow-time boredom was my only complaint
about my job. I have never gotten used to it; during the slow
time I worry that I'll never get busy again, and during the busy
time I long for it to slow down. I make big plans about what I'm
going to accomplish when I can finally breathe again: big mar-
keting plans, test shooting, studio renovation, cleaning and
organizing, renewing social ties, getting that garden in, and writ-
ing the great American novel. But most of these things never
happen. I've discovered it's easier to be productive when I'm
busy.

A typical December for me goes something like this: I work
like a maniac until the day of Christmas Eve, when I go from
sixty miles an hour to zero overnight. I never plan a vacation
until at least February, because I always get the mother of all
colds as soon as I slow down. I think this is a result of leaving
my survival mode and losing that adrenaline rush. Then I more
or less sit on my thumbs until May, when it starts all over again.

Now that I have a daughter, I welcome the slow time, because
I can spend more time with her. But the frenzied times are even
worse than they used to be, because it takes me away from her,
and the time that I do get to spend with her I'm often tired or
distracted. If I could serve the same number of clients each year
as I do now, but spread them out evenly over the months, that
would be my version of heaven.

Many other portrait photographers have an even tougher row to hoe than I do: those who shoot a more general clientele need to scramble to get their wedding clients taken care of so they can scramble to get their seniors taken care of so they can scramble to accommodate their holiday rush. If you enter this specialty area, you'll face these lifestyle issues, too.

PHOTOJOURNALISM

"You never know where you're going to be or what you'll be doing to get a good shot," says Stormi Greener, who has worked in war zones as well as in more mundane areas. "I was in Stillwater (Wisconsin) once shooting a bridge. I needed to get higher up to get the best shot. I was parked in the driveway at a private residence—no one was home. I went looking around for a way to get up on their roof. No dice. So I wound up standing on the roof of my car."

"Most of the time you're shooting mundane stuff, like the blue ribbon calf at the state fair," says former photojournalist Rob Levine. "But then suddenly you're at an accident scene or a fire, and you remember why you went into the business—to tell the stories."

WEDDING

Wedding photography has physical demands of its own. In addition to hauling around equipment, you often have to go long periods of time without bathroom breaks. A lunch break is unheard of. And a wedding photographer is on her feet for eight to ten hours at a crack.

Having a social life can be difficult, since you're at work when all your friends are at play, and vice versa.

A successful wedding photographer can be booked out up to one or two years in advance, which can be an advantage or a drawback, depending on how spontaneous you like to be.

CORPORATE

When you're shooting for corporations, you're often busiest right before the end of the year, when businesses are preparing their annual reports. "It fits in nicely with my fashion shooting,

because it picks up just when the fashion season slows down," says Lee Stanford. "But it is a lot of pressure when everybody's deadline is the same."

FEAST AND FAMINE

"The only thing you can predict when you're a photographer is that you can never predict your cash flow," says Bob Pearl. "Sure, there are certain times of the year when you'll be typically busy, or typically slow. But if you have one big client with a huge project, they can keep you insanely busy for a month during a slow time, and then it'll be a busy time and you wonder if you'll ever get another client again."

"You can have "regular/irregular clients," says Lee Standford. "Like me—I have music clients who need CD covers. They are repeat clients, but they don't shoot at any regular time. So I can be really busy when it's a slow time of year."

Wedding photographers can predict with somewhat more accuracy when they will be busiest—the lion's share of weddings happen on Saturdays in May and June. But while it may be more predictable, it also creates an even bigger cash-flow crunch. "You can count the Saturdays in May on one hand, and the Saturdays in June on the other. Those are my biggest opportunity days to make my living. Most people have a bigger window than that. Even if you look at the whole year, there are only fifty-two Saturdays."

MAKING HAY WHEN THE SUN SHINES

One of the difficult parts about this whole feast or famine thing is that you have to go against common sense when it comes to how to handle the sporadic nature of the business. You get busy, you think, "I don't need to market now! I don't have time to, anyway, I'll just market again after things slow down," and you kick back, ignoring that part of your job description. But it's a cruel irony that marketing during your busiest times pays off in spades, where as marketing during a slow time can bring disappointing results.

Says direct-mail expert Rick Byron, "It does make sense if you think about it, that marketing during a time when people

are likely to need your services will yield better results than marketing at a time when they probably aren't interested. So working to make good times great is smarter than working to make bad times tolerable."

And my experience bears out Rick Byron's assessment: marketing during the slow season may bring in a few clients, but marketing during the busy times brings in a boatload of clients. So the old cliché is true: you have to make hay when the sun shines. What does this mean as it affects your life in pictures? Plan on …

SAVING FOR A RAINY DAY

The extreme seasonality and unpredictability of the photography business creates the necessity of planning ahead; you may gross six figures one month and feel like you're rolling in dough. It's tempting to live like a king—or queen. But say the next month your gross is next to nothing, and your quarterly taxes are due, and if you haven't set aside the money, it won't be there. You'll feel like you're paying more in taxes than you actually made, and wonder how that can be.

Accountant Jim Orenstein specializes in entrepreneurs and small businesses. "You should ideally have enough money set aside to cover six months of your personal expenses," he advises. "And it should be liquid."

One of the ways in which self-employed people in photography as well as in other industries get lulled into a false sense of security and wind up scrambling when it's time to pay the big bills is by looking at their gross and overestimating what their net will be.

"And don't forget, you have a partner," says Orenstein. "His name is Uncle Sam." Between income taxes, property taxes, self-employment tax, employer's tax, and sales tax, 50 to 70 percent of your income goes to the government.

THE MYTH OF AN "AVERAGE INCOME"

You may already have heard this old joke: What's the difference between a large pizza and a photographer? Give up? A large

pizza can feed a family of four.

You probably have also heard some rather alarming statistics about what the average photographer can expect, income-wise: an annual net of $23,000, with only 10 percent of us making more than $40,000 a year. It's enough to make you run for the hills. But take a breath, and think for a minute—what do statistics mean, anyway? In my humble opinion, they actually represent squat. Sound and fury, signifying nothing.

Let's take, for instance, our odds of being struck by lightening. Say it's one in a million. Sounds comforting, but it's meaningless. Because for that one, single guy with the smoke pouring out of his ears, his odds are 100 percent. And to imagine that the risk of that one in one million is equally spread out among all of us is ludicrous. Because probably, Smokey Joe was out running around on a golf course waving a metal club over his head during a thunderstorm. And maybe you don't golf. Maybe you like to curl up in bed with a good book during thunderstorms. So for you, and for Smokey Joe, and for the other 999,998 souls represented by this equation, that one in one million figure is totally abstract, with no application in real life at all.

The same principle applies when you use statistics to try to predict your likelihood of success or failure, big or small bucks, in the photography business. Some photographers are going to do the financial equivalent of running around on the golf course with a lightning conductor—courting disaster by neglecting clients or charging too much or too little for their services or choosing a specialty that's wrong for their market or any number of other ways to induce mediocre performance. The Smokey Joes of the photography set will draw the lighting and earn the meager incomes while those with talent, common sense, adaptability, and a good work ethic will rake in those seemingly elusive big bucks.

See? Now when a naysayer questions the veracity of your career choice, you can smile tolerantly and say with confidence, "Well, those statistics don't apply to me."

THE UNWRITTEN DRESS CODE
You know you won't have to wear a suit and tie. You won't

have to wear high heels or hose. Pasties and g-strings are definitely not an option. But this does beg the question: when you're a photographer, what do you wear to dress for success?

DON'T:
- Dress better than your clients dress.
- Be a slob.
- Try to look like a photographer. You'll only come off pretentious or, worse, ridiculous. Just dress like you. If you're naturally artsy and hip, you'll look artsy and hip without trying. If you're not, no amount of trying will help.

DO:
- Consider what you're doing that day. Do you have a shoot where you're going to be crawling around on the floor with a bunch of two year olds? Think knee pads and stretch denim. Shooting on the beach in 110° heat? Shorts and a T-shirt will do just fine, thank you very much.
- Dress it up a notch when you're showing your book or visiting clients. It's respectful. I don't mean pull out the funeral jacket or the pearls—I mean press your shirt, button the top button, tuck it in. Trade the jeans for khakis. Wear shoes, not flip-flops.
- Wear clothes with lots of pockets. You'll be juggling film rolls and canisters, body caps, lens caps, gels and filters, and other small items that are easily forgotten if you have no place to stash them.

So you can see that, while you probably won't be making Bill gates look poor if you become a photographer, you're not likely to starve, either. You'll probably join the ranks of the many, many photographers who are MAKING A LIVING.

You'll have some glamour. You'll have some stress. You'll have some physical challenges. And you'll probably have a lot of fun complaining about the rough stuff.

Opposite: This studio portrait of a dancer might be the kind of portrait many people think of when they hear the word "photographer," but there are as many different types of photographers (and photography lifestyles) as there are subjects.
© Vik Orenstein.
All rights reserved.

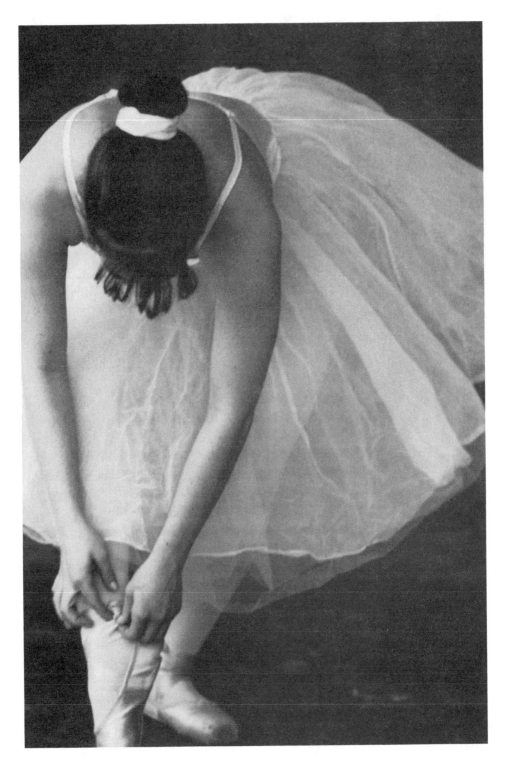

Finding Your Place: Networking with Other Photographers

There are a world of reasons to join the community of photographers: network, shoot the breeze, commiserate, compare notes, share technique, battle creative slumps, establish and maintain industry standards, the list goes on and on.

REFERRALS

One of the biggest ways my colleagues and I help each other is by trading referrals. This is especially important now that many of us have become very specialized. I shoot only black-and-white film for my portraits and offer only high-end, archival, black-and-white, sepia, and hand-painted portraits of kids, their families, and their pets. Period. End of story. No direct color. No corporate headshots. No (shudder) weddings. No packages. No special offers.

Frequently I get calls from clients wanting a service or product outside of my specialty. Requests for weddings; model composites, traditional direct-color senior portraits, or product shots are common. I used to try to accommodate these requests myself, but I was often less than happy with the results, preferring ultimately to work only within my limited specialty. So it's a great boon for me to have other professionals who are tops in their fields to whom to refer my clients. And it's always nice to

get a referral from one of them, of course.

MENTORS

Almost every single successful photographer I've ever known has credited their success in part to the generosity of a more established shooter who helped them learn the ropes. There's no law that says an old dog has to teach a new dog his tricks. And there can be some risk involved if the protégé turns into an up-start who runs away with part of the mentor's market. So why do it?

"It's for the joy of it," says Jim Moitke.

"It's a natural part of the life cycle," says Bryan Peterson. "You're born, you learn, you teach, you die."

Whatever the reason, our mentors have helped us create our careers.

PROFESSIONAL SERVICES

I've traded shoots and offered and received shoots and prints at a discount from my colleagues. I received a beautiful art print from a nature photographer in exchange for shooting his family. I've done portraits for a wedding photographer in return for shooting my wedding.

EQUIPMENT SAVVY

Whenever I've needed a new piece of equipment, especially when it comes to new technology with which I'm unfamiliar, I ask for the inside scoop from my photographer friends. A commercial shooter taught me everything I needed to know about digital capture, researched the systems from me, and helped me choose which one to buy. A fashion shooter taught me how to use strobes, an architectural shooter taught me about hot lights, and a photojournalist taught me that it's OK (and sometimes even desirable) to use mixed light sources.

In turn, I've helped some medium-format junkies break their addictions to fine grain and tripods; I've taught commercial shooter how to get two year olds to stand in one spot for a 250th of a second and laugh out loud; and I've shared my (somewhat paltry) knowledge of digital capture with a fellow film lover whose digital knowledge was ever paltrier than mine.

What goes around really does come around.

INDUSTRY STANDARDS

ASMP offers a book detailing industry standards for billing, figuring usage fees, and other practices. The book is invaluable. But ASMP, the society, didn't institute these standards. They were created by individual photographers—the guys in the trenches. Industry standards continue to evolve as technology, the economy, and our markets change. By networking with fellow shooters you can help create the standards.

CLASSES AND SEMINARS

Classes and seminars are a good way to meet other photographers. In addition to picking up some great Photoshop, marketing, and creative ideas over the years, I've also met and remained in contact with several photographers this way.

CONSULTING

There are times when you're going into a new specialty or making the transition to digital, or hitting a marketing slump, when you may need more than just the casual assist that a colleague or a mentor can offer—you may need a hired gun. I've both worked as a consultant for other photographers and hired other photographers to consult for me. It's a way to significantly shorten up your learning curve when you need knowledge and you need it fast.

INTERNET DISCUSSION GROUPS

Joining an Internet discussion group allows you to network with your brethren from all over the globe. You can put a technical, creative, or business question out there and receive twenty different (and often excellent) responses from twenty different individuals in a very short time.

TALKING SHOP

Networking with colleagues allows you to check the pulse of the business. You can find out if others are slow or busy; and whether they're sensing any new trends or having success with

new equipment and technology.

You can also commiserate with someone else who understands your experiences. I try not to be negative, but sometimes I just need to do a little venting, and having an ear from a person who knows what you're talking about is a wonderful thing.

You can also use the grapevine to find out about studio management software; good vendors and labs; and studio sales where you can pick up used equipment for pennies on the dollar.

You can compare business practices, get the name of a good lawyer or accountant ... you get the idea.

Some shooters are afraid to network for fear of having their clients, ideas, or business practices stolen. And yes, it does happen. But in my experience, the gains far outweigh the losses when you share your time and expertise with your fellow photographers.

CROSS DISCIPLINE TRAINING

I'm a portrait photographer but most of what I know about lighting I learned from architectural photographers, and my philosophy of photographing kids comes from a style prevalent among fashion photographers in the early 1980s. One way to develop a distinct visual style is to do things differently from the way your competitors are doing them, and you don't need to roam far afield or be intentionally clever or contrived to create a new look. All you have to do is pick and choose from established, solid traditions in other photographic specialties, and networking makes it easy.

HOW TO START

If you've never networked before, it may seem a little daunting. Many of us dislike asking others for their time or knowledge.

• *Be specific.* I'm much more likely to take time out of my schedule to talk to a peer if she's specific about what kind of information she's looking for. For instance, I'm unlikely to go out of my way to meet with someone who just calls up and says, "I'd like to pick your brain about photography." But if someone calls and says, "I'm at the stage in my business where I'm forced to decide whether to scale back, or expand my studio space and

take on more employees. Since you have experience with this, I was hoping we could meet and discuss the pros and cons."

- **Have something to trade.** If you're looking for marketing ideas, for instance, you might say, "Hey, I have some promotions I've been using with some success, and I was wondering if we might get together and bat some marketing ideas back and forth."

- **Tell them why you chose them.** You're more likely to get results if you tell your colleagues why you chose them to speak with rather than appearing to have picked them out of the phone book. Say, "I've seen your work and I love your use of color, and that's why I'd like to ask you about your creative technique," or, "I really admire what you've done with your business, and I'd like to hear your ideas on how to sell."

- **Food is love.** It's human nature—we feel more comfortable and relaxed when we break bread with someone than in any other setting. So suggest lunch, or even coffee. And pick up the tab.

PROFESSIONAL ASSOCIATIONS

Here I go again with the same old song and dance—join your local chapter of ASMP or Professional Photographers of America or one of any number of other great organizations. You're looking for colleagues to network with. This is a way to find a whole room full of them all primed and ready to talk shop.

YOUR NEIGHBORS

I'm lucky enough to have my studio in a warehouse building that is also home to tens of other photographers in different disciplines. When I was just starting out, I rented studio space on an as-needed basis from a commercial photographer, and he taught me all about medium-format equipment. All I had to do was go across the hall when I needed to borrow a sync cord (the photographer's equivalent of a cup of sugar). And when a client pulled a fast one on me and brought a reflective product to shoot that was only supposed to involve kids, I excused myself, went up two flights, and got a quick lighting lesson that allowed me to do the shot unfazed. And I in turn was able to help a fash-

ion shooter keep an uncooperative four-year-old girl on white seamless and get her to pose and laugh. (I stuck a raisin to the bottom of her foot and told her to say "diaper head.") Look around you—there are no doubt photographers nearby who would be happy to network with you.

How to Learn—and Break—the Rules

Even small children can often tell which rules are just dogma—don't cross your eyes or they'll stick that way, don't go swimming until at least an hour after you eat or you'll sink like an anvil and drown. And they know which rules are justifiable and should be followed—look both ways before you cross the street, don't bite.

The rules become more complicated the older we get. When we show up fresh and inexperienced in a new industry like photography, which requires you to know not just business rules, but creative and technical rules as well, it can be harder to sort out the dogma from the important rules. One way to make this easier is to begin by examining the context within which the rule was created.

ABRAHAM HAD A LOT OF EXPLAINING TO DO

Let's take, for example, the story of Abraham and Isaac. I've always had a real problem with this one. For anyone who doesn't know or doesn't remember this Old Testament Bible story, this is my version in a nutshell: God told Abraham to take his first born son, Isaac, up on a mountain and kill him to prove his devotion. I'm paraphrasing, but Abraham said something like, "You're kidding, right?" but God was serious. So Abraham takes Isaac up on the mountain and prepares to kill him, and

God says, "Never mind. Let's sacrifice a goat instead."

I struggled with this story, until one day I talked about it with a friend who is a pastor. He said that if you considered the context of the culture at the time of Abraham and Isaac, the story actually makes perfect sense.

His theory holds that this was a period in history when many people practiced a fertility religion, which did, indeed, include human sacrifice. He viewed the story as a way for the people of the time to come to terms with—and explain the transition from —human sacrifice to animal sacrifice, and from there to the more modern religions with which we are familiar.

The context of the story—where it came from—provided an entirely new possible interpretation for me.

NO SPITTING

Another context story: when I was in Hong Kong in 1994, I noticed signs posted all over in public places that said, "No Spitting." I found that odd. To me, it seemed a lot like posting signs all over public places in the United States that say, "Don't stick your gum to the bottom of your chair," or "Chew with your mouth closed."

Then I took a ride on a ferry boat and was calmly and contentedly enjoying the ocean breeze and the sunset when suddenly I heard all around me that sound of hocking loogies. It seemed that every male between the ages of seven and seventy-five was spitting, right on the deck.

Suddenly, in considering the context of the culture, I realized the signs made sense, after all.

The good news is, apparently people in Hong Kong don't need to be told to keep their clothes on: I never saw a single sign the said, "No Shirts, No Shoes, No Service."

SOME PHOTOGRAPHIC RULES IN CONTEXT

In teaching my online photography courses, I hear some of the same questions about technique and equipment rules over and over. Here are some of these rules, and my attempt to put them in context for you:

• *It's unprofessional to use 35mm film to take portraits.* In

the photographer's equivalent of Old Testament times, before film was invented, negatives were big glass plates that necessitated long exposures. It was expensive to have your portrait taken (Sears portrait studio didn't come along until later), so it was a very formal occasion: you put on your best clothes and you sat still. Very still, for a very long time. If you've even wondered why everybody looks so stoic and stiff in antique photos, that's why. If you were lucky, you only had to do this once or twice in your life.

Then along came film, and film had grain. Grain was considered undesirable. A larger negative provided images with proportionately smaller grain. No matter that a bigger negative meant a bigger camera tethered to a tripod—no one had yet thought of shooting a portrait of a person actually moving. It just wasn't done. If you wanted to be a professional photographer, you got a big honkin' camera and you made people sit still.

Years went by. New film types were invented that yielded finer and finer grains at faster and faster speeds. Finally it got to the point where a 35mm negative could produce an image with grain as fine or finer than the old films in medium formats. But the "professional" photographers didn't care. They continued to shoot portraits in their old tried-and-true ways.

Times changed. People were ready for portraits in which the subjects didn't look like they'd been prepared by a taxidermist. A few intrepid individuals started handholding 35mm cameras and shooting fashion photos of models running, jumping, and moving. Soon a new wave of portrait photographers caught on, and started shooting portraits of subjects (especially children) in motion and at play, interacting with one another.

The popularity of this style is evidenced by the fact that medium-format cameras are now available that can be hand held.

The old-school photographers are still doing things the old way. That's OK. Live and let live, I say. I won't call them dinosaurs if they won't call me unprofessional.

• *RC (resin coated) paper is not as high of quality as fiber-based paper.* OK, it's true—when RC paper was first introduced, it stunk. It contained little or no silver and the tonal range was

tiny. But since then, these papers have improved dramatically. They now actually rival fiber-based (tree pulp) papers in tonal range and a selenium or sepia-toned RC print is as archival as an equivalent fiber print.

- *Always correctly expose your film.* Yeah, right. By overexposing your black-and-white film, you can subtly change the tonal ranges into which skin tones fall, reducing overall skin texture and creating a "glowing" effect. Fashion photographers use this little secret to great advantage, since skin texture is a no-no in the land of beauty. By underexposing color transparency film, you can create a moodier, contrastier, more saturated look. Then there's underexposing and push processing to heighten grain (yes Virginia, there really are people out there who think grain is a good thing) and increase contrast; and overexposing and holding the processing to lend an ethereal, other worldly look. There are all kinds of great reasons not to expose your film correctly.

- *Zoom lenses never have optics that are as good as fixed lenses.* Again, we're back in Old Testament times, here. In Methuselah's day, zoom lenses only gave good results in the middle of their focal range, which sort of defeated the purpose of having a zoom at all. But now zoom lenses—even some of the cheaper brands—have great optics from 18mm to 800mm. So zoom to your heart's content.

You get the idea. Sometimes we keep on doing things the way they've always been done even when there's a better way just because we're creatures of habit. Every once in a while it takes a newbie to come along and shake things up. And even then, the old school will be unimpressed. They'll still be over in their camp shouting, "We never do it that way, we always do it this way!" Any rule pertaining to equipment or media that contains the words "always" or "never" is probably just dogma, and rightfully should be broken.

RULES YOU CAN BREAK

There are rules—written and unwritten—in every specialty area of photography. Rules pertaining to business practices, creative

techniques, technical expectations, marketing, and even what to wear. Often, it pays to play along by the rules—especially for a newbie. But just as often, distinguishing yourself from the crowd and achieving a high level of success requires rule breaking.

When I opened KidCapers Portraits in 1988, common wisdom held that portrait photographers had to shoot everything: weddings, seniors, kids, families—it just wasn't believed that Minneapolis was a big enough market to support a "specialist." That was the first rule I broke. I only shot kids.

In 1988, I was among the first portrait photographers who hand held my 35mm camera, used auto-focus and a zoom lens, and let the kids run around the studio. The risk was worthwhile: my four studios grossed around $2 million, last year.

Commercial photographer Patrick Fox has broken many rules when it comes to the structure of the relationships he maintains with the professionals who work with him. For example, Fox works with a photographer's rep—a traditional relationship—but the arrangement he has with her is totally unconventional.

"Traditionally, the rep is paid a percentage of all the work the studio does," says Fox. "But I pay my rep a flat fee for each time that she shows my book." I don't know of anyone else in commercial photography with a similar working relationship.

Another rule Fox has broken is the way in which photographers partner up, or share studio space and resources. Traditionally, the sharing of studio space happens one of two ways: two or more shooters who are at similar places in their careers get together and sign a lease. Usually they have different specialties and/or client bases and therefore are not competitors with one another. Or an established shooter gets large enough to hire newer, younger photographers to shoot his client work. In this case the new hires are employees of the established photographer.

But Fox has found yet another way to structure this type of relationship. Rather than take on a partner, a roommate, or an employee, Fox has shooter Rod Nokomis do business out of his 6,000-square-foot studio.

"We do all the production for Rod, and in exchange we get a

percentage of his billings," says Fox. "It's a win/win. He has no overhead, and use of a big studio's resources."

Are there really rules about what to wear?

"You can get away with being really casual, even a slob," says David Sherman. "You're an artist, people don't expect you to wear a suit and tie." In fact, there is an unwritten rule that a photographer should never dress better than his clients dress.

As he mentioned in his profile in Chapter Two, Peter Aaron broke an unwritten rule of lighting when he came to the business of architectural photography with the idea of using tungsten lights to create a richer, more natural style of shooting. Up until that point architectural photographers had been using strobes to create high-key, comparatively flat light. Of course now many architectural photographers light in a similar way to Aaron, although perhaps none do it as well.

"That's what happens when you blaze a trail, there are a million other people who hop right on behind you and follow you," says Lee Stanford. "It's just a given. It's unavoidable. You just deal with it."

"That's how you know you've come up with a great new innovation," jokes Hilary Bullock. "When somebody copies you."

RULES YOU SHOULDN'T BREAK

"Anything you could go to jail for," says Fox, only half joking. Though he has bent and broken countless rules, Fox follows the letter of the law when it comes to legal and ethical issues. "But really, I play by the book when it's important. I pay my taxes, and I expect everybody else to, too."

Fox tells the story of an art director who took a product from a shoot for his own personal use. "I told him we hadn't shot it yet, and he said, 'Tell the (art) buyer you broke it and get another one.' This same guy had us building sets to very mysterious, specific dimensions—it was a huge pain—and it turned out he was planning on using the sets in his home after the shoot, so he was having us customize them for his living room. That's disheartening—it's demoralizing." Rules about personal conduct, and about being respectful to others, benefit everybody in every profession.

Certain cardinal rules of marketing should never be broken,

in my opinion. I speak from experience. I knew from the kind mentoring I received from marketing expert Howard Segal that a direct-mail piece should always have a special offer with a deadline in order to create the ever important "call to action." But I thought, heck, my clients spend $4,000 on average, what's a free 8" x 10" really mean to them, anyway? I was also worried about appearing less classy by virtue of running a special, or a giveaway. So I sent out a mailing piece with only a picture and the story of the studio.

This was the infamous mailing I describe in detail in Chapter Eleven, which yielded worse results than a totally random mailing would have. This is one rule you really shouldn't mess with.

THE WISDOM TO KNOW THE DIFFERENCE

So how can you be sure which rules it's OK to break—which rules if fact, are just begging to be broken and which ones to leave intact? Don't break:
- rules pertaining to ethics
- rules pertaining to respectful, professional conduct
- rules pertaining to money paid to the government: sales tax, employment tax, income tax, etc.

WHY YOU NEED TO KNOW THE RULES

If you're going to do things your own way anyway, why learn the rules in the first place?

"You want to make informed decisions," says Fox.

"It's more fun to break rules if you know you're being, you know—naughty," says Lee Stanford.

Ultimately, you need to know the rules before you can decide to accept or reject them. Then you'll really be the master of your destiny.

Here photography student Gina Hillukka composes a location portrait of angel children at a small water-fall. In a by-the-book photography class an instructor might spend time breaking this photo down into each of the rules used (and broken) in its composition. Just remember that whether the photographer and client are pleased with the final result is just as important (if not more important) than which rules were followed and which rules were broken.

Summary

So now that I've burst your bubble, how do you feel? Do you have a let-down feeling, now that you know the life of a photographer is not all hearts and flowers? Or do you have a steely resolve to work hard and meet all the challenges and rise above the competition to one day be tops in your photographic specialty of choice?

Maybe you're thinking the fantasy photography life you'd envisioned wasn't all that great, and the reality isn't all that harsh. Maybe you're thinking, "Hey, I can do this."

I can be a business person: I can make projections, get a tax ID number, protect my name, get invoices out on time, and anything and everything else necessary.

I can fulfill the obligation to fully and passionately tell the stories of my subjects—whether my subjects are two year olds in ribbons and bows holding bunny rabbits, or war-torn refugees.

I can be my own product, my own message. I can leave my clients not just with beautiful images, but with excitement about the experience of working with me and about the special understanding and creativity I brought to their project.

I can put my clients at ease, earn their trust, and build strong intimate working relationships with them.

I can hang on for the creative ride from the highs of learning to the thrills of mastery to the valleys of boredom—and bring

myself back to the highs of learning all over again.

I can reinvent myself when the economy, the marketplace, the trends, and the technological advancements dictate the need—and I can feel good about it.

THE STORIES OF THOSE WHO HAVE GONE BEFORE US

Learning the stories of those who have established photography careers can give us a context for our career choice and validate that choice. Understanding the disparate places in their lives from which these people all entered the same creative field helps us understand that we are, each of us, both more unique and less alone in our visions and our desires than we had thought.

Having the luxury of seeing the ways in which they built their careers and beat the odds gives us hope that we can do it, too.

In frankly sharing their mistakes and fears as well as their victories with us, they allow us to identify with them, to see ourselves in similar lives one day, and allow ourselves to have fears and to make mistakes, too.

HOW TO BECOME A PHOTOGRAPHER

There are so many ways to learn the craft and art of photography that any aspiring shooter should be able to find one or more that suits his personal style and that he can easily fit into his life.

He can work as an apprentice, assisting a photographer. He'll make little or no pay, but if he's observant and asks questions, he can learn it all—creative technique, technical know-how, and business protocol—from the inside out.

He can work as an assistant, making $175 to $250 a day, and get a bird's eye view of an established shooter's business.

Going to a two-year tech school is a relatively quick option that allows the student down-and-dirty, hands-on experience with the whole range of equipment and in a variety of disciplines. It may not hold the prestige of art school or photography school, but it sure gets the job done.

A top notch school like Brooks Institute of Photography offers two- and four-year programs that are intensive and expensive. Many shooters start out in Liberal Arts College and then transfer credits to finish out their photography major at such schools.

A photographer with an art school education can do well if he remembers to consider his clients' satisfaction into his equation of how to do business.

Clubs and professional organizations, including online discussion groups, can provide a great forum for new and established photographers to network and exchange knowledge and information.

A liberal arts degree creates a well-rounded person with good general knowledge, who knows how to study and how to think—an excellent platform from which to dive into the photography business.

Many of the photographers profiled in this book are self-taught. This doesn't mean they learned the business in a vacuum, without teachers or mentors. It simply means they had no formal photographic training. If you're incredibly motivated and confident in your talent, you might be able to make self-teaching your platform into the photography world.

Working in a camera store gives you exposure to a lot of different professional photographers, intimate knowledge of equipment, and a natural forum to discuss every aspect of the business with fellow employees and store patrons.

If you can get informal, informational interviews with established photographers, you'll get to spend a little time in the inner sanctum and get some answers to questions that are burning in your mind.

Reading books on photography can nicely supplement any other avenues for learning you choose to pursue. Just don't read a book and assume you've learned its lessons; you need to take the lessons out into the field and apply the theories and techniques you read about to your actual shooting experience.

To really shorten your learning curve, you can hire a consultant at $200 to $500 an hour, to show you exactly how to run a business in your specialty area. For people who have the resources and know precisely what they want to do, hiring a consultant can actually result in a huge savings in time and money spent compared to a two- or a four-year program at a photography school or an art college.

Aspiring portrait photographers can learn some of the ins and

outs on the job at chain studios and photo mills. You can get a lot of practical, hands-on experience dealing with clients and a variety of subjects, and learn some technical basics while getting paid.

Of course finding a mentor can really jump-start your career. An older, more established shooter who takes an interest in your career is worth his weight in gold.

People who want to learn photography, but who have day jobs, families, or other pressing obligations, often find Internet classes to be a perfect solution. You can complete the lessons at your convenience and receive invaluable feedback from highly credentialed instructors, as well as from the rest of the class.

FINDING YOUR PLACE

With the competition fierce in every photography market in every part of the country, now more than ever before it is important to choose a specialty and refine it, so that you distinguish yourself from the pack. Clients should be able to look at your work and know that it's yours without ever seeing your credit line.

In choosing your specialty area, you need to weigh your interests—what it is you love to shoot—against the realities of your market—what people will buy. It's important to consider your desires. The photography business is too tough to be in if you don't love what you do. But it's equally important to consider your market. If you can't make a living you'll be just as miserable as if you're stuck shooting in a field you don't like. So you need to do some soul searching and then commit yourself to a narrow area of expertise.

PLANNING FOR A BOUNCING BABY BUSINESS

A business plan is a document that describes your business, your market, and how you intend to position your business within that market. It projects your fixed overhead, cost of goods, and the quantity of goods you'll have to sell, and at what price, to make a profit.

Your business plan spells out exactly who you are, what your products and services are, what makes your products and services better than your competition's, and who your targeted clients are.

Your business plan will help you test the feasibility of your economic goals, thus helping you avoid ugly (and costly) surprises.

In doing the research necessary to complete your business plan, you will learn about your competition and your market. This knowledge will help you make your business more successful.

Likewise, figuring out exactly what and how much you need to sell can help motivate you to meet financial goals, in the same way that quotas help motivate a salesperson.

If you intend to apply for a bank loan, or woo potential investors, your business plan is an invaluable sales tool.

STARTING UP

When you're starting up your own business, your to-do list is going to be really, really long. Don't let it daunt you. You have to be unflappable. You have a lot to do.

You need to choose the type of entity, or business structure, that's right for you. You need a professional, kids—don't try this at home! Consult a CPA or a tax attorney before you try to tackle this one.

You need to choose a name for your business, and protect that name by getting a trademark for it, unless you're simply doing business under your own name—you don't need any protection for that.

You need to file for a tax ID number; you can't do business without one, and you need it so you don't have to pay sales tax on items for resale.

You need to learn when to charge your clients sales tax and when not to, and when to pay sales tax and when not to. This can be trickier than it seems.

You need to establish a record-keeping system that works for you and get into the habit of keeping meticulous records.

Figuring your own taxes and filling out the 1040EZ form are now a thing of the past for you. You need to hire a CPA.

You need to choose a location for your business. Do you want to work from your home? Open a point of destination or a retail studio? Share a space, partner, or rent on an as-needed basis from another photographer?

If you sign a lease, you should understand rent plus CAM

(common area maintenance) charges.

Considering the purchase of an existing studio or a franchise? Learn the pros and cons of each.

Recognize the difference between employees and contractors, and hire the one(s) that are appropriate for your business needs.

REJUVENATING YOUR EXISTING BUSINESS

Just when you think you can coast, it's time to start pedaling again. Sure, your business has survived the treacherous start up stage, and you've experienced some real success. But now is not the time to relax.

Keep up your marketing. Keep your portfolio up to date. Use that phone—it's still your most valuable customer relations tool. And speaking of customer relations, keep those up, too. Don't start taking those people, who are the very reason for your success, for granted.

Some photographers find this stage of their business life to be a time of disillusionment. They've come, they've seen, they've conquered—and now the excitement is gone. Fight this pitfall with a variety of tactics: take a vacation, volunteer, do some test shoots or pursue your personal work with extra ambition, count your blessings—remember, you're one of the lucky ones. Explore alternative careers. You might find one you that you're more suited for, but the more likely result is that you'll reaffirm the choices you've already made. Finally, vent your spleen! Do some good old fashioned griping. Get it all out.

Having more business than you can handle is another dangerous milestone in the life of a small business. You have to decide whether to grow or whether to contract—and possibly turn business away.

You need to examine your role—it will change if you expand. You'll become more of a general and less a soldier in a fox hole—supervising rather than doing. Some photographers like this; they naturally find their own management style and they don't mind delegating. Others like to stay on the front lines. Which one are you?

Ask yourself: am I making enough money right now? Because if you are, it might not be worth the risk of the added liability

and exposure to expand. Sure, a larger, well-run business will pay bigger dividends during a good economy, but bigger isn't always better—profit margins are smaller, and when the bad times come (and there will be bad times), your risk is greater.

There are pros and cons to this stage of business life. As a someone once said, being old is better than the alternative. But you're not growing anymore, you've topped out. The thrill is gone. You need to recharge your creative batteries. Maybe you need to find greater satisfaction and excitement outside of work. Or maybe this is a good time to explore new niches within the photography industry.

EXPLORING NEW NICHES

There are a host of reasons to change your niche or add one at every stage of a photography career: a market shifts, your personal preferences change, you get bored, you lose the physical stamina for location work and come home to the studio.

Changing niches can be extreme (from outdoors/travel to studio portraits), or it can be slight (editorial architecture to commercial residential interiors). It may involve a total shift in technique and subject, or it may involve doing the same work, but marketing to a different client.

Making such changes can be done at any stage in your business life. When you're just starting out, you're hungry and you're flexible, and you'll do whatever is necessary to succeed. When you're middle-aged, you might resist making changes because you're comfortable in your habits, but on the other hand, you've mastered photography and you have resources to make the transition easier. When you're in the later stages of your career, changing niches could be a godsend or a heartbreak, depending on the reason for the change. If you're going back to the subject matter you always wanted to shoot, then the change is a godsend. If your market dried up and you are forced to change to survive, that's the heartbreak. But then again, you might find you like the new challenge. It might bring some of the thrill back that you were missing.

Whatever you do, hedge your bets. Give yourself a safety net. Don't quit your old specialty until the new one has firmly taken

root. Don't rob Peter to pay Paul; taking resources away from one to put into another is dangerous and foolhardy. And don't follow the crowd—if there's a mass migration out of your specialty area, wait it out. You may find yourself surprisingly and happily alone.

PULLING NUMBERS OUT OF THIN AIR

Sometimes that's what it feels like when you're trying to determine what to charge for your products and services—pulling numbers out of thin air. But there are standard fee structures and price ranges for every industry. You need to research the standards in your area, and there are several ways to do this. You can join a professional organization for photographers in your specialty, such as ASMP (American Society of Media Photographers.)

Within your industry there is a range of price levels in which to compete. You have to decide where to position yourself within that range. If you're just starting out, you probably want to be somewhere in the middle of the range, between bargain basement and carriage trade. If you charge too little, you're competing with the masses and your work may be perceived as shoddy. Charge too much, and you limit yourself to a very small portion of your market.

Remember to consider your costs of goods (COGS) and fixed overhead when setting your prices.

And consider price-point appeal: $19.99 sounds a lot cheaper than $20. Don't ask me why—human beings are funny animals sometimes.

Small, steady price increases over the years will serve you better than sporadic, sudden increases. Your clients will be happier and you'll cover your inflationary expenses better in the long run.

THE PHYSICAL REALITY OF A BODY OF WORK

You probably thought your biggest job was going to be making your images—silly you! Actually, one of your biggest jobs is going to be keeping track of them: organizing, archiving, distributing, showcasing, packaging, and just generally handling your

originals and prints.

Presentation is everything! When you're showcasing your work, whether it's on the wall, in your portfolio, or in its package, do it right. The way you present your work tells your clients how to regard it. Great work can look like terrible work if it's presented poorly.

Organizing originals is a huge task all by itself. But a mislabeled or lost original may as well not exist at all. You need to know exactly where every image is, all the time.

Storage is another big deal. You need to have adequate, archival storage containers, and cost-effective, fireproof and waterproof storage areas for your originals.

Some photographers purge their negatives or originals after a period of time has passed and the likelihood of the client reordering has passed.

GET OUT THERE AND TELL YOUR STORY

The ability to be a good marketer is more important to your ultimate success than your ability to make great images—you probably don't want to hear this, but it's true. You could be a fantastically talented photographer, but if you don't get out there and spread your message, and show people your work—and your face—you won't be in business long.

You don't just find a client base—you make one. You may not realize it, but you are on commission. You are essentially a commissioned salesperson, just like the one who sells you your clothes at the mall or sells you your waste management services.

You have to know what makes you and your work stand out from the crowd. Make up a clear and recognizable story about it, then get out there and spread your rap.

Be persistent. It takes more than one contact with you before a client will hire you. Even if your contacts don't result in jobs right away, keep going back. It's like planting seeds. It can take a while for germination.

Target your audience. Market to the people who are likely to use your products and services. You don't have to get your message out to everyone, just the right ones.

Set goals, so you can track your progress.

There are many different marketing methods. Some are hard, some are easy. Some cost nothing, some cost a lot. You'll probably benefit most from a combination of methods. Direct mail, Web sites, and cold calls are just a few.

Have a marketing plan and a marketing budget. It's even more important than your business plan—if you have clients, you have a business. If you don't have clients, you're out of business.

SELL IT, BABY

Sales is like marketing, but instead of selling a potential client on using your products or services, you're selling a person who is already your client your products or services. I look at marketing as outside sales (going out and getting the clients) and sales as inside sales (selling your clients your stuff).

Remember that sales is all about customer service and relationships. People buy from people they like.

Don't be shy about taking control of the sales meeting, design consultation, or any other client situation. Your expertise is not an intrusion, it's a service. It's added value.

One way to take control is to set the tone. Often, we unconsciously mirror the behavior of the people with whom we are dealing. If the client comes in flustered or defensive, we reflect this back to them. But instead of just reflexively taking the clients' lead, you set the tone. Demonstrate a relaxed, positive attitude, and the client will relax and become more positive, too.

You should learn the little tricks of the trade: selling up, meeting objections, repeating the client's concerns in your own words. But ultimately you have to develop your own sales style, based on your own personality, and the specific things that motivate you.

PUBLIC RELATIONS

Public relations is all about community. By creating a presence in your community you foster good will and make your own story a part of your community's story.

You can do your own public relations work, writing and sending out press releases and drumming up opportunities for public speaking—or you can hire a PR firm.

Other ways to become a presence in your community are to

become involved in charitable activities, professional groups, and pro bono work.

DIGITAL TECHNOLOGY

I love film, and I have an inherent mistrust of digital capture. But I'm gradually learning to embrace digital technology as a valuable tool in certain circumstances.

Simply put, digital capture is a different information storage method. Film stores visual information with grain. Digital stores visual information with pixels.

Digital technology can not make a bad photographer into a good one, or a poorly lit image into a work of art. What it can do is allow you to remove those nasty power lines from your exterior architectural shot, or that blemish off the face of the model in your fashion shot.

It can give your clients faster turn around time—sometimes you can just hand them a photo CD as they're walking out the door after your shoot. It can sometimes save you money on media, savings you can pass on to your client.

In some situations and for some methods of reproduction or distribution, digital images can look as good or better than film.

But digital equipment can be very expensive, and it becomes outdated quickly. If you already have an established, film based business, you need to do some number crunching to determine whether the addition of a digital system is justifiable financially. Will your $50,000 new equipment purchase result in $50,000 worth of increased sales or increased media savings? If the answer is no, then you need to wait.

It is really time to go digital or die? No. Is film dead? No. Digital technology is not a magic bullet, it's not satan's little helper—it's just another tool in our belts.

CRADLE TO GRAVE

The life cycle of a small business goes something like the life cycle of a person. Gestation is an exciting and scary time. You're full of hopes and yet full of fear and doubts—what if something goes wrong? Will I be able to handle this new responsibility?

Infancy is hard—there's no joy in Mudville. You'll be working long hours, and often everyday of the week. But you'll be able to see the payoff coming.

Toddlerhood is a dangerous time: you have some mobility now, and you've built up some momentum, which is the good news and the bad news. If you go toddling off in the right direction, you'll be OK. But if you toddle off in the wrong direction, you'll make the business equivalent of smacking your head on the table edge—investing your resources unwisely or focusing your energies in the wrong place.

The preteen stage is awkward. Sometimes you'll feel like the new wunderkind on the scene, and sometimes you'll feel like an impostor impersonating a photographer.

Young adulthood is great—you're feeling secure, but still challenged and engaged, and you're still growing a little.

Middle age, and the thrill is gone. You need to consciously find ways to charge your creative batteries.

Our golden years might not be as golden as those of other entrepreneurs. Unlike other businesses, which are conceived with the idea in mind to one day sell them, we might come to retirement stage with nothing to sell.

LAWYERS

There are a lot of lawyer jokes, but they're only funny until you need legal advice. Then you stop laughing.

There are a lot of reasons why photographers need lawyers. More than ever, we need help protecting our intellectual property. We need help deciding on what type of entity our businesses should be. We need help trademarking our names, and understanding employment law and tax law—both areas where a misstep can cost you big time, too.

Find a good lawyer by asking for referrals, and interviewing potential candidates. Look for a generalist in a small firm or a sole practice, who has the integrity to refer you to a specialist when it becomes necessary.

ACCOUNTANTS

The first professional you hire should be your CPA. He will be

the director of the team of professionals whose services you will use to grow your business. Your accountant will not only do your taxes, he will act as a financial and business advisor, and help you put together your team. You'll need a banker, book-keeper, insurance agents, and lawyer.

To find a good CPA, look for one in a small firm that specializes in small businesses like yours. Ask people you know and trust who have similar businesses who they use, and just as with the attorneys, don't be afraid to ask for an interview with your potential candidates.

LIFESTYLES

Many of us expect the lifestyle of a photographer to be glamorous and easy. All right, yes, there is some glamour—but it's anything but easy. In many specialties, you wind up working nights and weekends. Often the work is physically demanding. The work can be seasonal or sporadic, so at times you'll be working 80-hour weeks, and at other times you'll be wondering if you'll ever have another client again as long as you live. You have to save for a rainy day, because just as the work comes in spurts, so does the money.

But if you can handle uncertainty, the pay off is big: you get to make pictures.

NETWORKING

There are a world of reasons to network with your fellow photographers. You can help set industry standards, refer clients to one another when you get a request for a job that is outside of your area of specialty, find a mentor, trade secrets, and learn techniques from other specialties that you can use in your own—sort of cross-pollinating.

Places to network include professional organizations, online discussion groups, and seminars and workshops.

LEARNING AND BREAKING THE RULES

The photography business is full of rules, written and unwritten. Some of them are necessary and good. Some of them are just dogma. You need to be able to tell the difference.

Examine the context of the rule—did it originate in an earlier time, when equipment and media were different? If so, it could be an artifact that belongs in the retirement bin, and not in actual practice.

Generally, rules pertaining to ethics and proper business practices should be followed. But rules pertaining to creative technique can—and should be—broken on a regular basis.

Ten Special Projects to Inspire Your Business Brain

PROJECT 1: MAP OUT YOUR LIFE

If you drew out your life as a map, like the kind they provide at shopping malls to help you figure out where the important stuff is, like the food court, the restrooms, and the movie theaters, where would you appear on it? I want you to seriously draw your map (it can be on the back of an envelope or a napkin—it doesn't matter) and look at this moment in your life as a geographic location, and not just as one of a series of moments strung together like beads. You are a visual processor, after all, and what you can visualize, you can do. So if you visualize yourself here, and your successful photography business over there, you can make a plan—you can chart your path—from point A to point B, because point A and point B both exist in the now, they are just in different places. But if you think of yourself as in the now, and your successful photography business as somewhere in the future, as most of us do, you might never find yourself in that projected future business. It's not real. It doesn't exist. It may come into being someday, but it may not. On your map your business exists, and it's right over there.

Start with your birth in the middle of the map. I don't believe you need to include your death, because no one can really imagine that, anyway. But if you operate better on a deadline, go ahead and include it (preferably some place obscure!).

Going clockwise in a spiral, indicate the major milestones in

your life leading up the present. These could be schooling, major moves, illnesses, accomplishments, relationships, marriages, parenthood, jobs, and careers—whatever has formed the you you are today. Make each milestone, or location, a size to indicate its importance to you. For instance, let's say you attended college for five years and you had a three-month summer job. College left you flat, but the three months at this job inspired you and set you on a new life path. Draw the job as larger than the college time in proportion to its importance to you.

Once you've come to your present, that's where you draw the little arrow that says "you are here." What comes next? Remember, you have the power to decide. You can draw it on your map, you can make it in your life. Perhaps you want to indicate that this is a turning point or a new beginning for you by drawing a path or road with a gate across it. Open the gate. On the other side draw a camera, or a diploma, or something that represents your new endeavor.

Always feel free to revise your map at any time. Take those big wonderful formative moments and put them closer to the center. Relegate those negative or uninspiring moments to the edges and corners of your map. For instance, I had a second-grade teacher who drained the desire and joy for learning math right out of me. Her class is at the lower left edge of my map indicated by a math textbook in a circle of flames. What can I say? I was a sensitive child.

Indicate the landmarks on the road to your established photography business. Assisting, internship, purchasing equipment, writing a business plan, taking classes on business or marketing, joining a professional organization, your first test shoots, your first paid shoot, finding and registering your business name, your first stock sale, your first commercial client, whatever you can imagine, map it. Remember to keep the spiral going. Time happens to us in a straight line, but life doesn't.

Your successful photo biz is big on your map and close to you, because it's good and it's important.

Your map can be layered. For me, high school was a great place where I learned to be outgoing and really tap into my creativity. Part of that was a result of being involved in high school

theater. So on my map, high school is a large green area with smaller yellow areas (theatrical performances) on top of and overlapping it. If you really want to get fancy with this exercise, throw away the napkin you're drawing on and get some vellum or tracing paper, and really show the three dimensional layers of your life.

If you already have a studio, then map the next step—indicate the milestone or event that means you've made it to the next level of success. This could be a move to a bigger, better space, or better equipment, or the hiring of employees, an annual gross or net, or a number of clients. Put it all down in black and white—and red and yellow and blue, too. If you can see it, you can be it!

PROJECT 2: CREATE A FULLY REALIZED FANTASY BUSINESS

J.R.R. Tolkien created Middle Earth and peopled it with Hobbits and elves and wizards. He created an entire language and generated maps of his imaginary land, and created histories and genealogy for the characters. He left no detail undeveloped. That's what I want you to do with an imaginary business. You should approach this exercise as a complete work of fiction— you mustn't plan on making this business a reality. (If you do wind up doing that later, kudos. But don't go into it with that expectation.) What you want to do here is get comfortable with making up a new business, and conversant with every aspect of the process. By developing a pretend business rather than the one you ultimately will be developing in reality, the pressure will be off and you'll be able to proceed fearlessly and playfully. I do this exercise once or twice a year, simply because it keeps me fresh and I enjoy it. It helps me bring creativity into my business dealings. And then when I do create a new studio that I intend to invest real-life time, energy, and money in, it feels a lot easier and more fun. When I create a fantasy business, my brain doesn't know that it's only a fantasy—it thinks it's real.

To do this project successfully, you have to pay close attention to the minutiae. Choose a name, a venue, a market, develop a product, create a fee structure and price list, research the costs of creating the imaginary product and run projections (how

many clients would I have to have at what average expenditure to make my nut?). Make a to-do list. Don't forget to include applying for your imaginary tax ID number and vendor tax exempt forms. Get an imaginary copyright for your imaginary name. Decide whether you eventually want to sell your imaginary business, or franchise it, or expand it to other markets.

Then, after you've fully realized this new business in your mind and on paper, put it aside and create another one. Do two or even three. The more of them you do, the easier it becomes.

PROJECT 3: TOSS OFF SOME PROJECTIONS

Do you already have a photography business and wish it were performing better? Create as many scenarios as you can think of and make some projections of how they might work financially. For instance, say you want to increase your profitability but not necessarily your work load. How much savings would you realize if you moved to a smaller space or shared your existing space with another photographer or compatible business? Which of your fixed expenses could you trim in order to realize greater profitability? Could you do without one of your phone lines? Give up the window cleaning service and buy a squeegee and a bucket? Make your studio manager part-time and hire a student or intern to answer the phone and do production? What if you instituted a price increase, or changed your fee structure?

Or can you handle more business? How many more clients can you serve in a month? What if you could raise your average sale 20 percent and serve 25 percent more clients? How profitable would you be then? What if you could serve 35 percent more clients and raise your average sale 100 percent?

The key words for this exercise are "tossed" and "off." Have fun with this—don't take it seriously. Run ludicrous projections. This is the business equivalent of a gesture drawing—stay loose, get wacky. You may stumble upon a viable course of action, or you may not. It's all about the process, not the results.

PROJECT 4: TEACH SOMEONE THE ROPES

A bit rusty at your bookkeeping skills? Or perhaps you were never really good at it. Having a hard time developing operating

systems, or any other business issue you're struggling with? There's no better way to learn than to teach.

Bryan Peterson is a living example of how this approach works. Having begun his photography career shooting exclusively in black and white, he eventually found himself drawn to direct color film. But having no experience with it, he looked for a class to take at a local college. "No, we don't have course on color photography, but it sounds like a good idea," he was told. "Why don't you teach it?" Never one to shirk a challenge or let an opportunity pass him by, Bryan took the job. After teaching the first session he thought, "OK, that was great, but what do I teach for the rest of the sessions? That was all I know about color photography—I'm all tapped out." For each of the remaining sessions he chose a technique, taught it to himself, then taught it to the class. "Sometimes I had only learned the technique a few days before I taught it," he says. Needless to say, he came away from the experience very conversant in the art of color photography.

Peterson learned photography technique by teaching it. But the same theory applies to business operations. Not that we all can go off and teach a college course in an area we know little or nothing about, but we can find students, interns, and young employees who are eager to get an earful. You may even consider creating a course syllabus as if you really were going to teach a course in business operations.

PROJECT 5: TAKE SOME SEMINARS AND WORKSHOPS

I never used to be a big believer in taking business classes or workshops. It was partly a matter of, "If he/she is so great at running his/her business, then why does he/she have time to teach this silly workshop?" I was of the old school, "those who can't do, teach" theory. But eventually I broke down and took some business seminars and workshops, both those geared specifically to the photographer and those geared for other or general businesses. I learned a lot. I still attend marketing and business classes from time to time. Sometimes it serves to remind me of what I already know and had been forgetting to put into practice. Sometimes I come away with a really precious tidbit or

two of information that is actually news to me, things that I rush back to the studio excited to put into practice. In any case, I've never regretted the time spent.

PROJECT 6: FORM THE "A TEAM"

I have a cousin who has owned and operated an advertising agency since she was eighteen years old. Way back before anyone had coined the word "networking," she had a gang she called her "breakfast group." The breakfast group was comprised of people from various businesses she'd invited to join her on weekdays at some unbelievably ungodly hour at a coffee shop. Sometimes they talked business. Sometimes they simply socialized. Sometimes they traded services, and sometimes one would help another out in a pinch. I never attended the breakfast group, since my heart doesn't even start beating until 8 a.m., but now I wish I had. The thing that impresses me most about this network/support group/social club is that she built it herself. She created a community based on her needs and the needs of the other members. It was organic and fluid in nature and evolved over time as the members' needs changed.

She didn't wait for someone to invite her, or wait until there was a formal club or organization to join—she just picked out the people she wanted and tapped them on the shoulder, and they became her "A team."

You can do this, too.

PROJECT 7: DESIGN SOME WEB SITES

In the casual spirit of Project 3 and using the fantasy businesses you created in Project 2, toss off a few Web site designs. You don't have to be a Web site designer and you don't have to wind up with any usable sites, but give it your best shot and see what you come up with. Again, it's the process that's the important part here.

PROJECT 8: CREATE A YEARLY BUSINESS PHYSICAL

Most of us (especially those of a certain age) have a yearly physical. We don't have these because it's fun to go to the doctor or

because we have worrisome aches and pains—we go in perfect health, and with the expectation of being told as much by our doctor when the exam is over and the test results are back.

You should do the same for your business. Don't wait until its sick to take its pulse. Pick a date—it could be the end of the year, or a period during which your business typically slows down. Then run down your checklist: Is your gross stable? Is your net up or down? Are your clients mostly repeats, mostly new, or a combination are they coming from the same places geographically and demographically, or are they changing? And how's your product? Is its quality consistently good? Or is it time for a little extra quality control? Have you had any complaints over the past year from clients, and if so, are they running along the same lines, indicating that perhaps some of your policies or procedures need a second look? Did you do your normal amount of advertising over the course of the year, or did you neglect to send out a postcard or a newsletter? You'd better know now, because you won't see the damage until later.

Pretending your business is a human patient, assess its overall health. Choose a couple of growth areas—things that you could be taking care of better. Red flag them and pay special attention to them over the coming year. See if they've improved by the time of your next physical.

PROJECT 9: COMPILE A READING LIST

Ever find yourself with some unexpected reading time, but nothing to read? You know there are a thousand and one books out there that you've been meaning to peruse, but darned if you can think of any of them now. This will never happen to you if you already have a reading list that you've compiled in advance, and maybe even some of the books on the list in a stack on your desk or next to your sofa. Compiling a reading list also has the added advantage of stimulating you to find the time to read more. After all, if your research turns up a book that intrigues you enough to put it on your list, or even purchase it and put it in your "queue," you're considerably more likely to pick it up and read it. Sooner, not later.

PROJECT 10: JOIN A PROFESSIONAL ORGANIZATION

Heck, join two. You'll learn a lot. You'll be a part of a community. If you're new in the biz, you'll start to see yourself as a real photographer and not just a green horn, or worse, an impostor. If you're a veteran, you'll benefit from going shoulder to shoulder with your peers, and you also might learn a lot from the new generation. Who do you think is more conversant with digital technology—you and your old cronies, or that kid over there that looks like he isn't even old enough to drive?

If you have limited time, you can only be available for meetings sporadically, join an Internet chat group. You can log on and off at will. This can be great for chronically shy folks, too.

Learning to Be Your Own Muse

KEEP A CREATIVE JOURNAL

I hope reading this book (assuming that you didn't pick it up and simply skip straight to this appendix) has helped get you creatively fired up. Ideas for images, for new techniques to try (or to pioneer!), new products to develop, and new media to master are swirling around in your brain. Don't let them get away! Start an idea journal, and religiously record every idea that crosses your mind. Don't edit yourself. Every idea has value and should be recorded. Don't worry if it's half-formed, seemingly too humble or too simple to be bothered with, or so grandiose as to embarrass you later when you look back on it. Most of the thoughts you record you will never act on. They will not become images or products: they will not bear fruit. But this is what they will do: they will serve as stepping stones to the creative work that you will ultimately do. The stepping stones are a necessity for you to get from here to there. They're an essential part of the journey, and without the journey, there is no destination.

I have sixteen feet worth of files full of just such thoughts, ideas, false starts, experiments, and prototypes. Some of them are just plain bad. They fall into the category of "what could I have possibly been thinking?" Like the really ugly color photocopy (pre-digital) portrait holiday cards, followed by the really ugly digital portrait holiday cards, followed by the really gor-

geous digital portrait holiday cards. Some of the prototypes were wonderful, like the portraits printed on wood, metal, and stone, but were infeasible commercially due to unstable and inconsistent media. Some of the work is just plain wild, with aspirations toward fine art. But the seeds from all of these are inside my products that actually made it to market.

And what's more, when I'm in need of inspiration, I look back through these files and all of them, even the failed ideas and images, help pique my creative curiosity and motivate me to either revisit the same techniques in a new way, or to use them as stepping stones to a totally different concept. Even just looking back at my process, how I managed to get from ugly photocopy to ugly digital to great digital holiday cards, for instance, is a source of inspiration because it reminds me that I can get there from here: it just might take a while.

WHEN THE WELL IS DRY

There will be times, though, when you'll realize you haven't pulled out that ol' creative journal in a very long time. You haven't added any new techniques or prototypes to those archives since ... well, you can't remember when. That's when you'll need extra stimulation to be productive again, to get outside of the vacuum that your own head can become and to begin to see creatively again.

The following are a variety of exercises, games, research projects, and self-assignments I suggest you try when you need to recharge your creative batteries, when you need to start seeing with fresh eyes.

DOMINANT EYE

Many of you may be surprised to discover that you actually have a dominant eye. Sure, you know which is your dominant hand, and you've heard that lefties tend to be more creative than righties because their right brain (the creative side) is dominant. But you may not have noticed that you also have a dominant eye, and it may not be on the same side as your dominant hand. In fact, if you are statistically average, you are probably right-

handed. And if you are a photographer, you are probably left-eyed.

Pick up your camera and look through the view finder. Which eye do you use? Chances are you use the same eye each and every time you shoot. This is not just a coincidence, or a habit you've picked up—you use that eye because it is the eye that most effectively delivers visual information to your brain. It is the eye you think with.

Just for fun, try shooting with your other eye. Don't cheat and just aim at anything—make a real effort to freeze action at a decisive moment, make a pleasing composition, or capture a great expression. I think you'll find that not only is it hard to actually physically do this exercise—you'll tend to involuntarily try to use your dominant eye, and you'll be struggling with your own camera as if you're possessed by a mischievous spirit—but you'll also find it hard to achieve good results. Your compositions won't be as balanced, your timing won't be on, your perception of your subjects will be fuzzy.

The difficulty of this exercise is precisely what makes it a great tool for busting out of a creative slump. It forces you to use mental and visual muscles in a new way. You'll be stronger and better at seeing for the effort, and as an added bonus, when you go back to shooting with your dominant eye, it'll seem pretty effortless. The following are some suggestions for subjects to shoot using your "other eye":

- Take a kid outside and ask him to run and jump around. Try to grab a good action shot. Just try it!
- Style and shoot a still life. For this one, because you'll be partly creating the composition before you shoot, you'll have to keep your dominant eye shut while you're setting up the shot. Otherwise you're cheating.
- Pick an adult and make a portrait. Make every effort to capture a warm, relaxed expression and a real connection between your subject and your lens.

After you've done this, compare your results with your real work made with your dominant eye. You may not wind up with

any usable images, but you'll have fine tuned your eye-brain coordination.

PHOTOSHOP AND DARKROOM

The darkroom is a great place to learn how to see. Your negative is purely raw material, like an uncut diamond. To make a print is to see the image in all its possible incarnations and to bring these possibilities to life. You don't simply see an image as it is, you see it as it could be. You hold the finished product in your mind before you ever make the print. You get to be a little bit of a clairvoyant, and a little bit of a magician.

For photographers of my generation, Photoshop wasn't even a glimmer in its father's eye when we began to learn our craft. A stint in the darkroom was de rigueur, and that often times stinky, claustrophobic, nasty little room was accorded the respect it deserved. But these days it's possible to become a working photographer without ever having set foot in a darkroom, or with only a brief, token nod toward it, and with no understanding whatsoever of its importance. That's a shame. Because the single best place to learn to be a photographer is not in the field or the studio, and it's not in front of your computer screen—it's in the darkroom.

Even those of use from the old school inevitably stop making our prints, unless we become printers as our vocation. It's not possible to do all our own (or even any of our own) printing while running a studio that does the amount of volume necessary to generate a comfortable living.

So ultimately, most of us either leave the darkroom, or never really came to it in the first place. But to cure a creative block, it's one of the places to start. So if you have an old darkroom setup (and who doesn't?) dig it out and (literally) dust it off. Set up shop—in your bathroom, if necessary—and pick two images to experiment with: a good, sound, properly exposed negative, and a poorly exposed one. You could go back through your early work and choose images you haven't seen in a long time, or you could choose more recent shots. Start with the sound negative and some good, multigrade paper. Make a dozen very different prints from this image. Vary the contrast and density, the dodging and burning, the cropping, and anything else you can think of. If

you're up for the challenge and you own a good respirator, try some different toners, farmer's reducer, and other treatments. Try tea-staining a print, or experiment with some of the new art papers. Go nuts. Don't expect every print to be a keeper. They won't be—they shouldn't be. The object of this exercise is to compare and contrast, to remind yourself of the wonderful malleability of a photographic negative, to find joy in the process of creative play without worrying about the outcome. If you wind up with a great, frame-worthy print, that's icing.

Then, after you've emerged from the darkroom, go to the photo lab that is your computer. Pull up your PhotoShop or whatever program you have for altering images. Armed with information you've gleaned from online discussion groups and bulletin boards, make a dozen prints of the same image using different effects and applications. If you feel like taking a workshop or course on the topic, or reading any of the numerous great books available, do that as well. But the information you get from other amateur and professional photographers on the Web will be valuable in a different way. You'll be as anonymous as you wish to be, so you may feel freer to ask questions you're worried are stupid or demonstrate your lack of knowledge. And when doing work on images that we know we will submit for critique by a teacher and our classmates, we may hinder our own creative process by worrying about the outcome or about having the best work in the class. The purpose of this exercise is, much like the darkroom exercise, to experience the process of visual play with your image using the tools your computer program provides. Even if you come up with a great image as a result of this exercise, resist the urge to post it on the Web. Although it might be tempting to share your triumph with the people with whom you've been chatting and sharing information, just knowing that you may expose this particular work to the scrutiny of others will inevitably change your process.

REALITY AND FANTASY: ONE AND THE SAME?

When it comes to our world—at least our visual world—there is no concrete reality. We all like to think that what we see is empirically correct and documentable and justifiable and con-

stant, but it's not.

And not only is the actual physical appearance of the world around us relative—colors change with the changing light; objects change with our changing perspective—so too is our perception of it. We don't see what is there; we see what we think is there. Take for instance, the way a child draws what she sees. The sky is a blue bar across the top of a picture. The grass is a green bar across the bottom. Houses only exist from an axial perspective and every flower, bee, and butterfly, and every pet and person, is facing the viewer—facing toward the child. Later, when she grows out of the stick-figure stage and starts drawing people with more nuances, with all their extremities and facial features, she will depict human hands considerably smaller in scale than they are in reality. They are actually as long as the human head—she will draw them about half that long. She'll draw the eyes in the top 20 percent of the head. In actuality, they are in the middle of the head. The child draws what she thinks she sees. And if you can get an adult to make a drawing, most will do the same thing. Because we spend all our lives looking, and very few moments actually seeing.

How can we actually see and not just look?

Befriend a person who has lost her sight

I have a friend who volunteers as a reader for a woman who lost her sight to macular degeneration. Over the years they have become friends. I have had the pleasure of joining them for lunch now and then, and the insight I've gained from Ruth's highly articulate description of her journey into blindness, and her ability to describe how and what one "sees" when one can no longer "see" have informed and inspired my work in amazing ways. I would recount some of her stories for you here, but that would be depriving you of experiencing first hand the wisdom of a person who knows both sightedness and blindness.

Learn about dyslexia

One of the books that impacted my photographic work was not a book about photography, but a book about a way of seeing that was previously considered a learning disorder, or even a

mild form of mental retardation. *The Gift of Dyslexia* by Ronald D. Davis is an amazing and wonderful investigation into the ways that the "normal" and the dyslexic person process visual information, and how our visual processing affects the way we store and use information, language, and symbols.

The dyslexic person absorbs and uses visual information almost exclusively. If the dyslexic doesn't have a mental picture to go along with a word, then that word simply doesn't exist. He must see it.

Printed words and the letters that make up our printed words are not static to the dyslexic, because he can pick up those words and letters in his mind and twirl them around, and look at them forward, backward, and upside down. Just reading this book and imagining how a dyslexic sees stimulated my creativity and gave me one more unique way to think about seeing.

ASK PERMISSION TO MAKE A STRANGER'S PORTRAIT

When new photographers are learning to shoot, we tend to ask our family, friends, and neighbors to sit for us. While this can be fun and rewarding when we can make great portraits of our loved ones, precious few of us will ever make a living shooting our kids, husbands, and wives. The process of making a portrait of a person close to us can be both harder and easier than making a portrait of a virtual stranger. It's harder because you may experience more impatience and eye rolling (both on your part and the subjects'), and you'll have a harder time convincing your loved one that you are the authority in this situation. On the other hand, you already have a rapport established and a level of trust with your family member. In any case, making a portrait of a person close to you, willing or not, will not prepare you for the reality of trying to connect with a stranger from behind your lens. It's kind of scary to make pictures of people we don't know, we have no relationship with. Sometimes the fear of this interaction with strangers is at the root of a problem that at first blush appears to be a creative block.

So, since I've always been a huge believer in baptism by fire, I recommend you go to a public place (a park, a lake, a beach, an outdoor coffee shop) and ask total strangers if you can take

their picture. Use any rap you like—you're learning photography, you like the way the light is hitting their face, you're collecting images of people and their pets as a hobby, etc. If you offer to send a print of the photo to the subject, that can be a plus. If you have a digital camera and you can show them the image on your LCD, even better. The more you put yourself in this situation, the less uncomfortable it will become. Some people will say no, please don't take my picture. That's OK. It doesn't mean you've failed. It may feel like rejection, but all it means is that that person didn't want his picture taken.

DO A TEACHING TRADE OUT

You can get a lot of bang for your buck if you trade out, not services, but expertise. For instance, a friend of mine who is a commercial photographer traded photography lessons with a fine artist in exchange for lessons in welding. She not only brushed up on her own photography technique by virtue of teaching it to another, but she learned how to mold metal—what more could a girl ask for? You don't have to limit yourself to trading with other visual artists—an informal exchange with accountants, computer geeks, personal trainers, and others can help you pick up or brush up on your business skills while honing your creative and technical photography skills. And there are a lot more people who would rather learn photography than accounting, so you should have no shortage of willing parties.

GAMES PHOTOGRAPHERS PLAY

Since I maintain that all photography is really about storytelling, one way to hone your photography skills and rejuvenate your creative eye is to play little storytelling games. One that I particularly like and that always seems to lift me out of the creative doldrums is a game I call "lies about real people." It's actually much more innocuous than it sounds. I go to a public place with a friend (you can do this one alone, but it's much more fun to collaborate), and pick a person or people nearby and makeup stories for them.

DESIGN ASSIGNMENTS OUTSIDE YOUR AREA OF INTEREST

Are you a portrait photographer who works primarily in color? Then assign yourself the task of creating a black-and-white still life or botanical. Try using a green or yellow filter over your lens just to make things interesting.

Is black-and-white nature photography your game? Then shoot a color portrait.

Do you usually shoot table top—food, jewelry, small industrial equipment? Then go out and do a landscape shot. Give yourself the assignment of shooting the polar opposite of your usual subjects, media, and techniques.

I know from experience that I can look at black-and-white studio portraits with new eyes after I've stepped off my beaten track and looked at color botanicals for a while.

CONNECT WITH OLD CLIENTS AND FUTURE CLIENTS

I get some of my best creative bursts after reconnecting with old clients I haven't seen in a while. They tend to tell me what they like and dislike about their portraits, and how their likes and dislikes have evolved over time. Their feedback serves dual purposes: first, it makes me feel good about my work by reminding me that I produce a product that people enjoy; and second, it helps me improve my product.

Meeting potential future clients can be creatively stimulating, as well. Talking to mothers-to-be about what kind of portraits they envision for their babies helps me develop new products. I never try to sell them on my portraits—I encourage them to sell me on theirs.

TREAT YOURSELF

Give yourself a special gift package: a health club membership, a month's worth of sessions with a personal trainer, and a month's worth of visits with a nutritionist. Speaking from personal experience, I'm much more creative and have more stamina for my work (physically, mentally, and emotionally) when I follow a routine including aerobic workouts and resistance training, and when I'm mindful of good nutrition. I get 90 percent of my best ideas either on the elliptical machine or in the shower after a

workout. Make the time! Spend the money! It'll be worth it.

I talk a lot about batteries in this section, recharging them and jumping them. The fact is, this is not a cliché—it's a truth. Your creativity is much like a rechargeable battery. It will run down. That's a given. And it will usually do so at the most inopportune times. But it will accept a charge, too. Learn to facilitate this process and you will have gone a long way toward becoming your own muse.

Index